Digital Abstract and Macro Photography

Ken Milburn

THOMSON

COURSE TECHNOLOGY

Professional ■ Trade ■ Reference

A DIVISION OF COURSE TECHNOLOGY

ISBN: 1-59200-613-2

Library of Congress Catalog Card Number: 2004114493

Printed in Canada

05 06 07 08 09 TC 10 9 8 7 6 5 4 3 2 1

Publisher and General Manager of Course PTR:
Stacy L. Hiquet

Associate Director of Marketing:
Sarah O'Donnell

Marketing Manager:
Heather Hurley

Manager of Editorial Services:
Heather Talbot

Associate Acquisitions Editor:
Megan Belanger

Senior Editor:
Mark Garvey

Marketing Coordinator:
Jordan Casey

Project Editor/Copy Editor:
Estelle Manticas

Technical Reviewer:
Sonja Shea

PTR Editorial Services Coordinator:
Elizabeth Furbish

Interior Layout Tech:
William Hartman

Cover Designer:
Mike Tanamachi

Indexer:
Sharon Hilgenberg

Proofreader:
Kate Shoup Welsh

THOMSON

COURSE TECHNOLOGY
Professional ■ Trade ■ Reference

Thomson Course Technology PTR, a division of Thomson Course Technology
25 Thomson Place ■ Boston, MA 02210 ■ http://www.courseptr.com

I dedicate this book to my hero—my son Lane.

His example has proven to me that everything is possible and within our reach.

Acknowledgments

No author ever created a book working alone, and that's especially true of today's computer books. They must be produced amazingly quickly in order to keep current with the latest releases of software. In this case, I was creating a book that took a totally new approach—the first in a new series—but still working within the same time constraints. And I was creating all of the photographs myself. Arrrggghhh!

The truth is that it was actually fun to create this book. A huge part of the credit for that goes to Megan Belanger, my acquisitions editor at Course Technology; and to Estelle Manticas, my copy editor; and to Sonja Shea, my technical editor. Thanks also to Bill Hartman, the layout tech; Kate Welsh, the proofreader; and Sharon Hilgenberg, the indexer.

I'd also like to thank my professional photographer friends and frequent companions, Markus Baue, Keehn Gray, Rick White, Roger Mulkey, and Maleña Taylor. You guys make photography a lot more fun and a lot more interesting; I've learned so much from you.

I can't leave out my good friends who are also authors of computer books: Bob Cowart, Janine Warner, Doug Sahlin, and Joe Sinclair. There is no substitute for friendship and there is no substitute for sage advice when the going gets strange or rough. You are definitely some of the best in this business.

I'd also like to thank Casio for sending me the EX-P600 EXLIM Pro 6 MP point-and-shoot digital camera. Its host of features and film-quality resolution made it easy to shoot the extreme close-ups in Chapter 9, "Macros."

About the Author

Ken Milburn has been consulting on and writing about computer-based graphics, design, and multimedia since 1981. He has been a contributing editor to the Microsoft MSN-PictureIt! Site, and has written 22 computer books in the past five years.

Ken's photographs have appeared in *TV Guide, Look Magazine,* and *The Los Angeles Sunday Times Magazine,* as well as in advertisements for Southern California Gas, Cole of California, Universal Pictures, Capitol Records, Strega Liqueur, and the Fluer Corporation.

Today, Ken specializes in the composition and manipulation of digitized images for the purposes of fine art and illustration. His work originates as photographs and he then uses computers to abstract them. *Design Graphics Magazine* has featured Ken's work in full color in two separate issues. *Computer Artist* and *Digital Video Magazine* have also featured his work. Ken created the poster for the 1998 Sausalito Arts Festival; his work has been featured in the 1999 American President Lines calendar, on book and record album covers, and in nine one-man shows around the San Francisco Bay Area.

The primary software tools Ken uses in the creation of his work are Adobe Photoshop, Corel Painter, Live Picture, Studio Artist, Deep Paint, Kai's Power Tools, Xaos Paint Alchemy, and numerous third-party Photoshop-compatible plug-in effects.

Contents

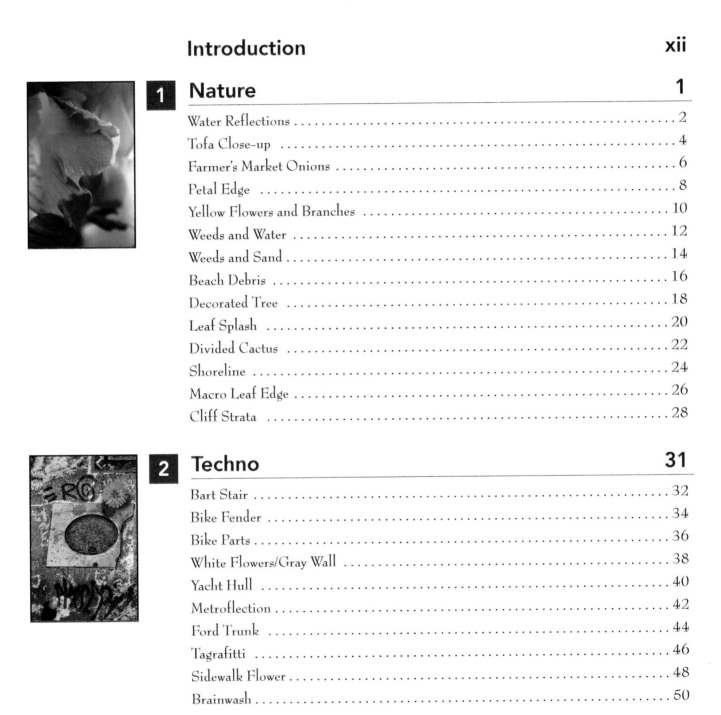

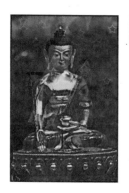

3 # Reflections and Transparency 53

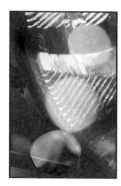

4 # Lights 77

5 Liquids 103

6 Collected Parts 123

7 Blurs 147

8 Bodies 169

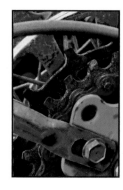

9 Macros 195

Introduction

This is the first of what will become a series of "coffee table" books on various aspects of digital photography. This book is meant to be fun to look at, but it will also inspire you to think about how some of the techniques shown could be applied to your own art. Each featured photograph is accompanied by a page showing the major "stages" it went through before reaching its final form. The manipulations that were made at each stage—and my reasons for making them—are also described.

For the reader who is new to digital photography, this approach will provide broad insight into what can be done during the creation of a digital photo and a glimpse at the wide range of possibilities for making photos that get noticed. Readers with intermediate to advanced experience in digital photography and digital image editing will gain insight as to exactly how the techniques presented in this book can be applied to their own photographs.

What Is an Abstract Digital Photo?

As it is defined in this book, an *abstraction* or *abstract* is any representation of an original subject in which information in the original has been changed in order to intrigue the viewer. One of the purposes of this book is to show a broad range of possibilities within that definition.

How to Use This Book

In this book, you will not find "step-by-step" instructions, such as those found in the conventional how-to books. Instead, this book is designed to do what I call *inspirational teaching*. On the right-hand page, you'll see a feature image that I hope will make you wonder what sorts of techniques and manipulations were used to create it. On the left (facing) page is a series of thumbnail images that show the major stages the image went through in order to get the look presented in the feature image. To the right of each of the stage thumbnails is a description of the goals and tools used for each of these stages. The idea is to make it easy for anyone—regardless of level of experience with digital photography—to get a quick overview of what went into the making of each feature photo.

Some technical terms are used in this book because there's no shorter way to give you a quick idea of what went on. Technical terms are also used so that the experienced reader can quickly grasp what was done in order to repeat the process on his or her own images. If you are unfamiliar with any of these terms, look them up in the glossary at the back of this book.

A Word about Third-Party and Independent Software

In this book, you will find quite a few references to software not made by Adobe. Most of this software is made to become a working part of Photoshop and/or Photoshop Elements once it has been installed. This type of software is called a *plug-in*. I have also mentioned in the text some competitive image editing software and software that creates special effects on an image that operates completely independently of Photoshop. When I mention such software, it is usually because it performs the job more quickly or gives you more options for variables within the effect than if you were working in Photoshop alone. However, it does not mean you can't achieve a comparable effect using Photoshop. In fact, my advice is: Always attempt to do everything using the tools built in to your favorite image editor first. Then, if you just can't get what you're after or just can't do the job as efficiently, you might want to consider whether add-on software is worth the add-on investment.

On the Web

An additional chapter for this book, Chapter 12, "Shadows," can be downloaded from the Course PTR Web site at http://www.courseptr.com/downloads. This chapter will reveal how to achieve some really dramatic effects with light and shadows.

Also at the Web site, you can download Appendix A, "Links to Product Sites." Here you'll find URLs to Web sites offering plug-ins and independent software as well as a short description of that product's most valuable qualities.

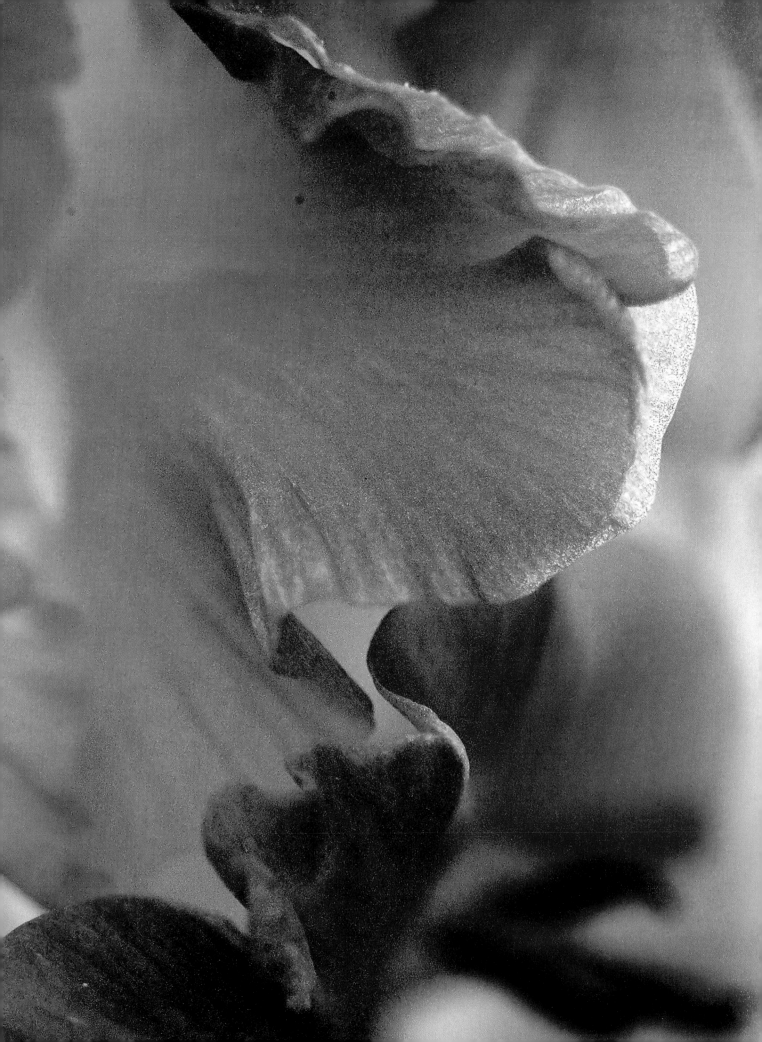

Nature

Water Reflections

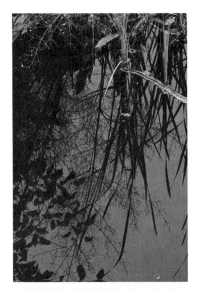

This picture qualifies as an abstract mostly as a result of selective in-camera framing. The picture doesn't identify a particular scene; it communicates peace and serenity. It was taken at a creek that normally flows into the ocean, but at low tide, when a sand dune cut off the water's flow. There was no breeze at all on this morning, so the water was a perfect mirror, and it was a foggy, so the sky was a flat, dark gray.

The image was opened in the RAW converter and the contrast and saturation slightly elevated in order to pop the green in the leaves. The image was then opened in Photoshop and the initial sharpening needed to bring all digital images to the sharpness level dictated by the quality of the camera lens and steadiness of the camera had the image been shot on film was applied. This initial sharpening is a task that all digital photographers should perform religiously. Before sharpening, spotting was done with Photoshop's Healing Brush.

A color equalizer was used to further abstract the image and to alter the coloration of the water. The interface in a color equalizer looks just like that of an audio equalizer, with rows of vertical sliders that adjust the intensity of certain ranges of colors, just as the sliders of a sound equalizer adjust the volume of sound within a given frequency range. Both the Corel KPT Collection and the imaging factory's filter set feature color equalizers.

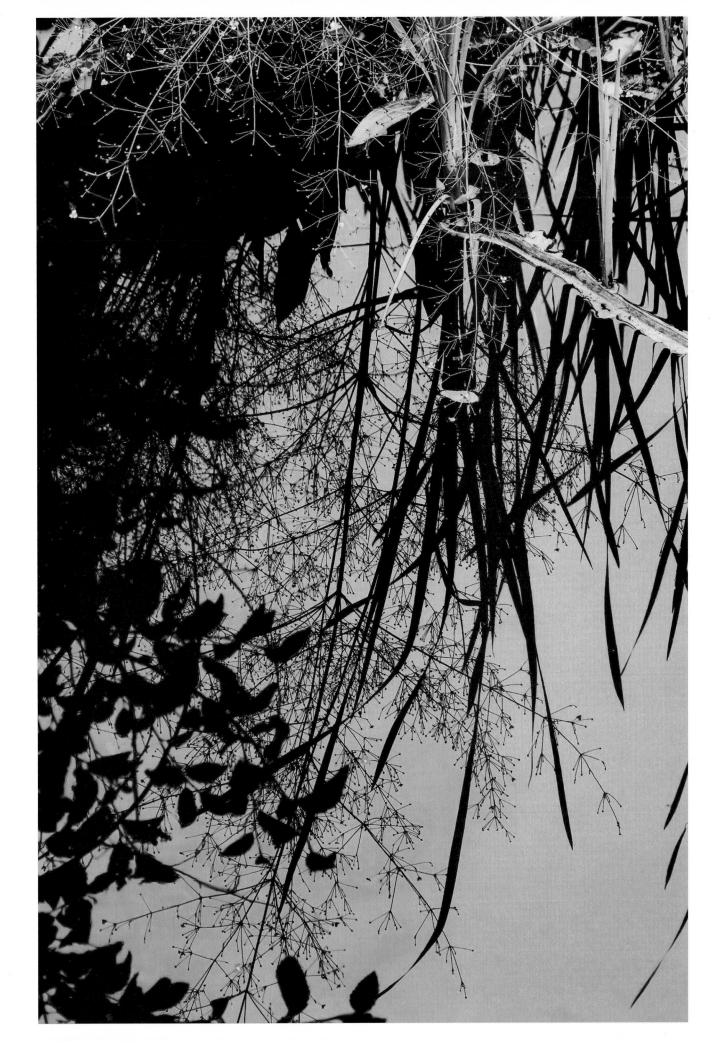

Tofa Close-up

Tofa is a salt formation that occurs when drought dries lakebeds every summer for centuries on end. This process of nature creates some interesting abstract sculptures, but the formations tend to be a nearly uniform gray. In this case, proper exposure for the sky rendered the tofa too dark for the viewer of a photographic print to distinguish its shapes. I adjusted the RAW file twice and saved the result under two different file names so that the second version wouldn't overwrite (erase) the first. I then did initial sharpening for both files using identical Unsharp Mask settings for both.

I then combined both the images to extend dynamic range. Here's how: Copy and Paste the highlighted version atop the shadow version. Use the Color Range command to select the highlights and feather the selection by approximately 75 pixels (make that number larger for larger files, and smaller for smaller files). Feathering a selection makes it "fade" from totally opaque to fully transparent. This causes whatever effect you impose within the selection to blend smoothly with those parts of the image that are not selected. Once you have made a selection, pressing Delete/Backspace erases the contents of the selection, revealing the darker sky and details in the underlying, darker version.

Flatten the image layers. Use the Lasso, Magnetic Lasso, or whatever tool works best to select the area of the photo in which you want to emphasize sharpness, detail, and color. Feather the selection about 75 pixels, then press Cmd/Ctrl + J to lift the contents of the feathered selection to a new layer. For the new layer, select Overlay as the Blend mode. In this instance, I got a really nice color effect, so I duplicated the layer and placed the second new layer in Overlay mode as well. Zoom in to 100% to better judge the sharpening effect you are about to create. Choose Filter > Other > High Pass and adjust the slider until you get the sharpening effect that agrees with you.

Now it was obvious that even more tonal control was needed. I selected the highlights with the Color Range command, and then removed the parts of that selection that were below the horizon. The selection was feathered by 150 pixels for a wide, smooth blend. Then I adjusted the Brightness/Contrast layer to darken the sky and to brighten the contrast in the cloud. The same selection was then recalled from the Channels palette, inverted, and used to mask a Curves layer. A severe S-curve heightened the number of apparent shades and colors in the tofa and surrounding vegetation. Finally, I used a Hue/Saturation layer to heighten this effect even further.

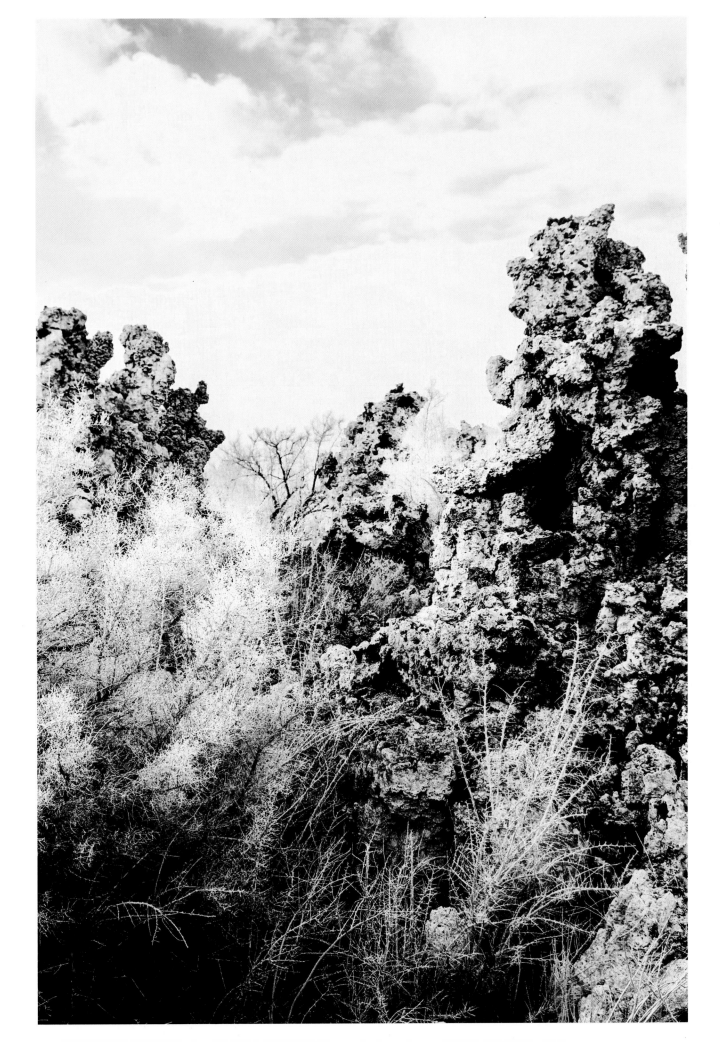

Farmer's Market Onions

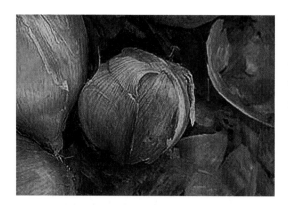

This was shot in daylight as a JPEG with a hand-held pocket camera. Note the extreme depth-of-field shown at this close range, which is due to the very short focal length of the lens required for the very small sensors typical of digital pocket cameras. Be sure to remove noise with Dfine, Noise Ninja, or (best of all, so far) Neat Image unless you know you're never going to make prints larger than 5×7 inches.

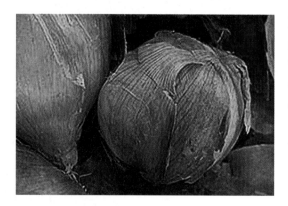

I moved the main onion away from dead center to improve composition. I did so by enlarging and then cropping the original image so that the end result was the same size as the original. If I hadn't been as close to the onion as the camera I was using at the time would allow, I would have zoomed or moved in even closer. Luckily, the 5MP image had enough resolution to let me do some cropping, provided I carefully removed noise and did some basic sharpening.

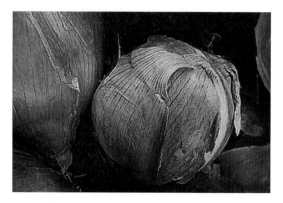

I wanted to raise contrast in the center tones, so I made a very slight S-curve in a Curves layer. Nearly all of the commands in Photoshop's Image Adjust menu are also available on adjustment layer. I (almost) always start making exposure and color changes by working in adjustment layers. Then I can go back and re-adjust them if a later step changes the original effect I wanted.

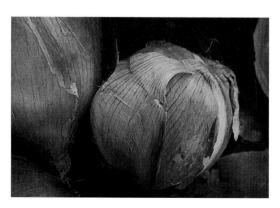

In order to place more viewer attention on the main onion, I made a selection with the Elliptical selection tool, dragged the selection so that the onion was in the center of the oval, inverted the selection (Cmd/Ctrl + Shift + I), and chose Select > Feather: 150 pixels. Then I used a Brightness/Contrast adjustment layer to darken the contents of the selection. It's an elementary technique, but it's certainly one of the most effective.

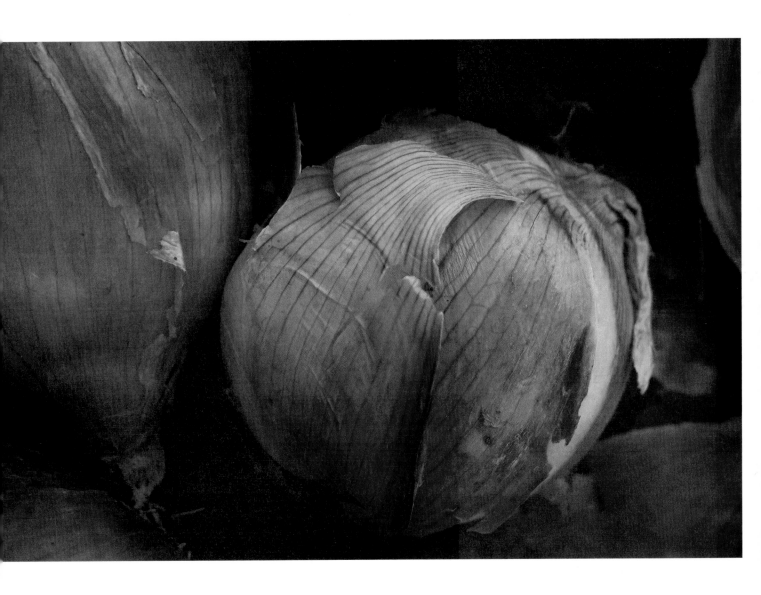

Petal Edge

The original RAW file was quite dark. In the RAW file converter, I dragged the Exposure slider to the right, but not so far that whites actually started to appear. After all, there were no whites in the original scene. I also increased the Overall Brightness, as well as the Contrast and Saturation.

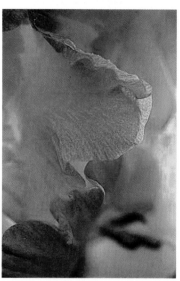

Because there were so few well-defined edges, I dragged the Camera RAW Sharpen slider to 75, and then did initial sharpening in Photoshop.

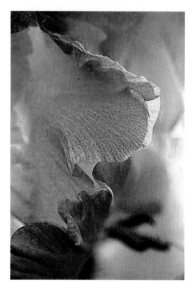

Finally, I played with the Temperature slider to create a feeling of flame, and to intensify the sensuality of the overall orange tone of the image. Next, I used the Levels command on each color channel to give more drama and definition to the edge of the petal. Then, to make it even more dramatic, I made a highly feathered and very loose selection around the curvy edges of the petal. I created a Curves Adjustment layer, and used a fairly severe S-curve to further brighten the highlights, darken the shadows, and make the edge texture more pronounced.

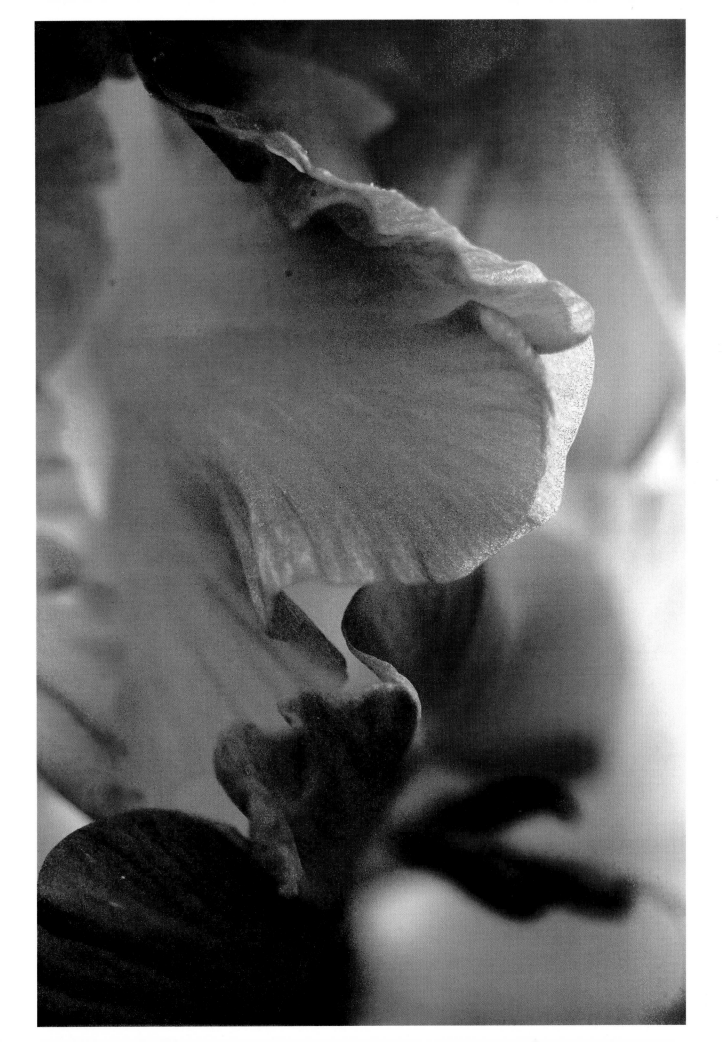

Yellow Flowers and Branches

This image reminds me a bit of a Japanese painting, with its bright lines and strong colors. The most important manipulation involved using the RAW converter to darken the shadows so that the branches and leaves really stood apart from the background. Intense color saturation and extreme sharpening were important in rendering the image more in the style of an Asian watercolor.

Back in Photoshop, I removed noise and refined the initial sharpening with the Unsharp Mask tool. I then used the Eyedropper to choose the darkest color in the background; then I chose the Paintbrush, set its mode to Darken and its opacity to 30%, and made sure the brush edge was extremely soft. I then carefully painted out the detail in the upper-right corner. When I zoomed out, the darkened upper-right corner was closer to the right tone, but the soft edges that resulted from the above technique were distracting, so I used the Clone Stamp to copy some of the other loose-leaf edges from other areas of the photo. That technique created a magically believable result. Finally, I resorted again to using the duplicate layer in Overlay mode, in combination with the High Pass filter, to crisp things up.

After studying the image for a while, I decided that I needed more drama in the leaves. I made a selection around the leafy areas, feathered it 50 pixels, and then used a Curves Adjustment layer to pop the contrast between the green leaves and the yellow flowers. I was tempted to hand-color some of the branches, but after seeing the nice color shades brought up by an increase I made in the saturation I decided to leave well enough alone.

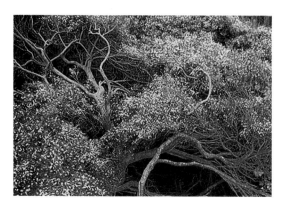

More was needed in order to qualify this image as an abstraction, so I used nik Color Efex Pro's Bi-Color User-Defined filter to tint masked portions of the image. I made the mask by using the Select Color command to select additional colors until the dialog's preview window showed me the mask I wanted. I then chose the colors and adjusted the blend until I felt that it might work, and then I applied the effect. I ended up changing the colors, as well as the point at which the colors graduated and the rotation of the graduation, until I was satisfied with the end result.

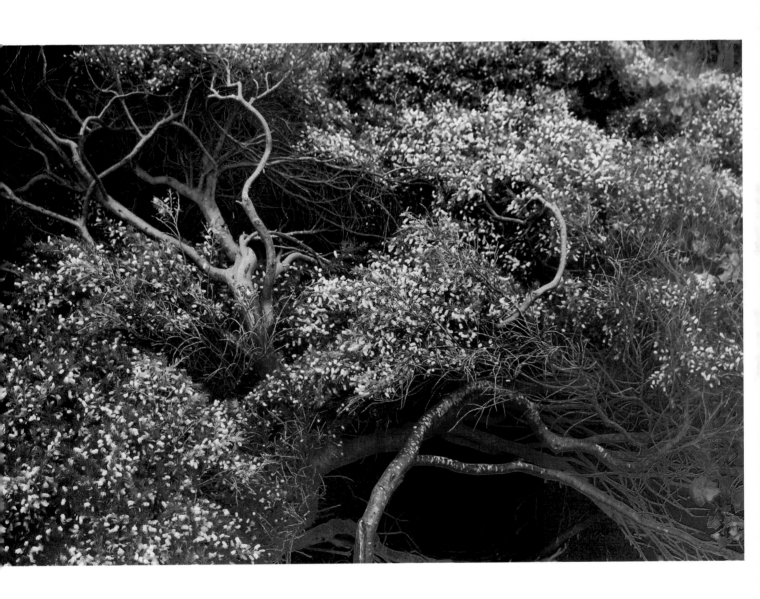

Weeds and Water

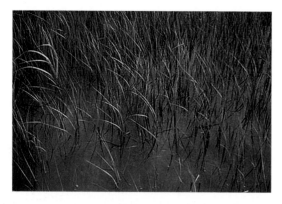

Here I wanted to create a strong contrast between liquid and vegetable. I wanted the weeds to be greener and the water to be bluer. After I used the RAW converter to make the image look as good as possible, I resorted to the Channel Mixer. In the Blue channel, I increased the level of blue. In the Green channel, I increased the level of green.

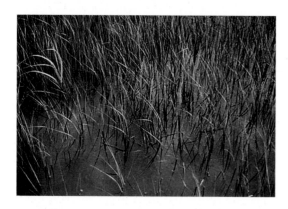

Next, I wanted a bit more life and transparency in the water and a lot more green in the leaves. I created a Curves Adjustment layer and then used the Eyedropper, while simultaneously pressing Cmd/Ctrl, to pick the highlights in the water. This placed a control point at exactly the desired point of brightness along the curve. I then used the Arrow keys to move the point until I saw exactly the tonalities I was looking for.

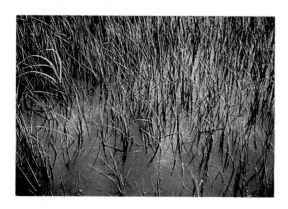

Now I was getting close, but the lower-right corner of the picture was just too darn bright. A 135-pixel feather on a Lassoed corner selection, in combination with the Brightness/Contrast command, produced exactly the result I wanted. Finally, I duplicated the layer, put it in Soft Light mode, and set the Opacity at 50% and the Fill at 80%. The result was an even more increased lighting effect, almost as though one were viewing this little scene in moonlight.

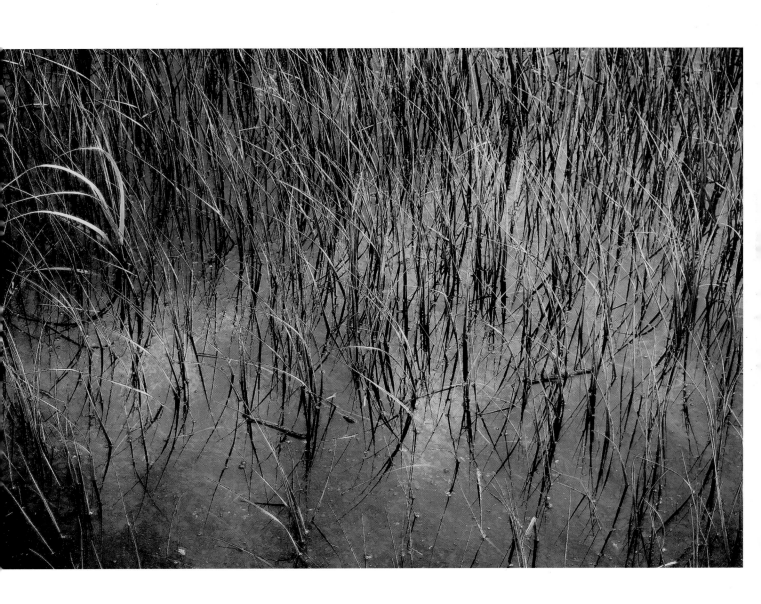

Weeds and Sand

There were such subtle and graceful hieroglyphics in the mixture of black rock and light marble that made up this sand. It was a perfect complement to the graceful bends in the tiny, solitary grass leaves. But it's hard to feel the punch in a scene with such subtle color gradations. In order to compensate for the camera's inability to see as wide a dynamic range as the human eye can, you must make adjustments.

To begin with, I exaggerated the color variations in the sand in the RAW file converter by adjusting the black point to a higher number of pixels and then increasing the overall brightness of the image. As you can see here, that wasn't enough. The blacks simply weren't black enough for my taste. I also wanted to darken the grass a bit more to emphasize the life in the leaves in contrast to the cold, hard stone in the sand.

Bringing lighting and contrast into the image was a matter of delicately changing the brightness of specific areas of color along the brightness curve in the Curves command dialog. In Photoshop, you accomplish this by dragging an eyedropper cursor to a specific area of brightness and then clicking while the Cmd/Ctrl key is pressed. This places a point along the curve that can be raised or lowered to brighten or darken that particular color. Pressing the Up and Down arrow keys brightens or darkens the surrounding colors. In this instance, the curve was raised to brighten the highlights in the sand, lowered in a restricted range to darken the leaves of the weeds, and lowered in yet another restricted area to darken the deepest shadows.

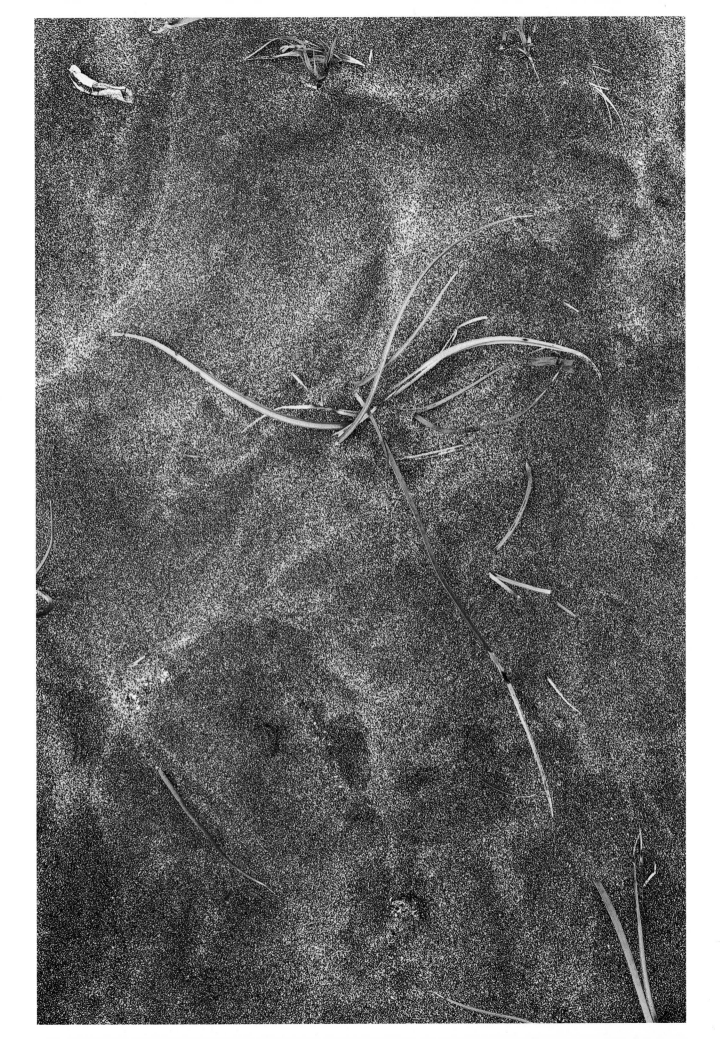

Beach Debris

The original image was shot at Drake's Beach on a sunlit spring day. Debris from tides and storms had washed up against an embankment and dried. I found something in the composition that fascinated me: the shape made by the brighter and thicker twisted stems at the center of the composition.

I first put the file through the usual sharpening and adjustment routines. At first that seemed to be enough, but then I found myself wanting to turn the image into more of a painting. I could do that by simply using the Paintbrush in Photoshop or Photoshop Elements in Color mode. I'll come back to that later. At this point, however, I didn't want to spend the hours it would have taken to color all the individual bits of rubble. Flaming Pear makes a filter called Aetherize that creates all manner of apparently hand-painted color effects. It works interactively, allowing you to drag sliders and see the effects they produce. I strongly suggest making a duplicate of your image so that you can simply dump it and start over if you don't like the result you get. The image at left shows the Aetherize image interpretation that I settled on.

The result produced by the Aetherize filter on this particular image was amazingly close to the result I wanted, but the highlights in the stem that was the center of interest were just too washed out. Also, I thought that painting the stem a specific color would set it apart. So I broke down and hand-painted the stem—twice, in fact. The first pass involved choosing a green that would look fairly natural in this context, but would still stand out. Then I set the Brush mode to Darken and painted more green. I then did a second pass, but changed the mode to Color so that darker colors and the new strokes would contrast slightly.

At this point, it struck me that lowering the contrast in most of the image without affecting the contrast of the stem would make the stem even more of a focal point. I used the Lasso to make a very loose selection around the stem, and then feathered the selection to blend the effect of the next step smoothly into the surrounding image. Then I used the Shadows/Highlights command to dim the brightest highlights and to open up all but the darkest shadows. If you're not lucky enough to have Photoshop Elements 3.0 or Photoshop 7+, you might want to try simply lowering the contrast within the selected area. I used Power Retouche Sharpen to do a sharpening effect on the stem after inverting the selection that I made in the previous step.

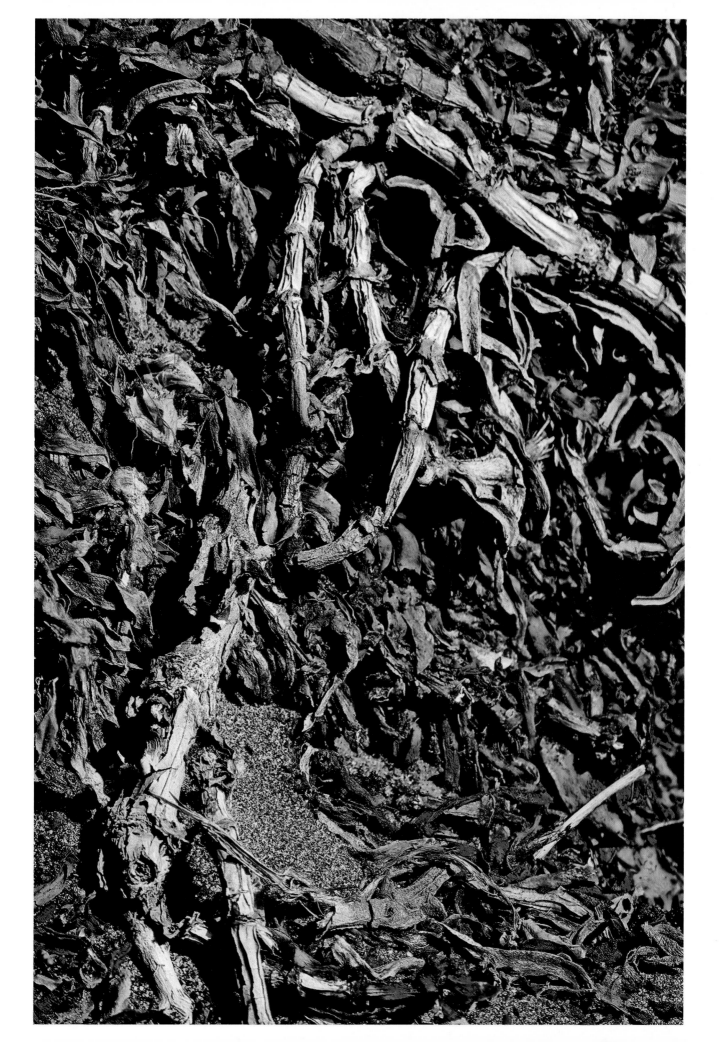

Decorated Tree

The background in this image, despite being out-of-focus, is much too distracting to allow the viewer to concentrate on the beauty of this small tree and its Zen decorations. I wanted to keep some sense of the tree's surroundings without making their exact contents identifiable, though. I copied the original image to a new layer just above the original image. I then removed the background so that the original could be seen behind it. If you were looking at the image at this stage, it would look exactly the same as the original. I then applied Photoshop's Gaussian Blur filter to the original layer to create the illusion that the background was entirely out-of-focus. I used the Brightness/Contrast command on the background layer to both darken it and to lower its contrast.

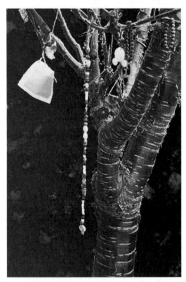

I still wasn't happy with the background, for a couple of reasons. First, it just didn't look very interesting, and second, the blurring created dark shadows around the trees. I decided to combine the blurred background with another layer that had been "decorated" by a texture filter. Any number of texture filters might be a candidate for this job. I used an add-in called Flaming Pear Glitterato, which creates cloud and star effects. I just played with the adjustments until I felt I was getting an attractive mixture of light and dark patches in the background.

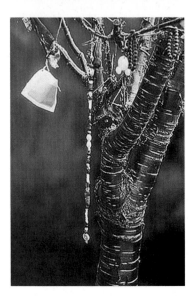

Once again, I used the Blend modes to combine the texture and background layers. This time, I used the Screen mode and lowered the layer's Opacity to about 20%. If you want to try this sort of thing, I suggest you drag the Layers palette out of the Palette well so that it floats over the Workspace, then experiment with the effect of various Blend modes by choosing the Move tool and continuously pressing the Shift and + (plus) keys to move down through the list of Blend modes. When you see an effect you like, drag the Opacity and Fill sliders until you get the exact intensity of the effect that you had in mind.

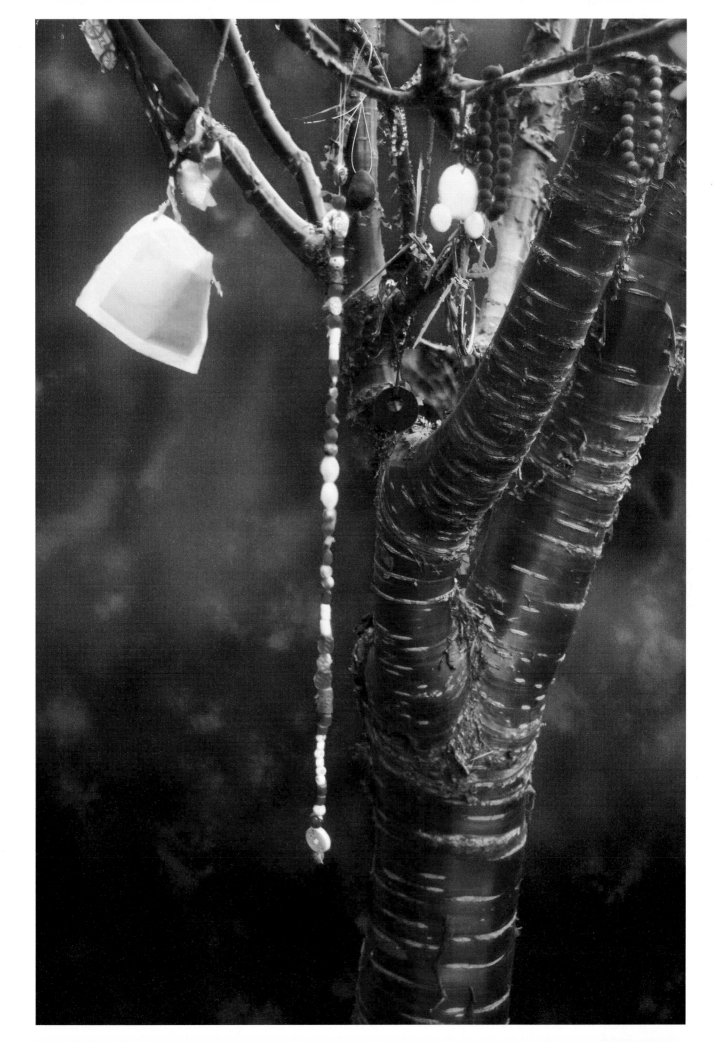

Leaf Splash

The cropping and point of view here make an agave plant look to me like a fountain of youth and energy. (At my age, I'm always on the lookout for fountains of youth.) The color of the agave plant's leaves changes from a solid green to multicolored stripes just prior to the plant's flowering. I've been fascinated by this change of color and by the fact that shooting the center of the plant seems to almost always produce a dynamic abstract composition. Given a bit more intensity and saturation, this original would have been quite striking on its own (as you can see in the illustration for the next stage, below).

After exaggerating the contrast and color saturation in the RAW file converter, I decided to experiment with further abstracting the plant by altering its colors. In this instance, I used a pair of filters called Color Correction and Color Equalizer from the imaging factory collection. The Color Correction filter allows you to choose a source color from the image and then change all the colors relative to that source color by adjusting sliders for the destination color. The Color Equalizer allows you to alter the brightness of individual ranges of color. I prefer the imaging factory filters to most competitors (Power Retouche is an exception) because they can be used while the image is still in 16-bit mode, which minimizes the posterization effect that often occurs in 8-bit mode.

I wanted something that was still brighter, something less real and more symbolic. For one thing, I really wanted to change the color of the few green leaves that were left. In order to change just one color at a time, I used Photoshop's Replace Color command. You simply pick a color with the Eyedropper tool, drag a slider to indicate the brightness range of the color you want to replace, and then adjust sliders for the three primary colors until you get the color you want to change to. As you can see, I was having too much fun transforming colors to stop with the green.

At this point, I was becoming quite happy with the end result. However, I thought the image might be look even better if I outlined the edges of all the leaves. Ordinarily, I outline edges with the Find Edges command. Then, because it produces what appears to be a color drawing, I use the Threshold command to convert the result to a black line drawing. This time, though, I became intrigued by the idea of combining the color line drawing with the result of the Replace Color command, so I just paged through the layer modes for the Find Edges layer until I came to the Screen mode. You see the result on the opposite page.

Divided Cactus

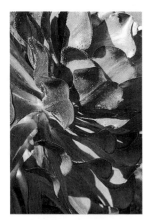

This started out as a simple close-up of a succulent. It was shot in direct sunlight with an add-on 2X close-up lens mounted on a 24-75mm zoom, racked all the way out and stopped down to minimum aperture. Shooting in bright sunlight made it possible to do this while maintaining a relatively high shutter speed—especially as I cranked ISO sensitivity to the camera's maximum ISO 1600. Camera settings were Aperture f-13, Shutter 1/750 second.

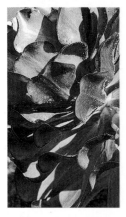
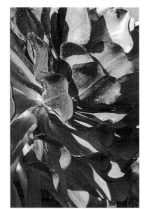

I wanted to render this shot into a more sculptured-looking pattern. I decided to borrow a technique pioneered by Jerry Uelsmann (a photographer who became world-famous for his surreal photomontages long before there were digital darkrooms). First, I doubled the image's canvas size so that there would be room for a mirror image of the original image. I then made a rectangular selection over the portion of the image I wanted to mirror, feathered the edge so that it would blend, and lifted the contents to a new layer. The new layer was then flipped horizontally. This "Uelsmann" technique is always most effective when the seams between images in the montage are invisible.

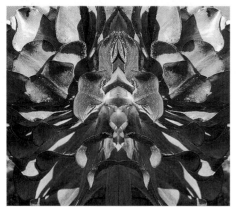

I zoomed in to 100% so that I could see exactly the positioning and blending that occurred with the merge. Then I used the Move tool to drag the copied image into position so that the reversed image blended nearly perfectly with the original. Once the image was ideally positioned, I flattened the image and used the Clone Stamp to fix any disconnected lines. The Healing Brush and Patch tool were also used to blend textures and edges when the Clone Stamp lacked the right subtlety.

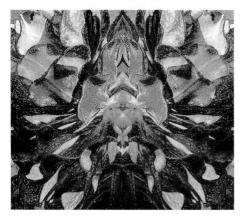

You could further interpret this image using just about any technique described in this book. What I thought would work best, however, would be to simply re-interpret color and line. The image at left was treated with two different processes on overlaid duplicates of the original layer. The first duplicate was treated with the native Photoshop Chrome filter. The second duplicate was first treated by equalizing the color, then by changing the darker green shades to dark blue using the Photoshop Replace Color command. Finally, the "chrome" layer was changed to the Soft Light blend mode. Now the shades in the chrome effect make the image look a bit like a texture painting.

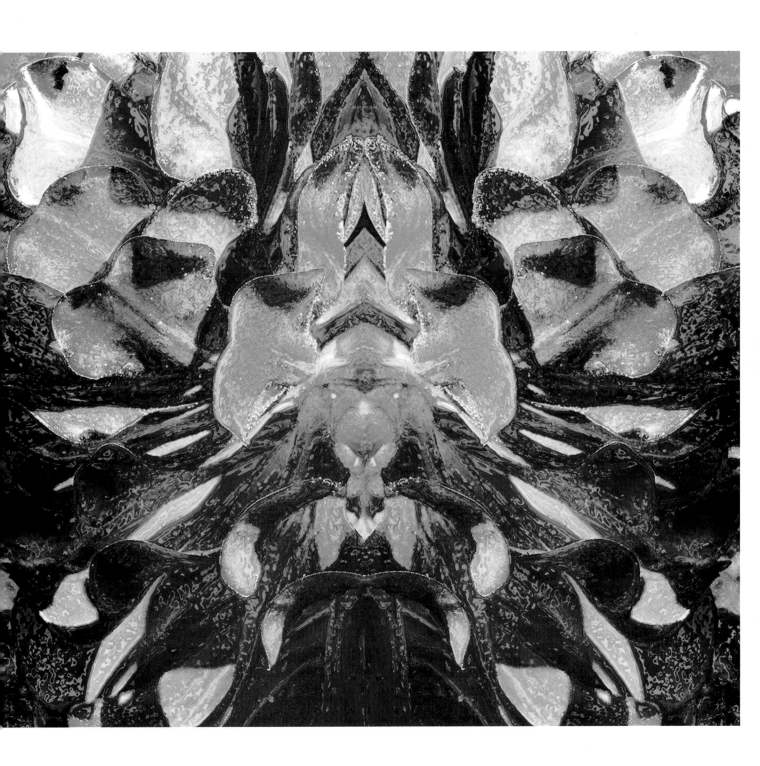

Shoreline

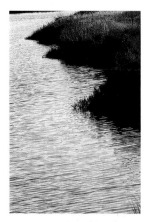

What you see here could be just about any inland shoreline in early spring. I made this image more abstract by shooting it with a long lens (75-300mm zoomed out to 150mm), which tends to flatten perspective by making all objects close to the same size, even when some are much closer to the lens than others.

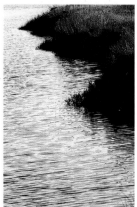

As you can see from this original, a bit more zooming would have been desirable, but the viewfinder was only showing me about 97%. It's also obvious that the shoreline would be even more abstract if it were given more contrast in shading. I used a highly feathered selection and the Brightness/Contrast command to add some detail and emphasis to the grass in the upper-right corner, and then I rotated the image slightly clockwise and stretched (Transformed) it evenly so that the far shoreline was cropped out. The image was then cropped to its original dimensions and flattened. Of course, I also performed the usual pre-sharpening routine.

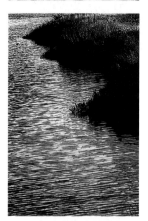

A Curves layer was added to give more character and lighting to the surface of the water. Next, the whole image was flattened so that it could be "sepia toned." Before toning, the image was converted to "black and white," and then the Channel Mixer was set to Monochrome only and the channel sliders positioned for the most dramatic black and white effect (you can actually use this technique to imitate conventional over-the-lens filters). Next, as I wanted to convert the image to duotone, I changed the mode to Grayscale, then to Duotone. The two colors I chose (you can choose several, if you like) were a coffee brown and black.

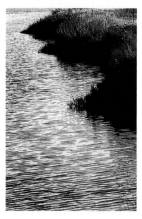

Next, I wanted to take the water back to a bluish color. To do so, I used the Image > Mode command to convert the water back to RGB color, and then I made a loose selection around the water, feathered it to make the color blend, and filled it with a new blue foreground color. I then used the Paintbrush in Color mode to apply the same color to all the little spaces between grass and weeds, water and shore. Aha! You could also use this method to tone an image. Unfortunately, the toning was a little too blatant, so I filled another highly feathered selection with green (also in Color mode) then used the Fade command to make the effect less garish.

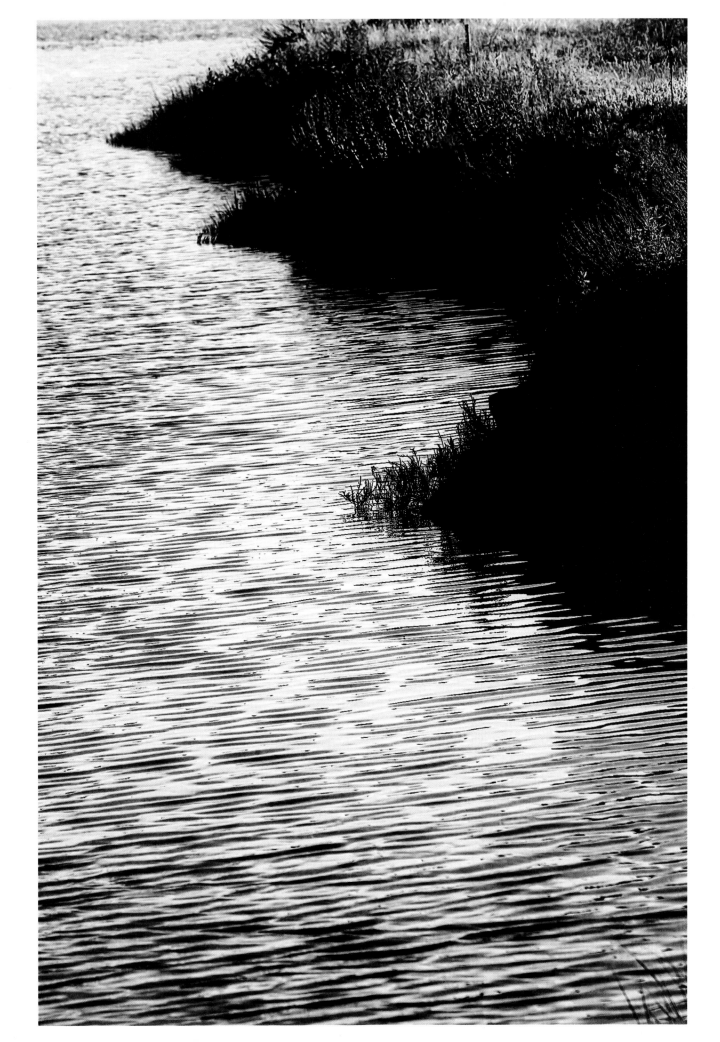

Macro Leaf Edge

I was fascinated with the texture and color changes in the edge of this cactus leaf. The spider's web added to the patina. I used my Fuji S2 DSLR with a 24-75mm lens to take this shot. I stacked a +1, +2, and +3 close-up filter. At this distance and aperture, the depth-of-field was so shallow that I needed to focus by moving the camera closer to and further away from the subject. The image you see at left is close to what I saw as soon as I made the "normal" adjustments to the histogram in the RAW file converter. I then removed noise with Dfine and did initial sharpening with the USM filter.

I used the Lasso tool to make a selection around the leaf and then feathered it 60 pixels in order to blend any changes smoothly into the foreground. I then darkened the background with a Brightness/Contrast adjustment layer and changed its color by dragging the sliders in the Hue/Saturation dialog.

Because the macro had so little depth-of-field, thanks to lighting conditions and the focal length of the lens on a typical DSLR, I decided to increase the drama of the edges with further sharpening. I call sharpening that's done at this stage *effects sharpening*. In this case, the job was done using the Focal Blade sharpener because it is capable of producing dramatic sharpening while allowing you to make adjustments that correct the defects that result from over-sharpening.

Finally, I wanted to make this image more "arty" and abstract by making dramatic changes to the colorization. This can be done using many different filters and techniques—simply duplicate the original layer and experiment with the filters on the duplicated layer. Once you've found something appealing, either stop or try using the layer blend modes. In this instance, I chose the Pop Art effect from nik Color Efex Pro, and then I blended it in Saturation mode.

Cliff Strata

In the RAW converter, I boosted saturation and tweaked the color temperature to get as much image detail as possible. I also experimented with a new noise reduction filter called Neat Image Pro +. It should be available in both Mac and Windows versions by the time you read this.

As a straight photo of a natural detail, this image could have stood on its own with very little additional tweaking. I did select and lighten the dark upper-right corner to help balance the overall shape and texture of the image. As abstract art, however, I thought this image should take on more sculptural dimensions. The first step in accomplishing that goal was to darken the sand so that the rocks and the yellow strata in the cliff would stand out on their own. I did that by using the Magic Wand tool, experimenting with the Tolerance setting, and unchecking the Contiguous box so that all the portions of the image that were the same shade and color would be selected. The selection was then feathered 20 pixels and a Curves layer was used to further darken the dark tone. Note that this also brought out a bit more texture in the rocks.

I thought that the whole image could be made to look more "painterly" by intensifying the color of the strata. First, I used the Select Color Range command to select the yellow edges of all the strata and feathered the selection—but only slightly. I didn't want the new color I was about to apply to spill out onto the sand. I then experimented with several means of changing the color. The most satisfying results came from using Power Retouche's Color Editor, which lets you adjust the tint by each primary color. Unfortunately, the preview window doesn't restrict your changes to the selection you made, so you can't see what happens to the selected part of the image in relation to those parts that will be unaffected as a result of the selection. As you can see here, it works just fine when you apply it, however. I did use the Fade command to make the change blend into the image a bit more naturally than was the case when the command was first applied.

I still found the top edge and corner a bit dark. I could have balanced that by burning in the bottom corners of the image. Though that's usually an effective technique, I felt it would diminish the feeling of endless textural and sensual pleasure this image produces. So I made a soft-edged selection around the dark edges and then used the Levels command to brighten just the tonal range that matched the tonal range in the bottom of the image.

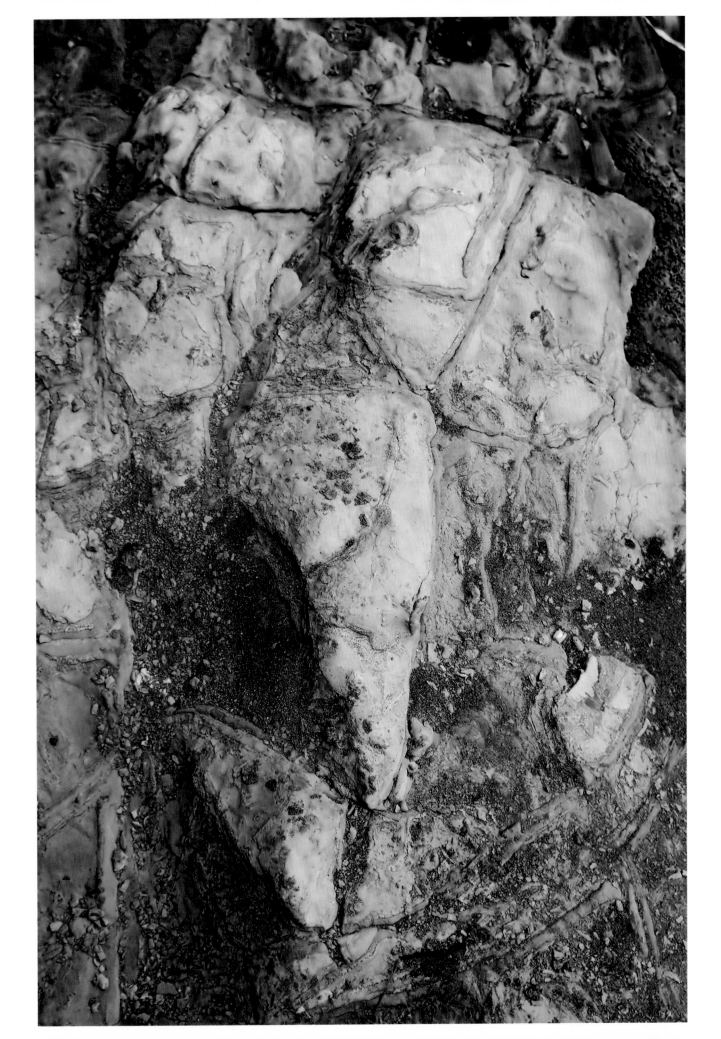

Techno

Bart Stair

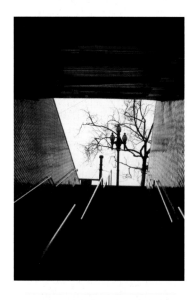

This image posed challenges because of the extreme contrast between sky and foreground. I removed all noise in the shadows and did preliminary sharpening. I corrected the perspective by dragging the corners of the Transform marquee outside the image and then cropping it. This is not a black and white image. It simply looks that way because there were so few colors in the original scene, due party to extremely foggy conditions on the day the photo was shot.

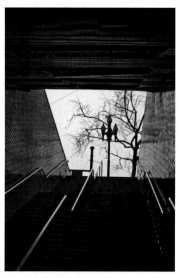

I wanted a bit more interest in the foreground, so I used the Photoshop CS Shadow/Highlight command to both reveal detail in the staircase and ceiling and to eliminate the glare of the foggy sky. I also hoped to see a bit more color in the tree bark, so I boosted saturation with a Hue/Saturation layer.

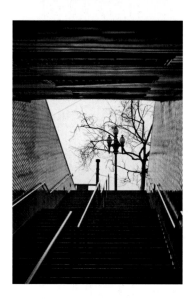

The image still felt a little grayish, despite the fact that the Shadow/Highlights command brought significantly more texture into the foreground. The grayness problem was remedied by using a Curves layer to "pop" the contrast in the overall image. I also wanted to see a bit of sunset color in the sky. The Replace Color command wouldn't give me the effect I wanted because the original color was so light and neutral. So I created a new layer, filled it with the color I wanted, assigned it the Darken blend mode, created a layer mask with the Magic Wand tool, and then filled the layer with a soft pinkish orange to suggest sunset as the time of day. Layer Fill was lowered to about 15%.

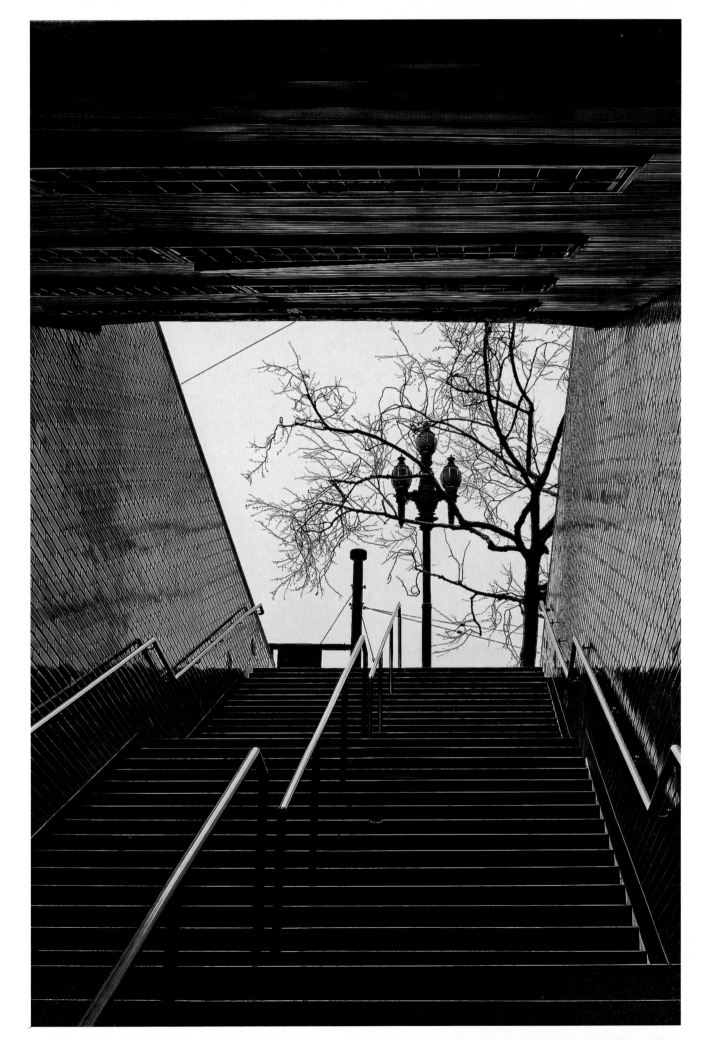

Bike Fender

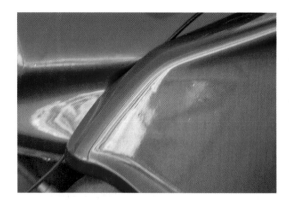

I just liked the colors and shapes in this detail of a motorcycle. I might have stuck with a more faithful rendition, but I discovered that because I hadn't used a tripod or manual focus, the image was actually a bit blurry. I still liked the shapes and highlights, so I thought I'd take on the challenge of radically changing its appearance while keeping the aspects that initially pleased me.

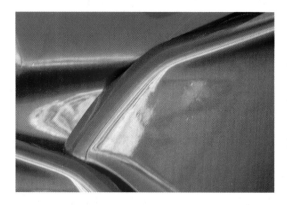

First, I "purified" the design by cloning out the gas line. Then I cut out the bottom-left portion of the image by selecting it with the Magic Wand, feathering the edge, and pressing Delete. Then I duplicated the original layer, flipped it upside down, and then moved and rotated it until it filled the hole I just made. Next, I refined the cutout edge by using a softened eraser and used the History brush to paint back in areas that I'd overpainted.

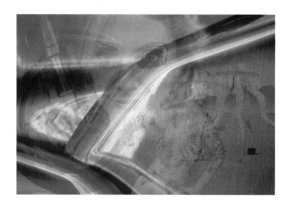

I wanted to "paint" the reflective surfaces with portions of other images that reminded me of the legendary motorcycle lifestyle. One by one, I opened images of another motorcycle, an octopus sculpture from Burning Man, the bare back of a tattooed lady, and a portrait of a costumed lady. I anchored the Clone Stamp in each of these, lowered the brush's opacity, and then painted the images onto a new layer. I then used the Curves command to adjust the brightness and contrast of the painted layer.

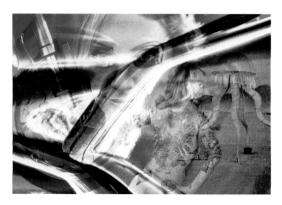

Believe it or not, this is just the way I'd visualized it when I started out tinkering with the image. I used Corel's KPT Collection's Channel Surfing filter to make a value shift to the Blue channel, played with the Hue values to intensify them and then used KPT's Screen Norm blend mode to make the image really pop. Of course, all of this could have been done in Photoshop itself, but the KPT filter makes is a lot more fun to play around with.

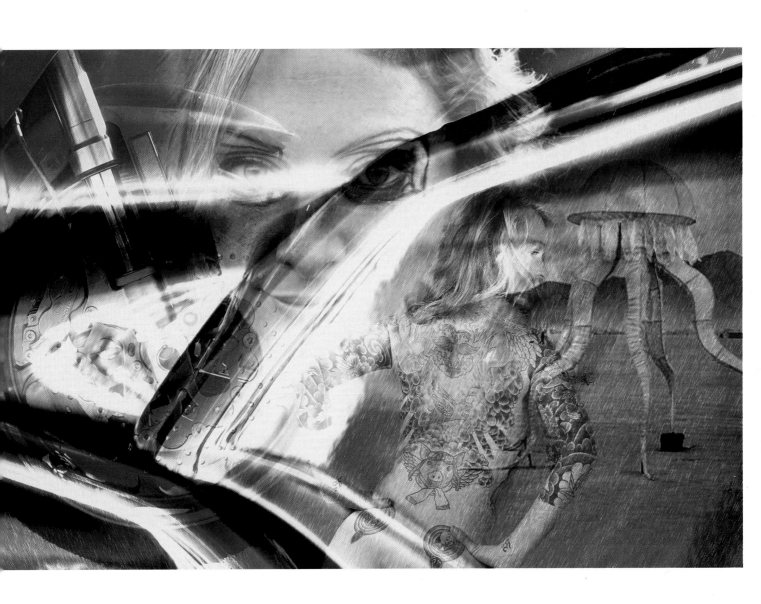

Bike Parts

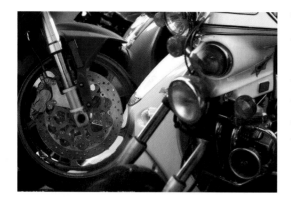

There was no particular technique used in taking the three photos that compose this image. The camera was simply set to point-and-shoot. I sized all three images to the same height. Then I dropped the police motorcycle into the left side of the image and the cycle wheel (yes, the same one used on the "Bike Fender" image above) onto the right side. Then a highly feathered eraser was used to make the edges of the photos blend.

I duplicated each of the three layers, and then treated each with Photoshop's Find Edges filter. I almost stopped here, but as one of the purposes of this book is to show the results of lots of experimentation, I forged ahead.

Next, I turned off the three layers that produced the above result, then turned on each of the other three layers and applied the Colored Pencil filter to all three using the same settings.

Finally, I applied the Hard Light Blend mode to each of the Find Edges layers. Once that was done, I adjusted each of the layers' color and contrast using a curves layer, and fiddled around considerably with the opacity of each layer. Finally, the colors were given even more intensity and contrast by using a Levels adjustment layer and dragging the Shadow slider far to the right.

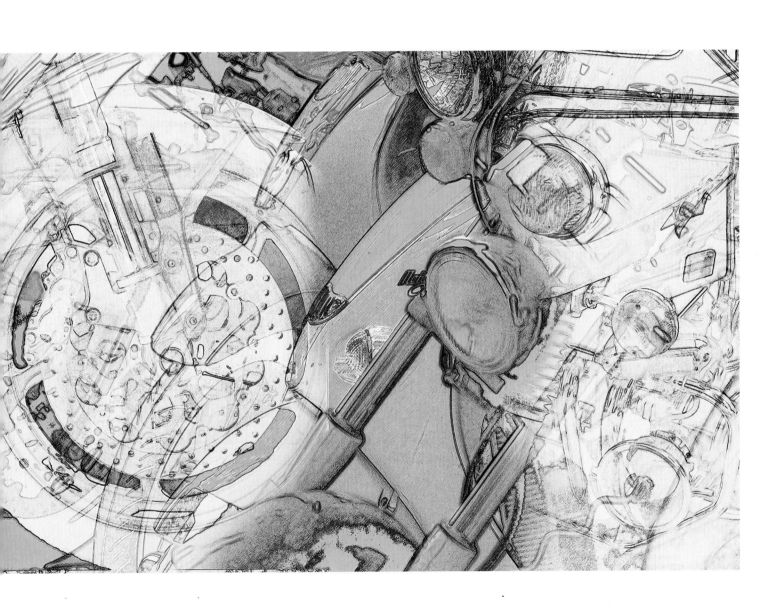

White Flowers/Gray Wall

The original image was slightly underexposed (1/2 stop) to ensure detail in the white flowers. I then created two eposures from the same RAW image. The first was adjusted specifically to show the detail in the white flowers. The second was brightened to give detail to the weathered gray wall in the background. The darker photo that you see here was then copied and then pasted into the lighter version of the photo as a separate layer.

With the lighter image placed on the top layer, I selected the highlights with the Color Range command and feathered the selection by 20 pixels so that the borders would blend smoothly. A press of the Delete key then revealed the detail in the most brightly lit flowers. Where needed, using the Eraser—set at very low opacity—revealed more detail in certain highlights. I also used the Eraser to bring more detail into the white windowsill.

At this stage, the image was flattened and perspective was corrected using Free Transform and the Crop command. I then used Neat Image to remove noise and performed initial USM sharpening. Then I revealed more detail in the foliage with Photoshop's Highlight/Shadow command—and even more detail in the flower petals after I tweaked the Highlights sliders. I really wanted to emphasize the texture of the weathered wood, so I used Power Retouche Sharpness for effect sharpening.

Now that the image was almost where I wanted it, I used Auto/FX Auto Eye to clean up the color a bit and to make the image show edges and details even more forcefully. In Auto Eye, I used the Enhance Strength 1X option and checked Automatically Enhance. This gave exactly the look I'd been craving to the wall and window. However, the flowers lightened up so much they lost all that detail I'd worked so hard to bring up, so I used the History Palette in Photoshop to show me the image before Auto Eye, and then took a snapshot. I then selected the Auto Eye History state and used the History brush to paint the detail back into the flowers. Hah!

Yacht Hull

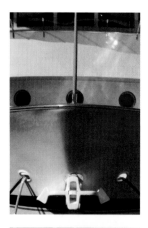

I just loved the simplicity and symmetry of the lines in this yacht hull. These qualities were emphasized by the pure whiteness of most of the surfaces, and the architecture and geometry were clearly visible. I lay on the boardwalk to get a low enough angle to allow me to shoot without creating perspective distortion. This is another subject that has so many strong highlights that underexposure of the RAW file was called for in order to preserve detail in the brightest of those highlights. In the RAW converter, I darkened the shadows slightly and adjusted for a cooler color temperature to suggest reflections from the blue water of the bay.

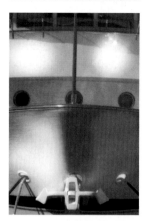

What you see here resulted from my fascination with the potential of Auto/FX Mystical Tint Tone and Color filter. This is a great tool for "painting with light" after the fact. While I was experimenting, I went straight to the Over-exposed effect. It seemed to me to do as glamorous a job on this hull as it would in creating a high-end cosmetic ad. What you see here is the result of simply accepting the default adjustments, then choosing the Brush On option. You can easily choose the size and hardness of the brush to be used.

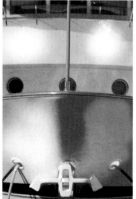

Still in Mystical TTC, I chose the Antique Photo Sepia effect. I increased saturation, upped the brightness slightly, and increased the contrast. This could take quite a while if you had to perform all of these operations separately in Photoshop. The advantage in using this filter set is that dozens of operations that would have to be individually applied in Photoshop can be accomplished in one pass and within a single and highly flexible interface when using TTC.

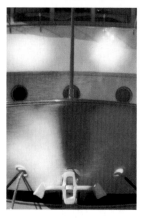

Two more Mystical TTC effects finished off this piece. I used the Soft Posterize effect to pump up the paint with light effect and to give the image a softer, more "nighttime" color balance (the photo was actually shot at four o'clock in the afternoon in the middle of August, when there was not even a hint of dusk). I also wanted the wood in the image to be closer to its actual color, so I used the Color Mixer to change the overall color of the image, and then chose Brush On to limit the color change to the area I stroked with a brush. In this case, that area happened to be the wood railing and the pole. I could just as well have used it for added paint with light effects.

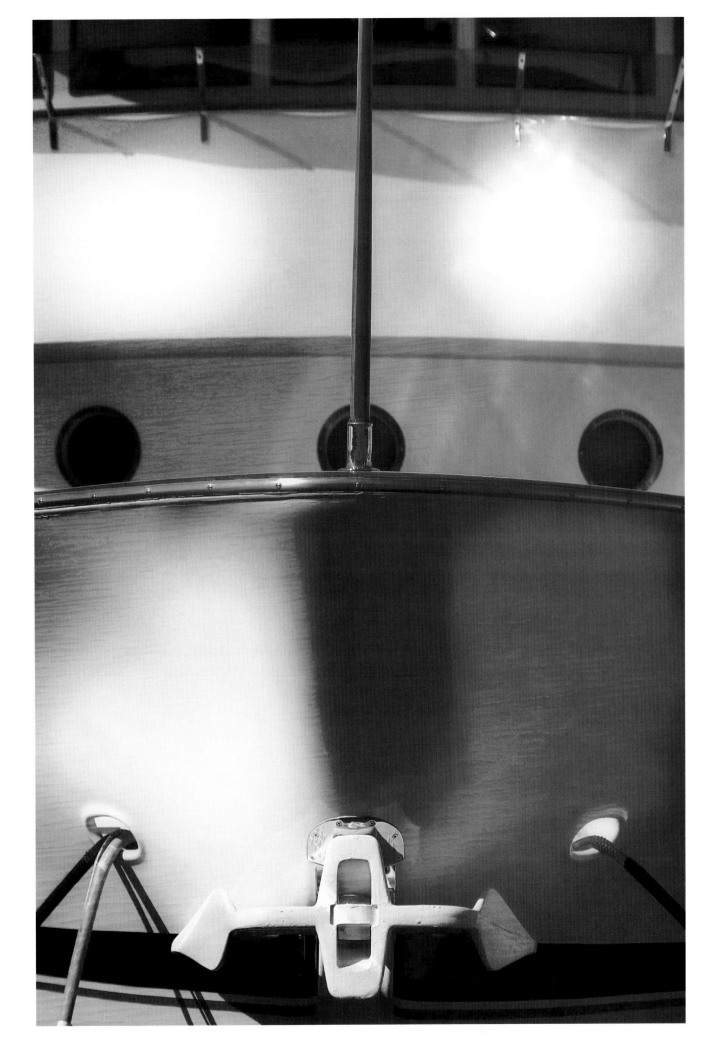

Metroflection

I really enjoy exploring San Francisco's Sony Metreon looking for architectural details that will lend themselves to abstraction. The Metreon is a modern entertainment center full of colored lights, glass, and shiny metal. Normally, when shooting building details, I want the camera on a tripod and fully stopped down. However, blurring is an advantage in this sort of abstraction. In fact, I'll use software to blur it even more before this is all over with. So it was perfectly okay to take this shot hand-held at a wide aperture. In the RAW converter, I maximized contrast and really kicked up color saturation. Because I knew I was going to blur the image, there wasn't much point in doing noise removal or initial sharpening.

The first thing was to remove perspective distortion by using Free Transform and dragging the corners away from the main image by pressing the Cmd/Ctrl key as I dragged the corner. This allowed me to keep the original image size. When I finished transforming, I just flattened the image, chose Select All, and then chose Crop. If I hadn't, all the information I dragged outside the frame would have stayed with the image and wasted file space. The next thing I did was duplicate the layer, create a layer mask by selecting the background junk at the left side of the frame, and then use the Lens Blur filter to throw the background totally out-of-focus.

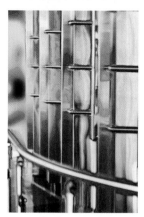

One of the most frequently used techniques in this book is some variation on making dramatic changes in an image's colors. In this one, I duplicated the background layer, then used nik Color Efex' Pop Art filter . I could just as easily have created a similar effect in Photoshop by boosting saturation and then using Equalize and Posterize. It's an interesting effect, but it felt a bit garish. I actually did this on a separate layer so that I could combine it with the layer below using a Blend mode. The one I chose, in this case, is Overlay, which I then reduced to 50% opacity.

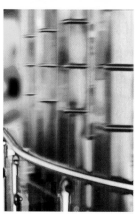

Now for the blur drama. I wanted to create the feeling that the brass frames were moving, so I flattened the version of the image above, then duplicated the base layer so that it could be blurred independently. The brass frames were first selected with the Lasso tool, then the selection was slightly feathered, and then I used the KPT Collection Blur filter. The shapes lost definition in the blurred version, but all I had to do to fix that was to lower the opacity of the blurred layer to 50%. Finally, I intensified the image by adding a Curve layer and creating a fairly severe S-curve.

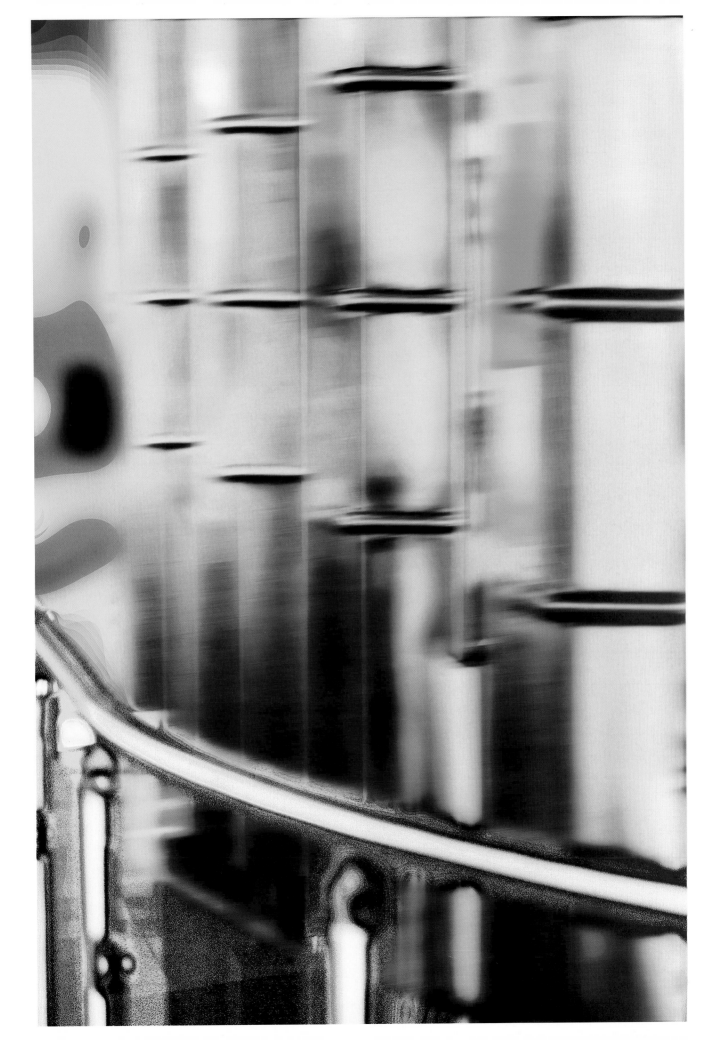

Ford Trunk

I was shopping one day in West Oakland when a rusty old Ford pulled into a parking space alongside me. I just ran to the trunk of my car, grabbed my camera, and started shooting every square inch of the rusty car. For some reason, the awareness of car theft in that rather rough neighborhood kept drawing me to the trunk and its lock. There was nothing unusual about the shooting technique: RAW mode on a Fuji S2 Pro. The lesson here is to learn to pay attention to the little things in life.

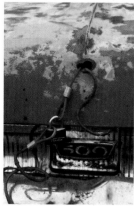

I added three curves layers above the base layer. Each was masked to control the contrast in a given area of the image—overall, top of trunk lid, license plate. I used a fourth adjustment layer, Hue/Saturation, to boost saturation and to improve the overall color balance of the more vivid image that resulted. One of the secrets of producing prize-winning images is knowing when to stop. The color and texture in this image tell me everything I need to know about this car and its owner—at least in my imagination. There's only one more little thing....

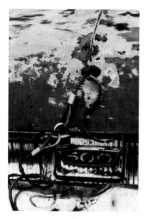

Okay, I admit it. I'm a little hung up on texture when it comes to abstractions of reality, especially this kind of gritty reality. I wanted to pop the color without losing significant image detail, and the KPT Collection's Channel Surfing filter seemed a promising way to do that. One of the presets gave me the contrast effect I wanted. I also wasn't getting quite the detail I wanted in the highlight. Fortunately, I'd followed my usual precaution of duplicating the original layer before I ran the filter. So once I'd finished using the filter, I just shuffled through the Photoshop Layer blend modes until I settled on Vivid Light and then reduced the Opacity setting to 49%.

I wanted to make this image now appear to have been hand-painted in thick oils while simultaneously maintaining a documentary look. I opened the Photoshop file in Corel Painter 8, cloned the image, and then applied Lighting in Painter using five simulated light sources and three different colors of light. Next, to get the impasto oil painting effect, I applied 3D Surface Texture from Clone in Painter with the Softness adjustment increased to make the brush stroke effect more obvious. I then re-opened the image in Photoshop and applied Curves to pop sharpness. I then sharpened the effect using Focal Blade Pro, which also considerably reduced noise that occurred as a result of all the previous steps.

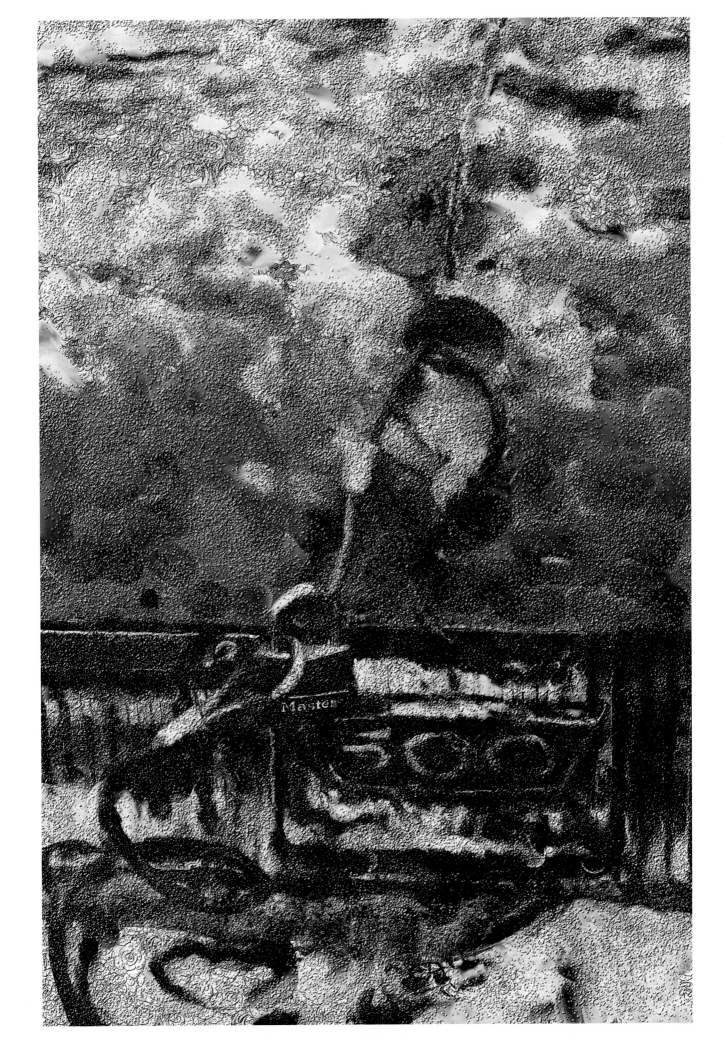

Tagrafitti

Wall tags, or grafitti, are a consistent source of subject matter for abstract photography. You can use them as backgrounds for other subjects, decorate them with other objects from the neighborhood, or emphasize their line and color with all sorts of digital magic. In this case, what caught my attention was the contrast between what might be called "urban blight" and nature—the tags and the cacti. In-camera cropping was a problem because there were objects leaning against the wall that I didn't want to include. There was also more cactus than I really wanted to show.

The excess cacti peeking from the left side of the frame had to go, as it spoiled the composition and detracted from the featured plant. Sections of the protected window cover were selected and raised to a new layer, then carefully implanted over the spare cactus. The Healing brush was used to heal the seams in the layers, and I took great care to vary the point from which the texture was cloned. The layers were then flattened, the noise was removed and I did the initial sharpening with the Unsharp Mask filter. Next, I used the Auto Color command to balance color and contrast in a single command—I often do this as a test and then undo and balance color using the Levels command. In this image, that didn't seem necessary.

One of the reasons the strong S-curve is used so often in this book is that it's so effective at separating graphic elements in a composition; it does so by separating and contrasting the different areas of color. Mystical Tint, Tone, and Color were used to further harden the details by automatically adding sharpness, contrast, and saturation.

Finally, I wanted to unify the visual appearance of the image by making the whole thing look like grafitti. First, I emphasized for effect the difference in colors and the sharpness of edges by using the High Pass filter and Overlay blending. Then, the *coup de grace*: I flattened the layers into one and then duplicated the Background layer. Then I chose the duplicated layer and used the Find Edges filter. The result was a lovely color sketch, but I wanted an ink drawing, so I used the Threshold adjustment to convert the edges to monochrome and to choose the range of tones that would be converted. Once I had my sketch, all I needed to do was change the sketch layer's blend mode to Darken. The edges were automatically traced.

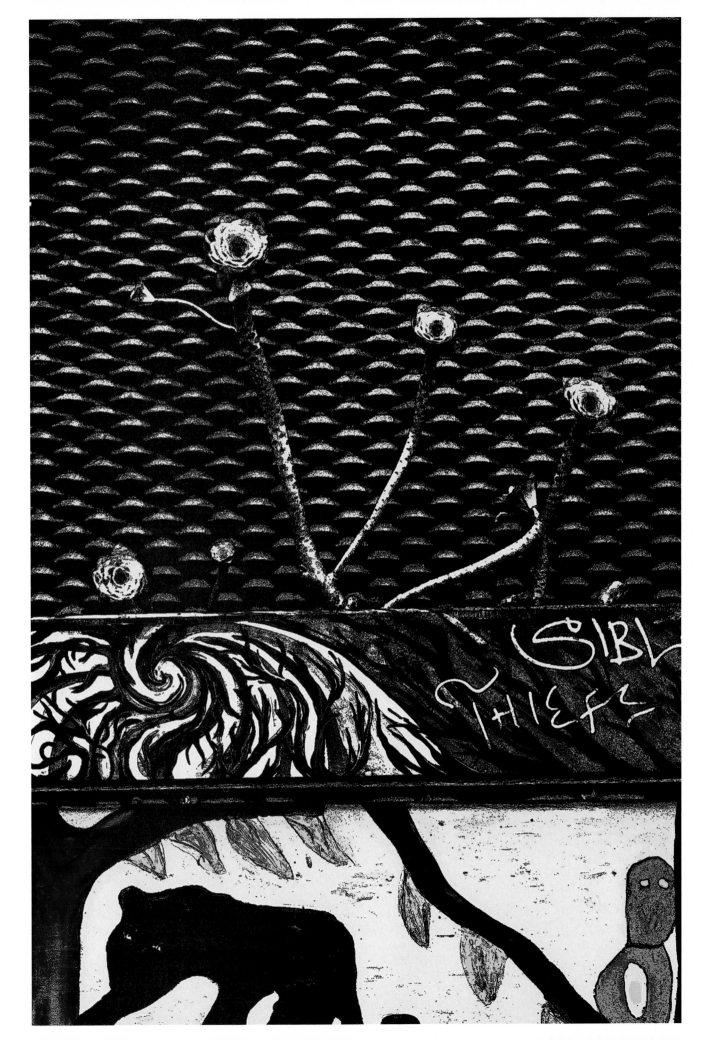

Sidewalk Flower

This image was pretty dull when it first appeared. I snapped it on a stroll through downtown San Francisco as part of my ongoing fascination with the abstract paintings that seem to occur in urban infrastructure. Since the shot was hand-held and the sky overcast, I didn't dare stop down enough to insure depth of field sharpness from front to back. To make it look more painterly, I simply cranked contrast and saturation in the RAW converter.

I thought it would be a nice to contrast to this rock-hard sidewalk with a softer natural element. I found this photo of a flower in my collection of flower photos and used the Extract filter in Photoshop to remove the original background. I was then free to place the image anywhere I liked within the sidewalk composition. It looked unnatural without a shadow, so I made a duplicate of the flower layer, filled it with black and blurred it considerably. I then dragged it below the flower to cast a shadow. The shadow was made less obvious by lowering the opacity of its layer. To improve the composition, I cropped the layer. Then I added a Brightness/Contrast layer and masked to darken the lower and upper left portions of the image.

I wanted to find an artistic technique that would simultaneously maintain the gritty reality of the urban sidewalk while adding a more painting-like quality to the image. The Poster Edges filter did the job automatically, except that I applied it to both the flower and the manhole cover layers, leaving the shadow layer alone. This added a surrealistic edge to the image that isn't readily identifiable.

Now I wanted to get a bit more of the urban surroundings onto the sidewalk. Sidewalk stencils would have been ideal, but as I didn't have any on hand, I cloned in parts of a tag image that I happened to have on-hand. Before I cloned the tagged image, I also used the Poster Edges filter on it so that it would have matching grain, texture, and technique. I then created a new layer to paint on so that I could control the transparency and blending of the tagging when I painted it in. After considerable experimentation, I settled on the Difference blend mode and a Fill of 68%.

Brainwash

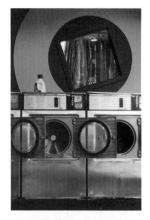

It was the repetition of geometric shapes in this image that really caught my eye, in addition to the personality of this hip South of Market Street laundromat that was so well reflected in the colors, shapes, and industrial look of the washing machines. When I took the photograph, I knew I wanted to turn it into an abstract "painting." Because I knew this when I started working on the image, there seemed no need to clean up the noise or to do initial sharpening. I did work with a curves layer to tweak the tonalities in the image and then did a very strong effects sharpening with Power Retouche, in order to increase my chances of having the next filter choose the edges that I wanted to emphasize.

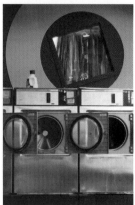

I wanted to reduce the painting to a posterized watercolor. There are several good tools available for doing this, depending on the exact result you're after. However, my favorite watercolor application for photos is a plug-in called Buzz Pro 3. It actually incorporates several different watercolor interpretation methods, and the interface even allows you to combine them, along with several other special effects, such as sketched edges. Because I wanted to simplify the geometry as much as possible, I stuck with only the first two of the three reduction methods.

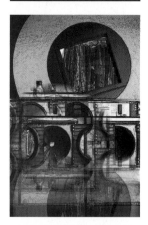

Next, I wanted to emphasize the circular geometry in the machine door. The Andromeda C-Multi filter (part of the Series 1 Photography set) allowed me to center a prism effect over the left machine opening. I could also control the circumference, center size, and transitional fade of the effect.

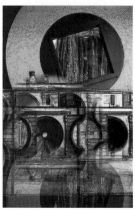

Now I wanted to make it even more textured and more abstract. I wanted the viewer to expect the piece to be art. I also wanted the viewer to spend a moment or two puzzling over what she was looking at. So I did two things: First, I duplicated the background layer and applied the Find Edges filter, and then I used the Equalize command to bring more detail and contrast into that interpretation. That layer was then blended with the Darken mode. Finally, I "reflected" the upper part of the image in the lower half of the image using Andromeda's Reflection plug-in. You can control the transition between reflections, the size and positioning of the reflection, and the transparency and angle of the reflection with this plug-in. In itself, the Reflection plug-in is a powerful tool for abstracting images.

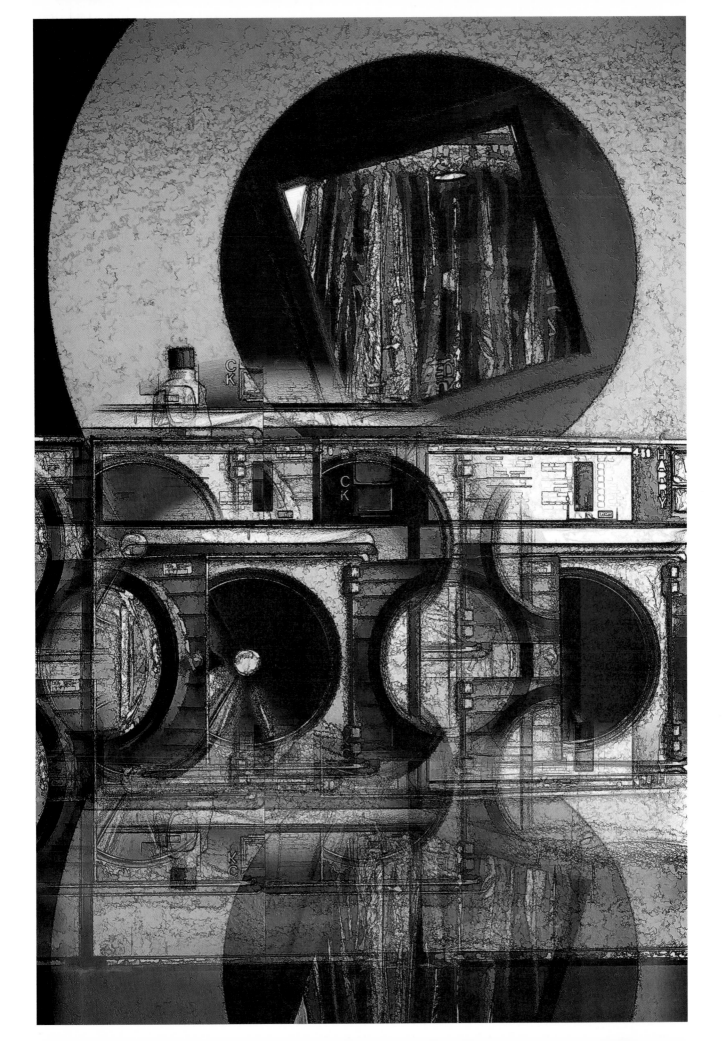

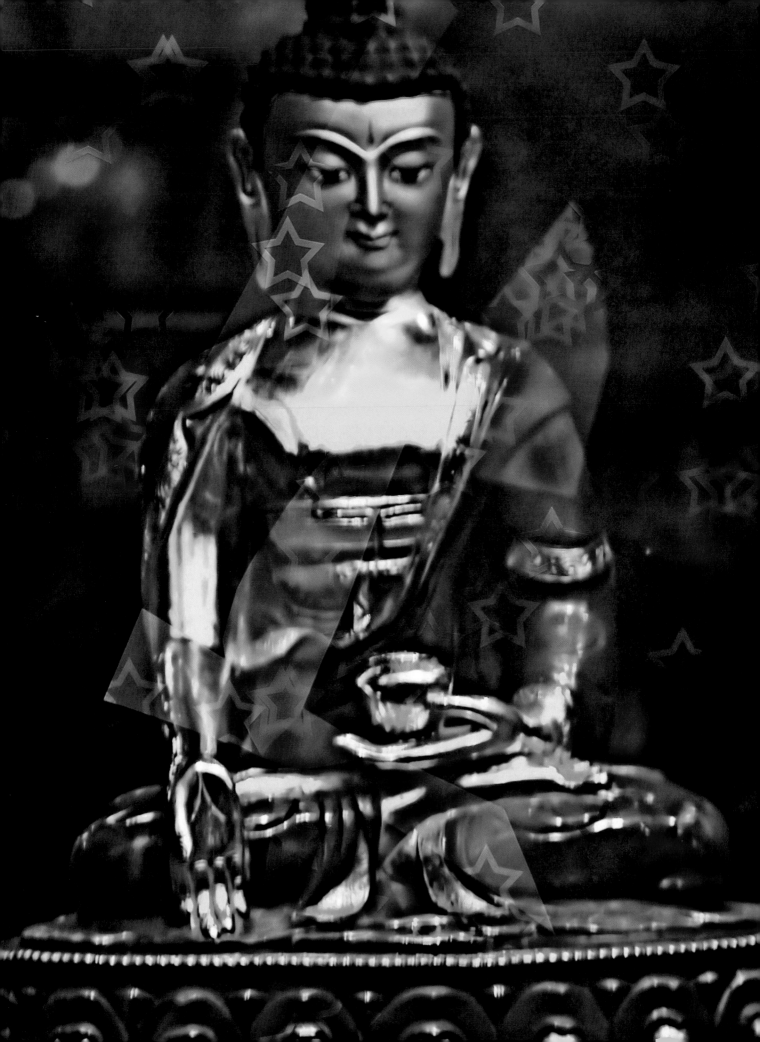

Reflections and Transparency

Ballroom Ball

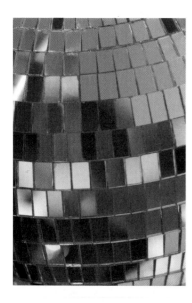

This ballroom ball was for sale, hanging in a booth at a county fair. I had the camera set to manual focus in order to keep it focused on the ball, rather than on the reflections in the individual squares. Fortunately, it was a brightly lit day, so I was able to use a small aperture and high shutter speed, resulting in a sharp image. Because the ball was reflecting so many levels of brightness, I had to bracket exposures in order to get one with detail in most of the squares. Of course, I cleaned noise from the image and gave it initial sharpening before proceeding.

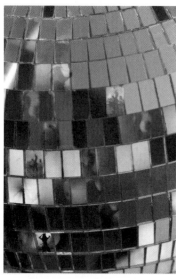

I wanted to create the illusion that dancers were reflected in some of the squares in the ball. I opened a few available light shots taken at a nightclub, and then individually selected random mirror rectangles and cloned portions of other images on top of them using the Screen brush mode. The dancers are barely recognizable as such, but somehow I think the viewer knows they are there. The effect is even more surreal because all the dancers are the same person.

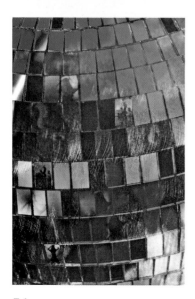

Once again, I wanted to give more variety and texture to the image. I wanted a texture that implied both grit and glamour, so I chose a macro (an extreme close-up) photo of a sheet of wire-brushed stainless steel. The image was cut and pasted into the ballroom ball image on its own layer. I then reduced Fill to about 65% and changed the Blend mode to Overlay. I used the Eraser at about 50% opacity to "polish" some of the mirror pieces, and finally, I used a Curves layer and the Shadow/Highlight command to control the brightness of specific tonal ranges within the image.

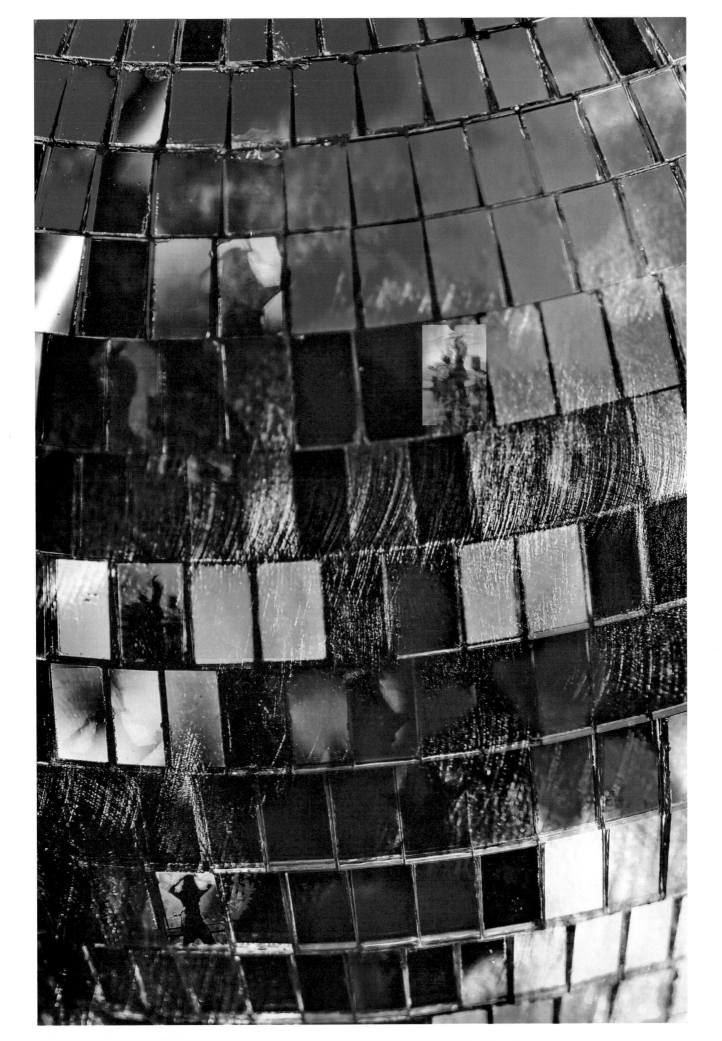

S&M Couple

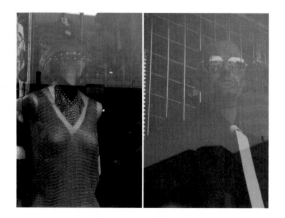

While walking down Folsom Street, in San Francisco's "Leather Ghetto," I was struck by the displays in two separate store windows. It also struck me that neither mannequin's eyes were visible. On looking at the proofs of the two images, I was unconvinced that either could stand on their own. But they seemed to have enough in common in terms of subject matter, lighting, and composition that putting them together would create a more compelling image.

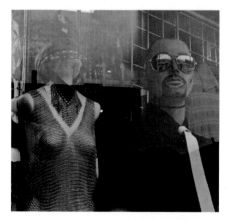

The two images were placed one on top of the other on separate layers. I used the Eraser tool at 100% opacity and softness to irregularly blend the left side of the male mannequin's photo with the right side of the female mannequin's photo. A Curves layer was added to boost the facial characteristics' contrast and then I boosted saturation. The last step in this stage was to use the Shadow/Highlights command to better balance the shades in the lower half of the image with those at the top.

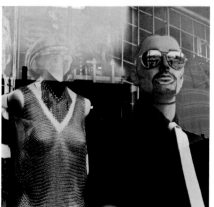

At this point, I duplicated the background layer and applied the Blend modes. I finally settled on Linear Light with a Fill Opacity of about 50%. I then used Auto Color on the top layer in order to produce the result you see here. The reflections look almost as if they were seen in the same window, but the fact that they don't quite match adds to the surreal feeling.

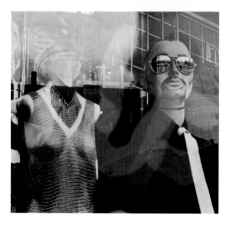

Now I wanted to give the feeling of a store window seen after dark, in a somewhat dangerous neighborhood. I decided to tag the window. I introduced a new layer, opened the Swatches palette, and freehand swabbed several different colors onto it. The Blend mode used for the tag layer changed the overall color balance of the image, so I made a selection around the male's face and used the Auto Color command again.

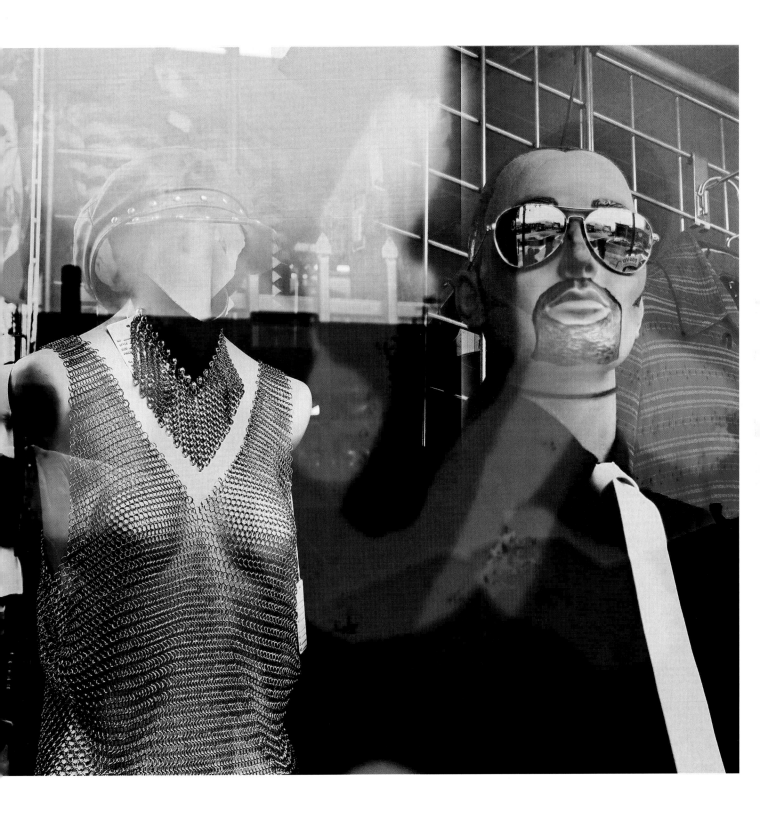

Theft Proof

The image on the facing page is a composite of two images, the one at the left and the one just below it. First, I opened this image, ran it through the standard noise and sharpening, and then adjusted it for brightness and contrast. I boosted contrast with the Levels command so that the darker tones that represent the transparent area in the window glass would be easier to select using the Magic Wand—which worked better, in this instance, than Select Color because it was easier to apply to specific areas of the image.

I wanted to give the viewer the feeling that what was behind the glass and the bars was valuable, so I used this image of a shop full of collectible antiques and artwork. I opened the image at the same time as the image above, copied it into the Clipboard, and then pasted it into the barred window image as a separate layer. I converted the original background layer to an ordinary layer and then dragged the shop interior (which was also photographed through glass) below the original layer.

I copied the first image to the Clipboard, and then pasted it over the store interior. Then, all I needed to do was use the Screen Blend mode to make it look as though you're looking through the barred and tagged door to the shop interior.

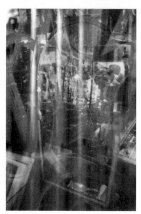

I wanted to raise the brightness and contrast of the barred window so that it would feel even more transparent and ghostly. I did so by applying the Curves command (so that I could specifically control the brightness of the tagging) directly to the barred window layer. I could have done this with an adjustment layer and made the adjustment layer specific to only one layer by choosing the Create Clipping Mask command, but it wouldn't have been as easy to see how the end result would apply to the combined image.

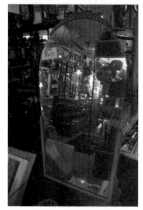

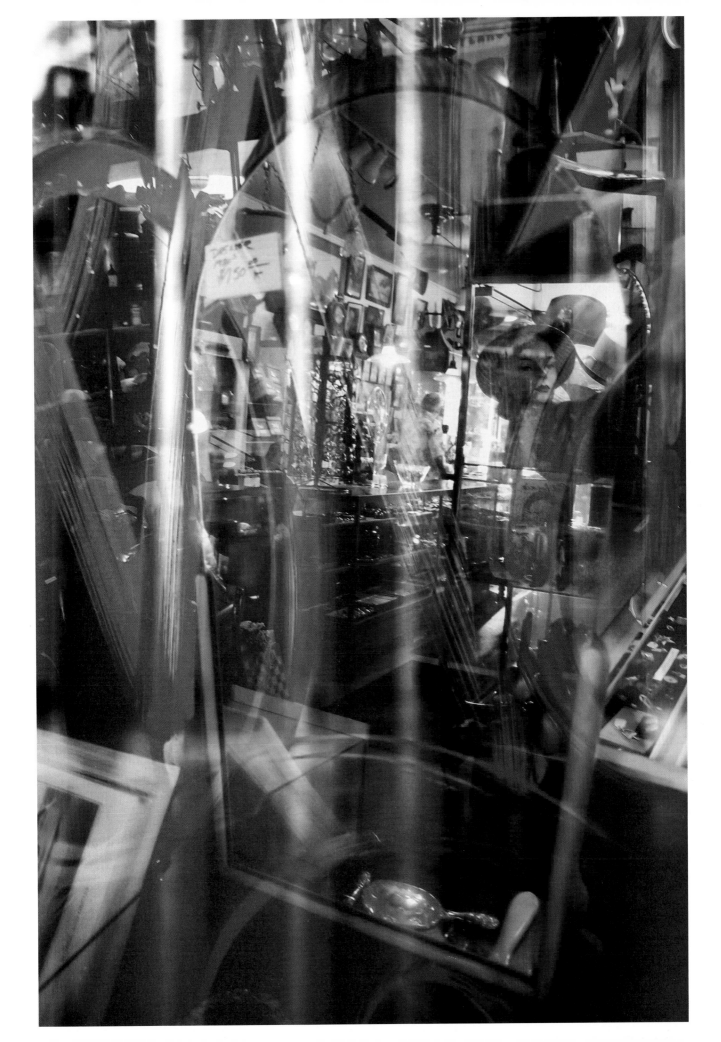

Windows on Market Street

I shot this picture at one of my least favorite times of day for shooting: mid-afternoon. At this time of day, skies tend to be a blank blue, shadows are too intense, and your pictures tend to look like everybody else's snapshots. Nevertheless, there was something about the juxtaposition of the trolley cables and the distorted reflections of the skyscraper intrigued me, so I whipped out my trusty S2 and took the shot. What you see at left is pretty much what the camera saw, with no adjustments.

Just looking at the image's histogram in the RAW converter made me realize that a few adjustments would brighten and dramatize it. I also wanted to correct the perspective distortion that resulted from shooting up at a tall building—especially one whose straight lines were so prominent. Several filters exist that would correct this condition, but I find it easiest to simply use Photoshop's Free Transform command while dragging the corner handles, simultaneously pressing the Command (Mac) or Ctrl (Windows) key. Of course, I then went through the usual routine of removing noise and initial sharpening. Finally, I just did a gentle Curves adjustment to emphasize the contrast between the cables and buildings a bit more.

I wanted even more sharpness and contrast in the cables, but didn't want to do overall sharpening because it might have caused the windows to compete with the cables for attention. I used the Lasso tool to make a rough freehand selection of the windows, then used Quick Mask mode to carefully brush a mask around the cables. I then converted back to Normal mode so that I could see selection marquee. Now the Focal Blade Sharpener's effect was restricted to the cable itself.

To give this image a more abstract look, I wanted to dramatize the tower windows by changing their color somewhat. I did so by duplicating the main layer and using the saved selection of the cables as a layer mask on the new layer so that the cables wouldn't be affected by the change I was about to make. Then I simply changed the layer mode to Overlay.

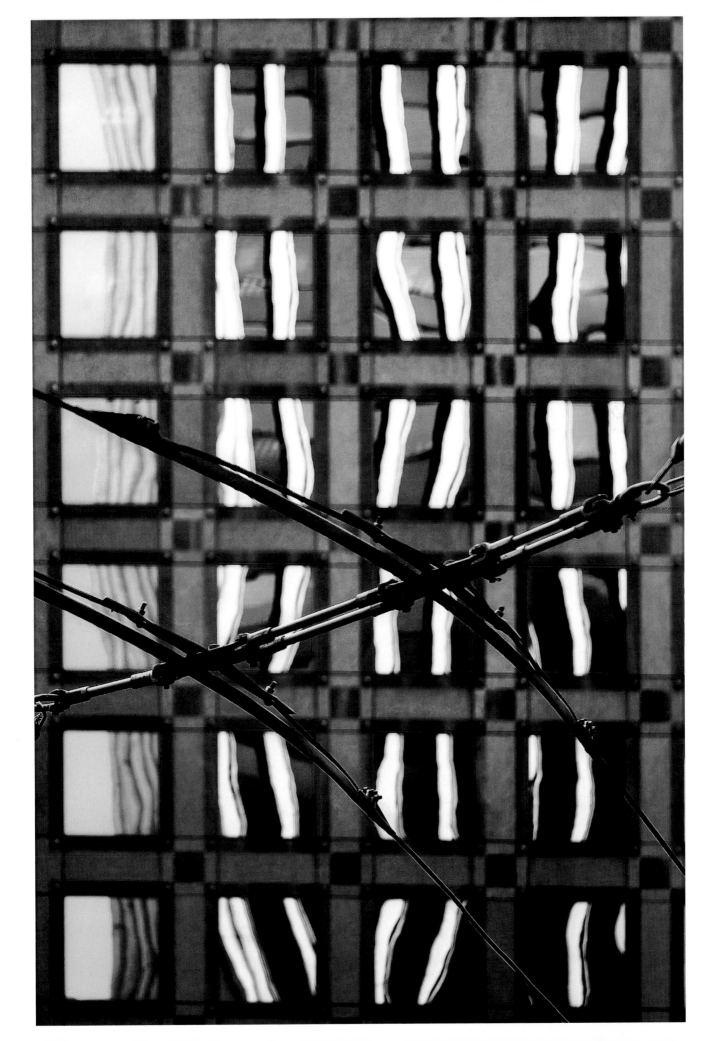

Exhibit

This shot of Moscone Hall in San Francisco shows what window reflections typically look like when they're first photographed. The glass reflects outside highlights to the point that interior blacks are somewhat washed out. I decided to just concentrate on making the image look as good as possible. This image was shot with a small-sensor ZLR, so it has considerable depth-of-focus.

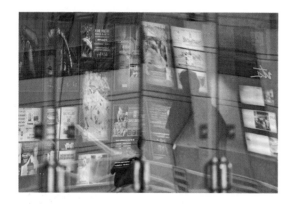

I wanted to bring out color, sharpness, and definition in this image. So after I used Neat Image to eliminate as much grain and noise as possible, I used Levels, Curves, and Hue/Saturation adjustment layers to give the image a richer and more poster-like look.

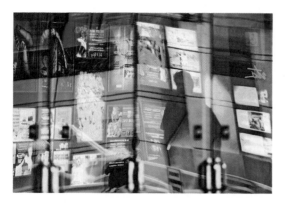

The next step was to really make the colors pop in order to make the image more attention-getting. First, I cranked up the image saturation considerably by dragging its slider in a Hue/Saturation adjustment layer. I then added a Color Balance layer and moved all three sliders until I liked the color balance better. (In an abstract, there is no requirement that you be faithful to the original.) Then I went back to the Curves layer and increased the midtone contrast by making the middle of the curve steeper.

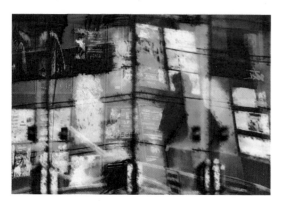

Next, I wanted to try a filter on the image. As filters seem to work better after adjustment layers have been applied and the image has been flattened, I did just that. Then I reduced the color mode to 8-bit color because I had a wider choice of filters that would work in that mode. I used one of the Xaos Tools Paint Alchemy Abstract styles, but I had to make the strokes smaller and the density greater. Then I reduced the Opacity of the "painted" layer to 75% and used Multiply as the Blend mode.

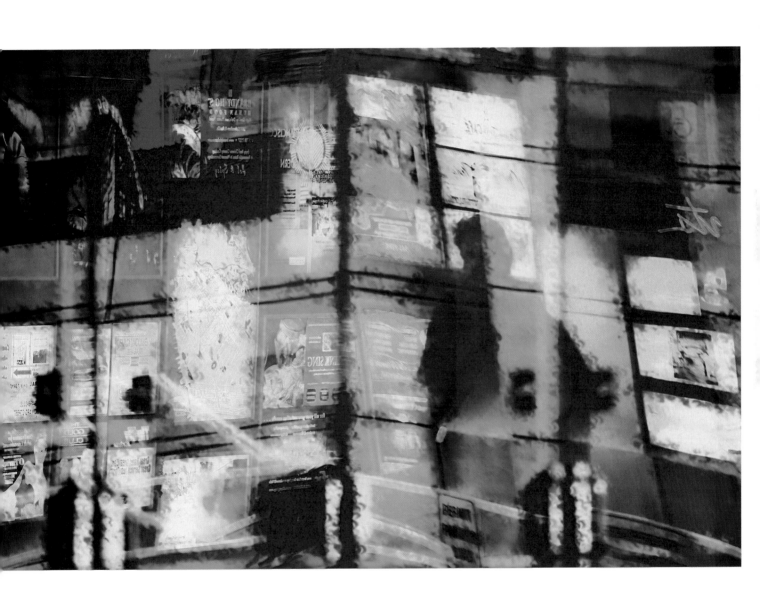

Star Burst

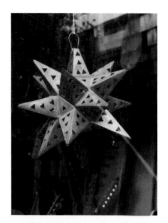

This is the Olympus 5060 image, just as it came from the camera. The scene is a "new age" music store, photographed through the store window, which reflects the atmosphere of the neighborhood. I made very minor adjustments in the Camera RAW dialog in order to produce the image you see at left. The main image you see in the window is what looks like a candleholder made of steel in the shape of a star burst. This photo was shot hand-held at ISO 200, 1.15 second at f-3.5. I was able keep the camera steady by pushing it against the edge of the window.

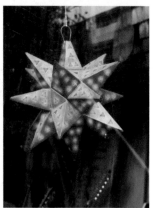

I wanted the candleholder (I think that's what it is) to look as though it were lit from within. I selected each of the openings, being careful to save the selections as I was making them so that I wouldn't have to start all over if I suddenly clicked in the wrong place. Where the openings contrasted sharply with the surrounding steel I was able to use the Magic Wand to select the openings. For the rest of the openings, I used polygonal selection. I then expanded the selection by 10 pixels and feathered it by 20 pixels. Then I filled the feathered selection with a very light yellow and brightened the fill with the Brightness/Contrast adjustment.

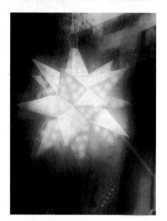

Next I wanted more of an overall glow, so that it would look as though the picture were taken at night rather than in the late afternoon. First, I flattened the layers so that the filter effect I was going to use would affect everything evenly. Then, to ensure that I could choose from all the filters, I changed the image mode from 16 to 8 bits per pixel. First, I used the Auto FX Mystical Lighting filter set to do a radial glow that would cover the entire star. Then I used Andromeda Scatter Light to lend a glow to the background image as well.

Next I wanted to add a bit more detail and drama to the image. I added a new, transparent layer and paint streaks of color picked up from the background with the eyedropper. I then used the Gaussian Blur filter to "defocus" the streaks so that they look like more colors of light reflected in the window; then I reduced the layer to 50% opacity. Finally, I changed the layer mode to Screen. All I needed to do then was to add a Hue/Saturation layer to intensify the colors in the image.

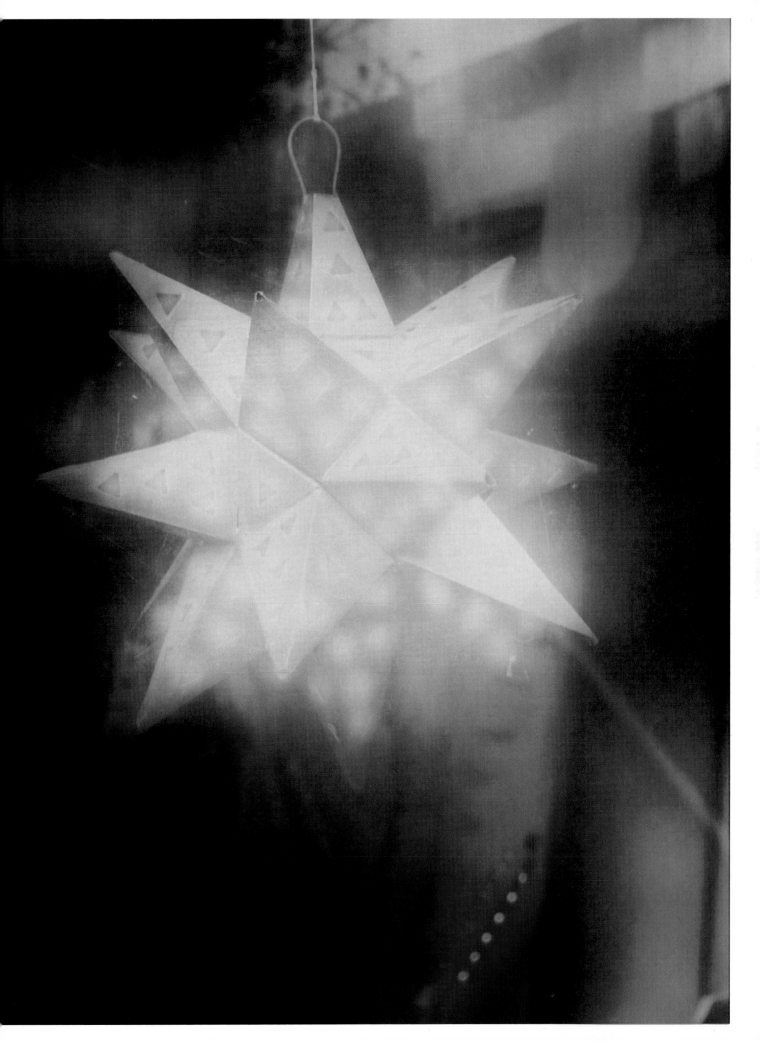

Tabletop

This photo was taken in a covered archway near sunset. I had no tripod with me, but I was so taken with the shapes, lines, and reflections that I figured I had to try to get a steady shot. So I took a deep breath and squeezed slowly. I ran the image at left through the Camera RAW processor, maximized for brightness and contrast. I then fiddled with the tint a bit to make the chrome look bluer. Once in Photoshop, I cleaned the noise that resulted from using a small-sensor camera and then sharpened using Power Retouche Sharpening.

You can feel quite a mood change in this version of the image, yet only one change has taken place: the image was processed in Auto FX's Mystical Lighting filter. The filter makes highlights glow, while giving you considerable control over the brightness, color, and center area of the glow—you can even include multiple glow centers. I used a pinkish color for the glow in this image in order to bring back some of the evening mood.

Next I wanted to punch up the effect of the geometry and lighting. I could have done this by using a Curves adjustment layer. However, by using the Corel KPT Collection's Equalizer filter, I was able to make the drama more predictable and controllable. The Equalizer can also perform dramatic edge definition tricks, should you need them.

Having taken the color changes this far, I decided to just go ahead and introduce a whole zoo of color. I used Power Retouche's Color Editor to experiment with a variety of color shifts. You can do this experimentation interactively by changing the settings in a dozen different sliders. The result becomes obvious as soon as you stop dragging the slider,. It's not, however, always so easy to settle on a particular result.

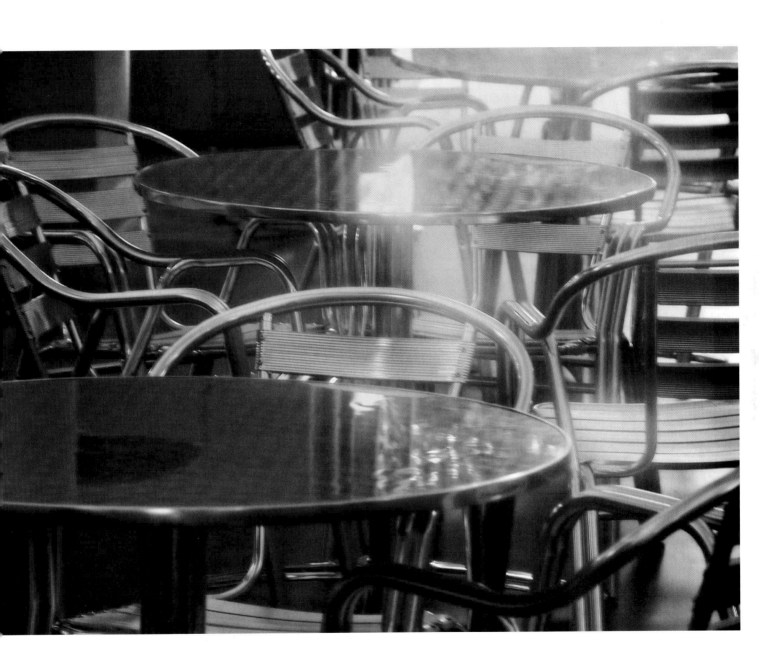

Bath Oils

This image started with a hand-held macro taken at a street-fair booth selling bath oils. It was shot with a +3 close-up filter on the 85mm-300mm zoom lens on my Fuji S2 Pro. In this instance, the short depth-of-field due to the combination of a APS-sized sensor and an approximately 220mm focal length was an advantage in abstracting the colors. In the Photoshop CS Camera RAW converter, I corrected the exposure and messed with the color temp until I liked what I saw. I then opened the image in Photoshop and used Neat Image to fix noise, and did initial sharpening using Unsharp Mask set to 300, .03, and 0. The image at left is the original. You can see the results of my adjustments in the next image.

I wanted to eliminate the bath crystals and extend the blended colors to fill the composition, so I used a feathered rectangular marquee to lift the colors from several sections of the image to a new layer. Each layer was then transformed to form a new shape that blended with and overlaid the new composition. Then the Blend mode for each layer was changed to add even more color variety.

I wanted the image to be even more free-form and abstract. I thought it would be more effective to create the feeling that the colors were liquids pouring down the page, so I began applying the Liquify filter to each of the overlaid layers individually.

After all of the layers were liquefied, I flattened the image. Then I put the image through the Liquify filter one more time so that I could push and pull pixels to give the image a more unified look. Once that was done, I created adjustment layers for Levels, Curves, and Saturation. As you can see, those final adjustments intensified the colors even more and greatly increased the drama in the composition.

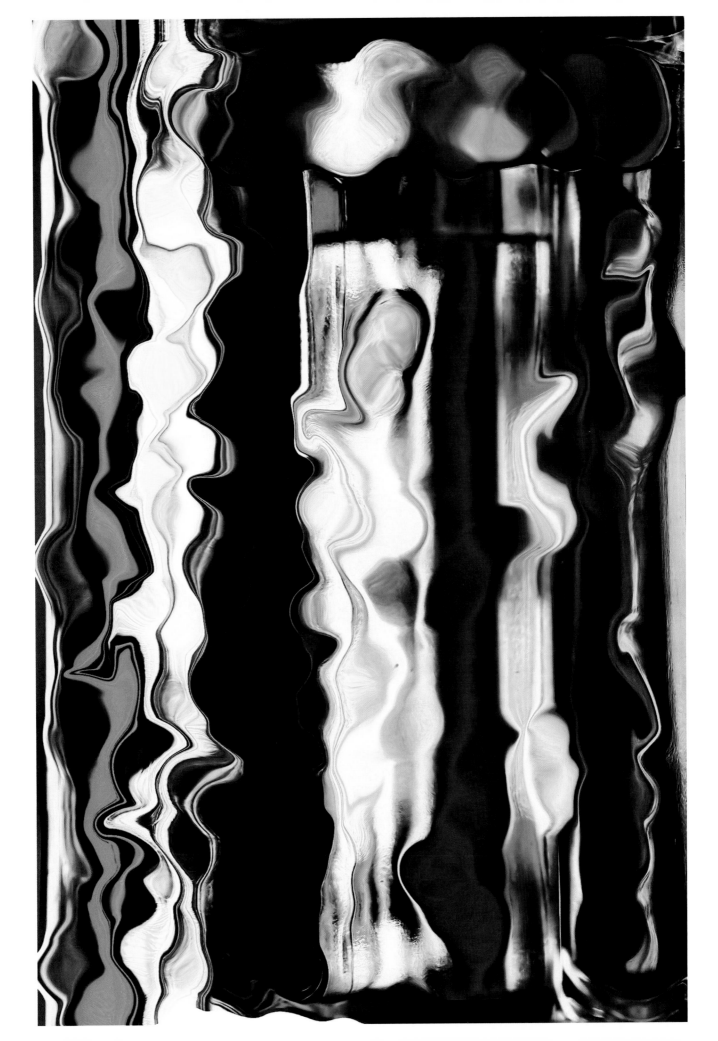

New Age Buddha

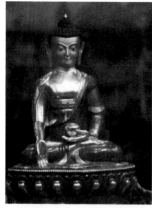

This image is a "double exposure," actually made by sandwiching two separate images with the colored paper sculpture on the top layer. I wanted to create the feeling that the paper mobile sculpture was being reflected onto the same window glass as the Buddha, so I lowered the opacity of its layer so that you can see through the colors.

I lowered the opacity of the mobile window to 40% and changed the layer mode to Screen in order to make the sculpture look more like it was reflected onto the glass. Also, I adjusted the sculpture layer with the Hue/Saturation command to intensify its colors. Note that putting the layer in Screen mode also brought out the reflection of the meditating face that is reflected in the original Buddha window.

I decided that it would promote the "heavenly" feel of the image to add reflections of stars to the window. I simply used one of Photoshop's standard brush shapes for the star and varied the brush size as I dabbed the stars onto a new layer while constantly picking up new colors from the Swatches palette. I then adjusted the fill of that layer to 50% and set the mode to Overlay to make the stars blend more.

Next, I wanted to darken the glaring highlights in the Buddha statue, so I selected them, feathered the selection, and raised that selection to a new layer. I placed that layer in Multiply mode but the effect wasn't strong enough, so I duplicated the layer. Next, I used the Eyedropper tool to pick up the color of the brass, chose a very soft-edged brush, and painted the color onto the layer. That did the job so well in the larger highlights that I kept painting to darken the smaller highlights in the lower part of the picture. I then chose the Elliptical selection tool and selected the entire image, inverted and feathered the selection about 150 pixels, and used the Brightness/Contrast command to darken the outer edges.

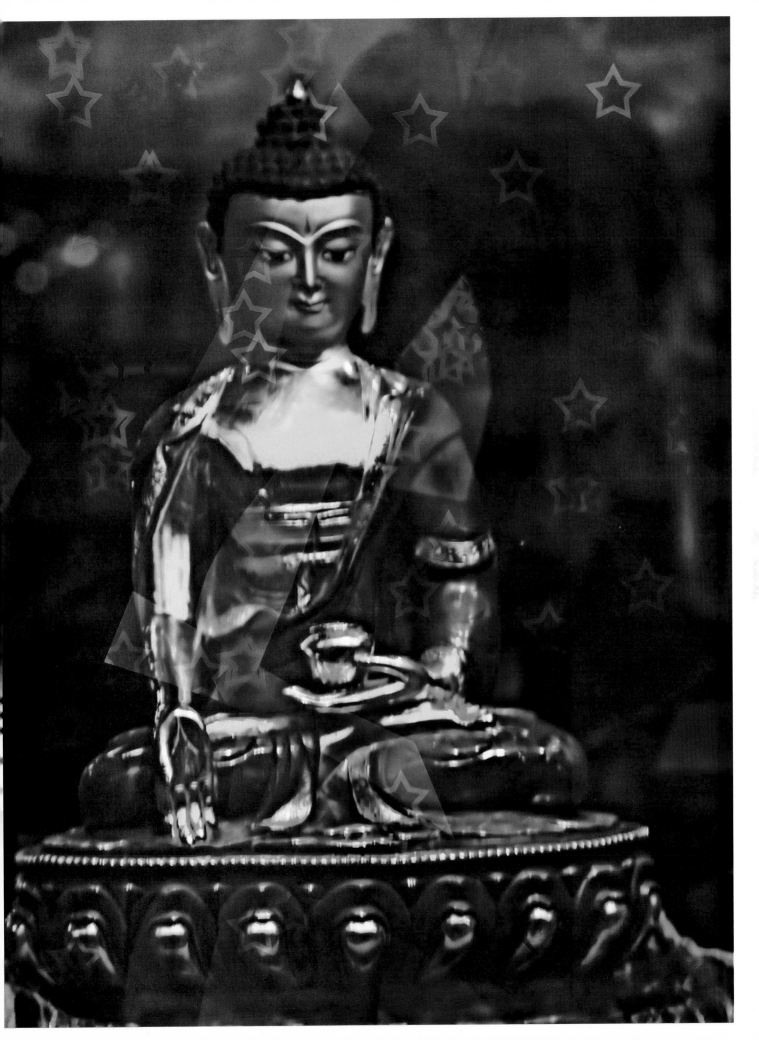

Vase

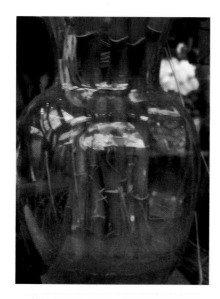

I'm entranced by what looking through curves in glass can do to what lays behind the glass. The possibilities are really infinite. I was actively looking for such distortions when I came across this vase behind a flower shop window. Unfortunately for me, it looked much more interesting in the viewfinder than when viewed on-screen at a larger size. I almost ditched the image because of the boring and over-bright detail in the background outside the vase. Then I decided to accept the challenge and see what a few small changes might produce.

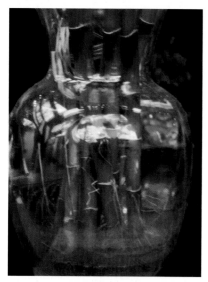

I used the Pen tool to make smooth curves around the edges of the vase, and then converted the vector patch to a selection. Next, I simply used the Brightness/Contrast command to darken and lower the contrast of the background detail. Finally, I added the usual Curves and Levels adjustment layers to jazz up the energy in the details inside the vase.

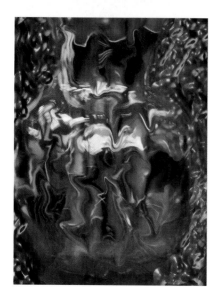

Well, I told you I started working on this image in a totally experimental mood. I wanted to see it looking much more abstract, so I first used the Liquify filter to distort the contents of the vase. Next, I painted the background with KPT Gel and did a little cloning of the gel effect afterwards to fill in some gaps. Of course, then I couldn't resist finishing things off by cranking up the saturation with a Hue/Saturation adjustment layer.

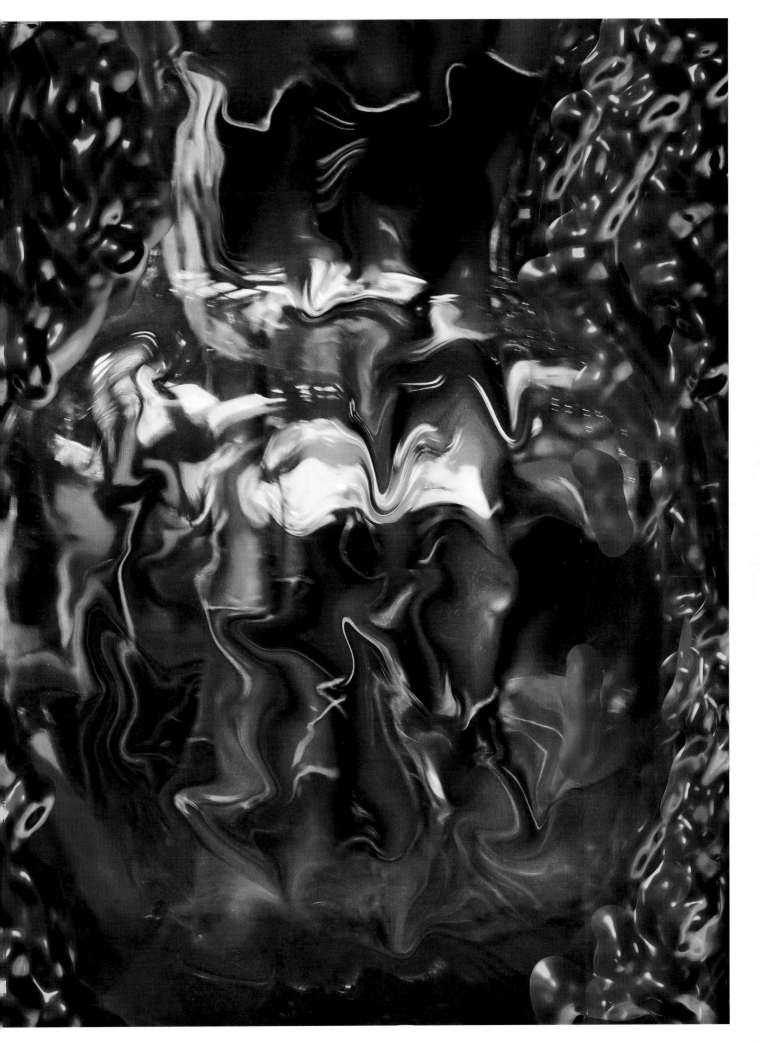

Color Vision

This represents all manner of reflection, refraction, and transparency distortions. The image is pretty decent as it stands, but it did need a few changes and a wee bit of retouching.

I blurred and darkened the background, and then used the Select Color command to select the highlights so that the "wand" at upper right is selected. I then raised the wand to a new layer, and darkened it by using the Multiply blend mode. Then I selected the star at upper right, raised it to a new layer, and put that new layer into Multiply blend mode so the the resultant darkening would add a bit more detail to the star.

Next I performed several actions in order to enrich the tones and dramatize the contrasts in the image. First, I created a moderately sharp S-curve in a Curves adjustment layer, playing with the exact shape of the curve until I was satisfied with what I saw. Then I used the Magnetic Lasso to select the literature under the glasses, then lifted and multiplied it, making it considerably darker and more colorful. Finally, I used a moderately large, soft-edged brush with a very low (8%) exposure value to darken certain areas of the background, knowing that I was about to impose some star filter effects over the whole image.

Before I imposed the filter effect, I flattened the image (but saved a copy with the layers of what had been done at each stage). First, I used Mystical Lighting to spread stars and "fairy dust" over the image. Then I used Andromeda's Star filter—with quite a few adjustments to make it more subtle—to create the "glare" in the right hand eyepiece of the lower set of sunglasses. Then I used a large and very soft round Brush at 36% opacity in Color mode to shift the tones in various parts of the image.

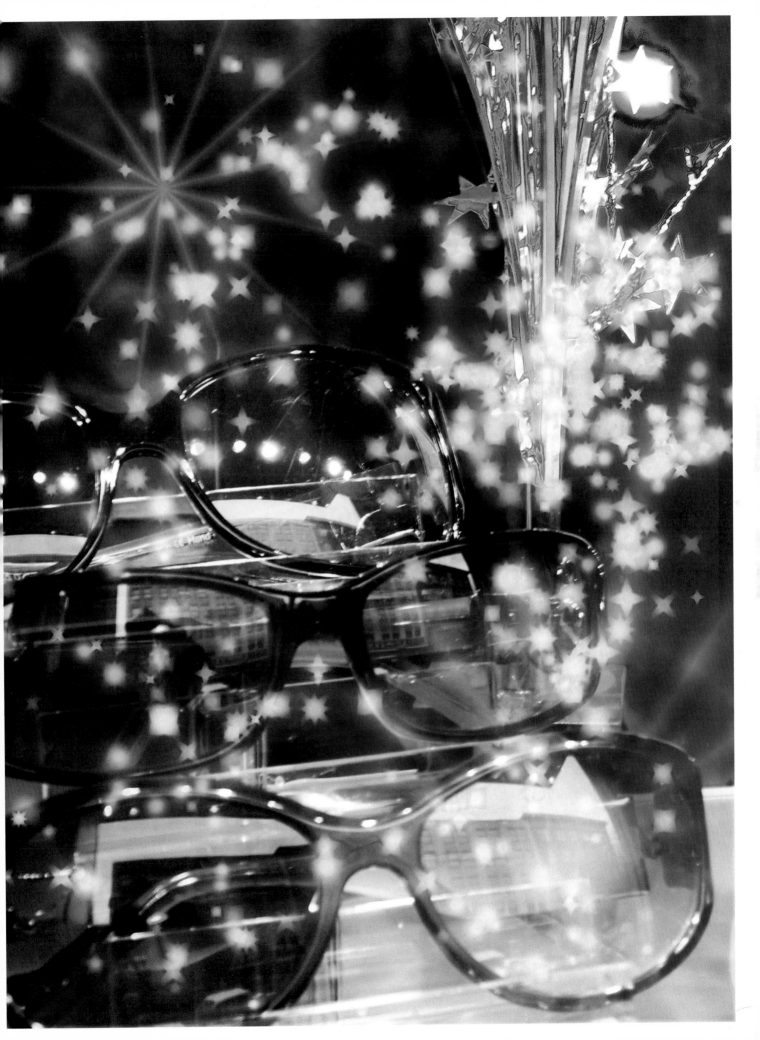

Lights

Streaking

This image was shot with my "walkabout" camera, the Olympus C-5060 wide-angle 4:1 zoom. I like this camera for abstracts because of its reasonably high resolution, excellent optics, and picture quality. For abstracts, the camera's main advantage is its small sensor size; as a significantly shorter focal-length lens is required to cover an equivalent angle-of-view, that equates to much greater depth-of-field than you can get from the APS- or 35mm-sized sensors found in professional DSLR cameras. Not that it matters here. As I had no idea what I was likely to get, I simply set the shutter to a slow (1/6 second) speed and wiggled the camera intentionally. I did this several times until I liked what I got. Here you see the original RAW file. By the way, images like this make excellent backgrounds for composited images.

As you can see, the image became much more dramatic when I made the exposure adjustments in the Camera RAW dialog. While I was in CameraRAW, I also boosted the saturation considerably, just for the dramatic effect. I'm actually very pleased with this image as it is, but it offered so much potential for experimentation that I just couldn't stop....

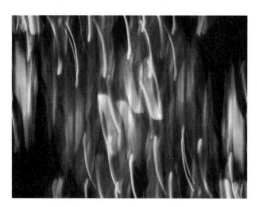

I duplicated the background layer, then flipped (Transform) it both vertically and horizontally. As I wanted most of the detail to show through, I used the Multiply Blend mode on the pair of layers. Of course, this made the image very dark, so I added a Levels Adjustment layer and used it to simultaneously brighten the mid tones and the highlights in both layers.

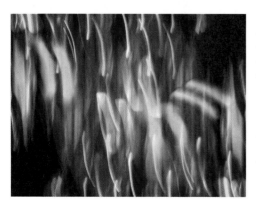

I wanted to add some movement to the composition, so I went to the bottom layer, encircled the two brightest streaks with a Lasso, and lifted the selection to a new layer. I then copied that new layer two more times. The Eraser was used to fade out all the extraneous background. Then I subjected each layer, one at a time, to a different variation on the Zoom or Motion Blur filters. Finally, each of these layers was dragged to a new location in the composition and its Fill percentage lowered so that it would blend better with its surroundings.

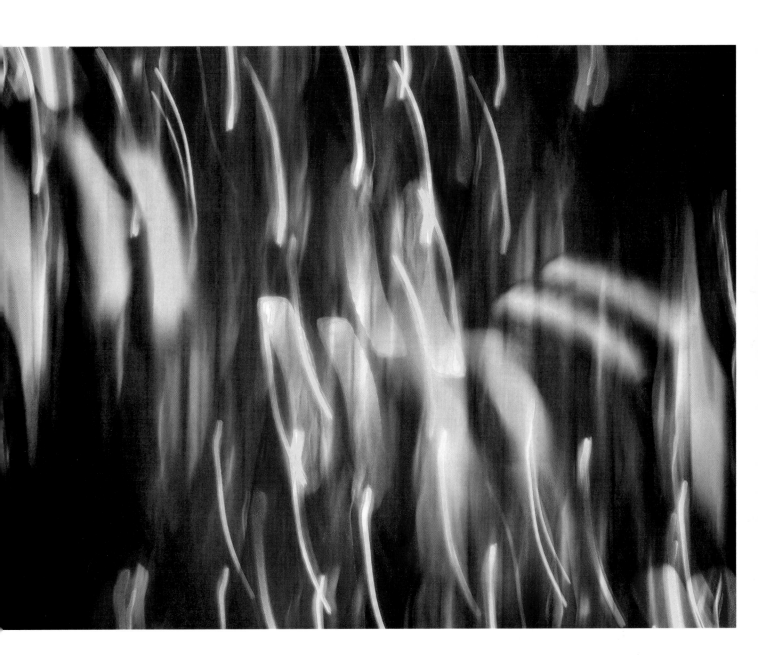

Signs of the Hood

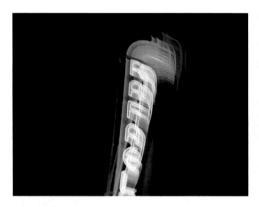

This image was also shot with the little Oly 5060. The Camera RAW dialog allowed me to reduce the exposure so that I could see more detail in the highlights. Once in Photoshop, I used a Curves Adjustment layer, anchored the original brightness line in several places so that I could control a fairly narrow range of brightness, and then raised the level of brightness of the theater building itself so that a hint of it can be seen. This image, all by itself, could make an excellent background for the Mill Valley Film Festival poster.

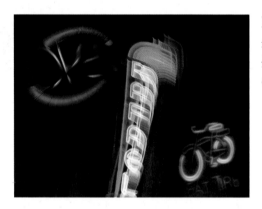

I also had a collection of images of neon window signs that I'd taken in a neighborhood in Santa Cruz. I experimented with many motion-blur filters, but the most effective in this situation was the Blur filter in the Corel KPT collection.

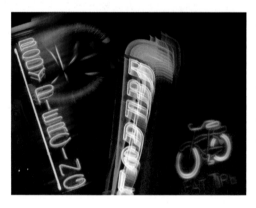

As the signs were all shot at night, it is possible to make the overall image any size you like because the background is all black. So you can create a new image with a a black background of the size you want, then just drop the original photo atop it. Each additional image is dragged and dropped as a new layer over the original image. It is then really easy to transform (scale, rotate, and so on) the image so that it fits with the rest of the composition in any way you like.

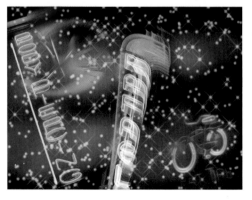

I've pulled this trick before, but it seemed appropriate here as well. I used the Alien Skin Xenofex 2 Constellation filter to create a starry sky to add a bit more "nighttime" feeling to the composition. I also added a cloudy mist by using a very large and completely soft-edged brush at about 20% opacity and simply painting in white on the same layer as the stars. I would have had even more control had I created a separate layer for the clouds.

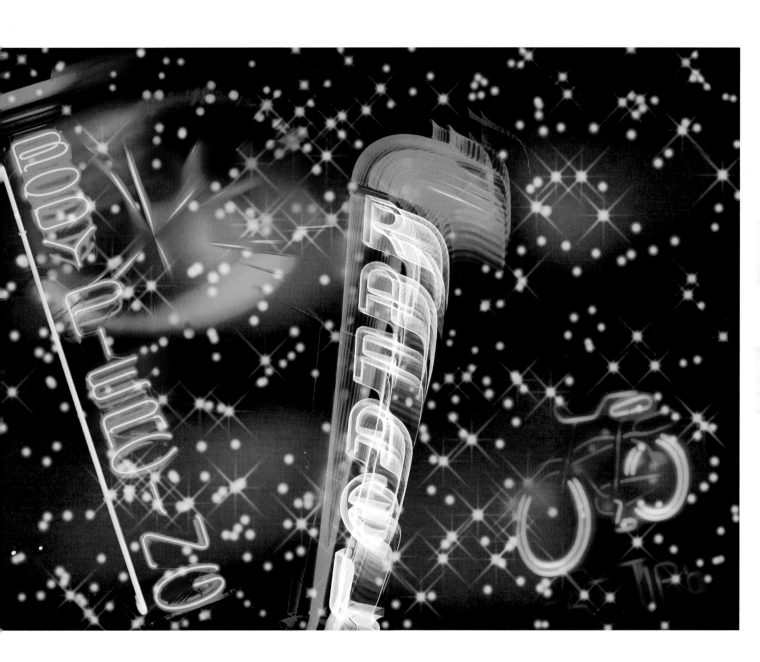

Thaiza in Red

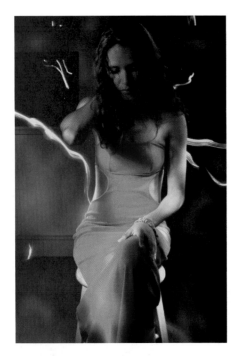

One of the most interesting techniques in creating abstracts with light is *light painting* (or *painting with light*). This technique is best accomplished when darkness prevails. You place the camera on a tripod (unless you don't care how blurry things get) and then use narrow light sources (such as flashlights) to "paint" the subject. Many digital cameras lack a "bulb" or "time exposure" setting during which the lens can be open indefinitely. It takes a lot of practice to do as much painting as you'd like—where you'd like it—in the span of a few seconds. Maximum open shutter time on my Fuji S2 was 30 seconds, so that was the shutter speed on all the light paintings in this chapter. I put two flashlights in each hand, told Thaiza, my model, to remain motionless when I said "start," and just ran as fast as I could while I streaked the scene with light. Being able to shoot RAW is a huge help because you have total control over color temperature after the fact.

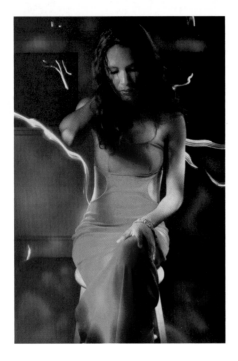

There was really very little more that could be done here, which is usually the case with light painting. The Burn and Dodge tools were used to refine the brightness of some of the light streaks, especially in the darker areas of the image and on Thaiza's face. Then the Curves layer was tweaked a bit to make the highlights more lively.

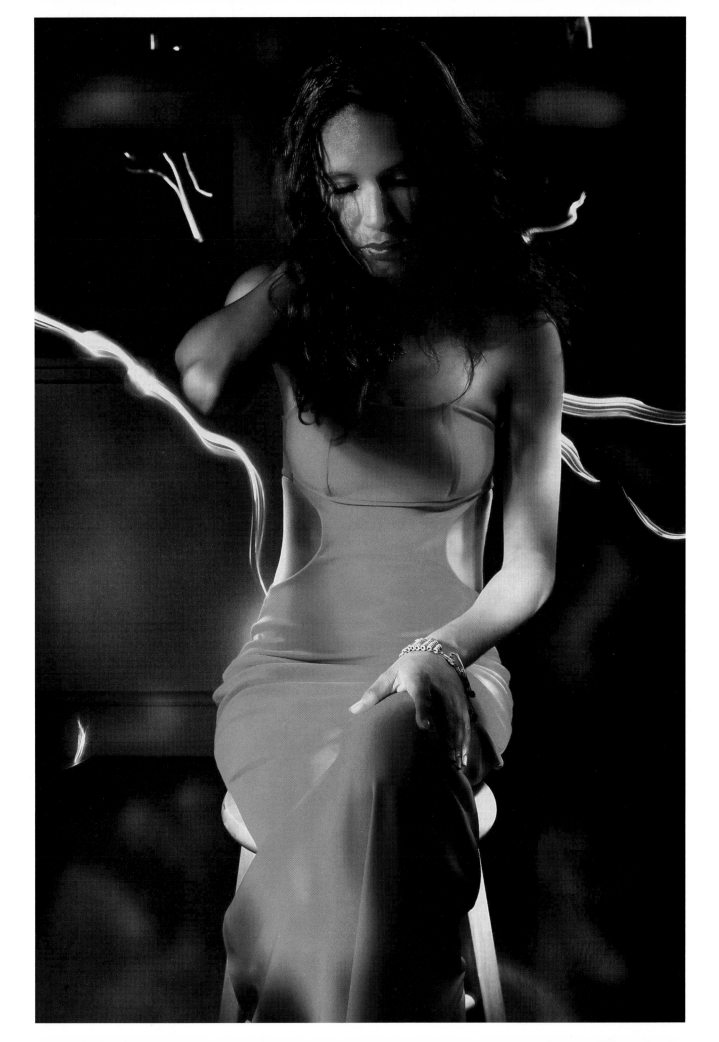

Thaiza in Black

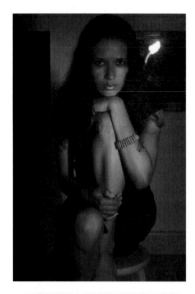

Here's another light-painted portrait of Thaiza. This time, you get to see some of the experimental stages that Thaiza and I went through before we got a picture that made us both grin. Think about all the motionless posing this very patient lady needed to do in order to get the two photos you see in this chapter. She looks as wonderful as ever, but the lighting's not very interesting and the color balance is way off.

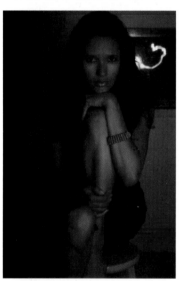

Another try. The lighting's even less modeled and the color balance still very far off. Thaiza also moved slightly while she was being painted. There is nothing interesting going on in the background, either.

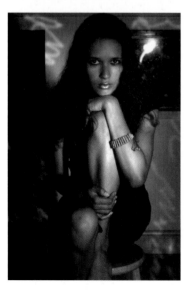

Ahh. Now I ran around with a pen light lighting the background. I held the big portable spot closer to Thaiza so the light was brighter on the face, forearm, and raised knee. Also, I put a lot of work into tweaking the color balance, both in the Camera RAW dialog and by using the Color Balance command in Photoshop itself. This would be a cool concept for a fashion spread, in case any agencies or magazines are interested....

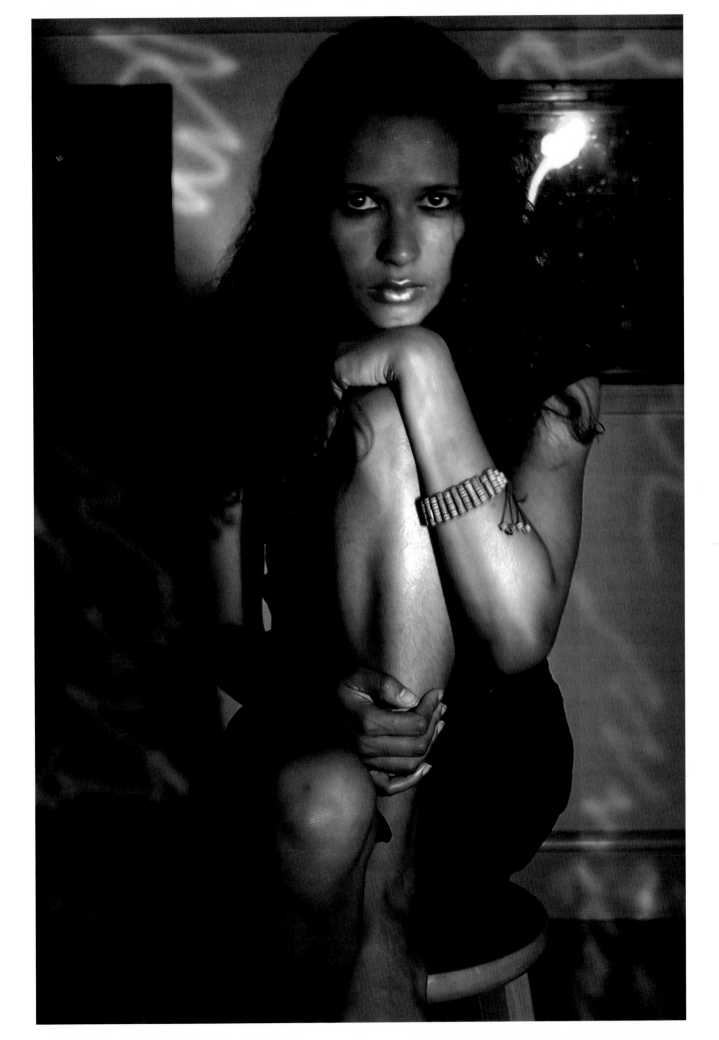

End of Evening

You'll notice these dying lilies (or their dead versions) popping up in several places in this book. It's really fun to discover the beauty of a thing, place, or person that had previously drawn little of your attention. Trying to communicate that vision of beauty is what makes photography so exciting—to me, at least. This photograph was taken on a night when there was a dinner party going on inside the house, so I needed to go searching for darkness. The hood of a silver car, the distant San Francisco Bay skyline, and the help of a few flashlights produced what you see here.

Digital photography is a huge asset when you're light painting because you can instantly see your last shot. If you don't like it, you just erase it and try again. That's why you won't see other versions of this shot on this page.

Keep your eye out for areas that need more or less light or light coming from a different direction. Also, be sure *not* to light whatever might be unimportant or distracting. By the way, there are a few digital cameras (and I wish I owned one) that will let you make multiple exposures of the same frame. If you're serious about pursuing the art of light painting, look into acquiring one of these cameras.

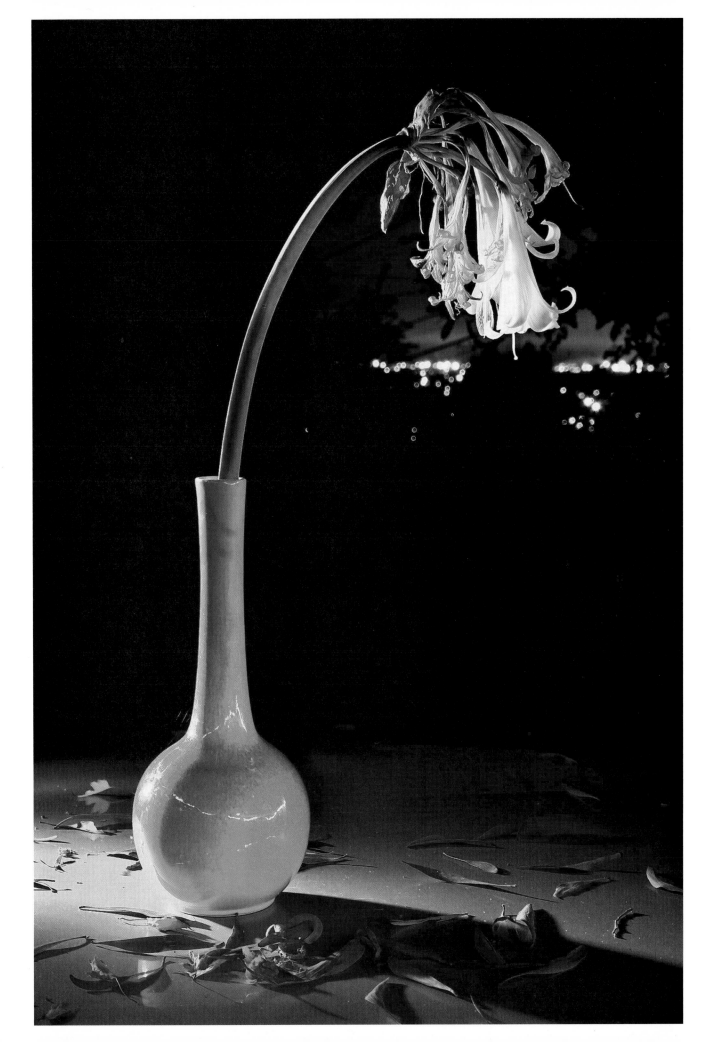

Showtime

This was the best compromise exposure I could get, as it came from the RAW file. I actually should have made a longer exposure to get more detail in the car in the foreground and a shorter exposure to keep the theater's neon and marquee from flaring and blowing out. But alas, I was stuck with just the original RAW file and I really liked this scene, with its blurred car headlights. By the way, I also used an ultra-bright portable spotlight to light the side of the theater where the tree is.

Lacking multiple exposures, I simply went back to the original and re-opened it in the RAW converter, then raised the black point with the Shadow slider and lowered the Exposure setting until I could see lots of detail in the theater signs. Then I selected the entire image and pasted it into the first interpretation of the RAW file. This puts all the details in perfect register with one another.

Now all I had to do was select the shadows with the Select Color Range command, highly feather the selection, and press the Delete/Backspace key to erase the contents of the feathered selection. Bingo—a near-perfect extended dynamic-range image of the scene. You can even read what's showing on the theater marquee. All that remains to be done is to put some stars in the sky and some detail in the car in the foreground.

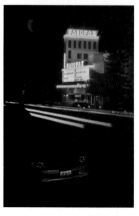

To bring out the detail in the car, I made a very loose lasso selection around it, feathered it severely (about 100 pixels), and then copied the contents to a new layer. I then adjusted the new layer with the Shadows/Highlights command until I liked the tonalities and color balance in the car. Once that was done, I still saw some objectionable borders, so I used a very soft-edged Eraser set at about 50% opacity to feather those border edges. Now I wanted a moon and stars in the sky. I copied the existing version of the photo to a new layer and used the Alien Skin Xenofex 2 Constellation filter to create the stars. The moon was one of the Nature shapes in Photoshop. I copied it to two layers and drastically blurred the lower layer to give the moon its glow. I used the Burn tool to give the moon a shadow side and then used Brightness/Contrast to adjust the moon and sky.

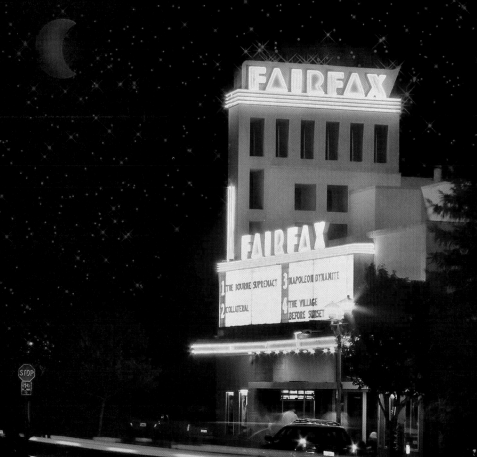

Veiled Mystery

This image was a photograph of a piece of sculpture on display at a San Francisco party whose theme was lights. It was lovely and interesting in and of itself, but it lacked punch, as well as the subtle variation in color that was in the original subject.

I boosted the saturation by moving the RAW converter's slider to the three-fourths point. I altered the color balance and tint just by fiddling with them until the effect seemed pleasing.

Next, I used both Levels and Curves to add variations to the shading in the image. Then I changed the basic color of the image by using one of the nik Color Efex filters. Finally, I added a layer above the Background (main image) layer, opened the Swatches palette, placed the layer in Overlay mode at 30% opacity, and used a large, heavily feathered brush to tint various sections of the image in a variety of colors. When I was done, I increased the effect by applying a Hue/Saturation layer and cranking up the intensity of the colors.

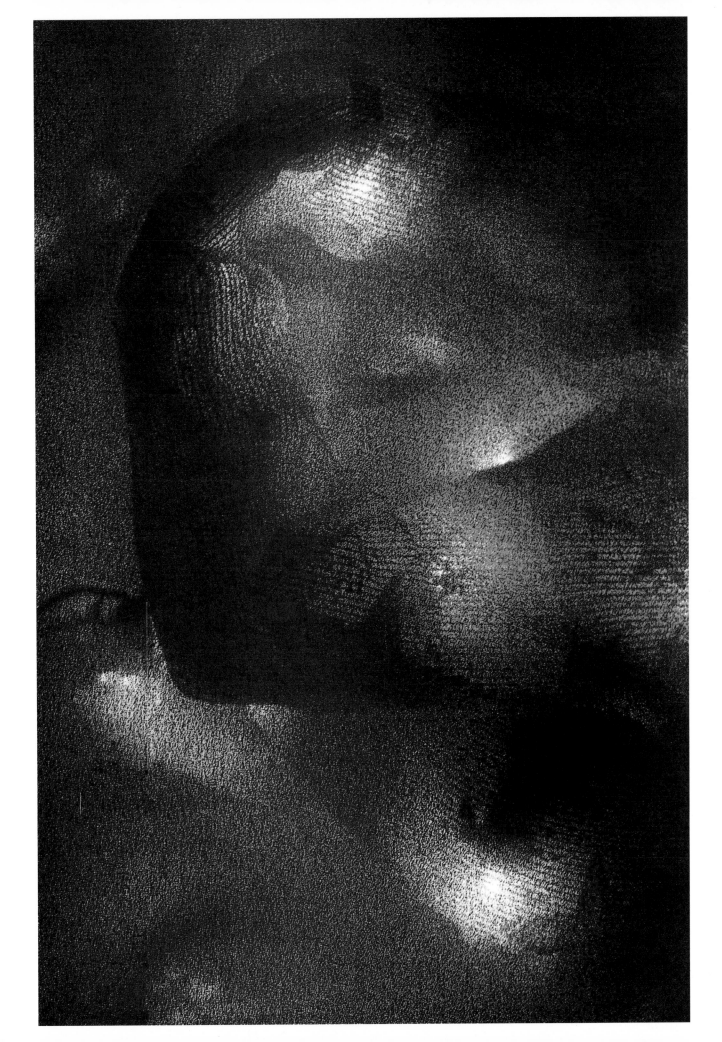

Light and Shape

This was a glass tabletop, shot straight on from above. I thought the gentle c-curve would make a nice base for adding other compositional elements, such as blurred lights. Of course, you know by now that I boosted saturation in the Camera RAW dialog, right?

I wanted to add lots of color variations as the background for the elements I was about to bring in from other photographs of light. nik Color Efex Pro has a palette, for use with the Wacom digitizing tablet, that lets you choose from a vast number of color effects, and then use your brush to paint them into the image. In this instance, I painted in several bi-color effects so that the colors also become part of the composition.

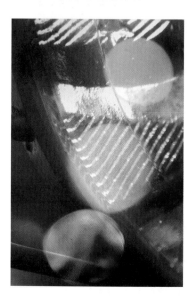

Here I added a photograph of sequins from a curtain, photographed at such close range that they appeared to be glowing lights. I pasted the image into a layer above the base (Background) layer. The new layer was then placed in Overlay Blend mode.

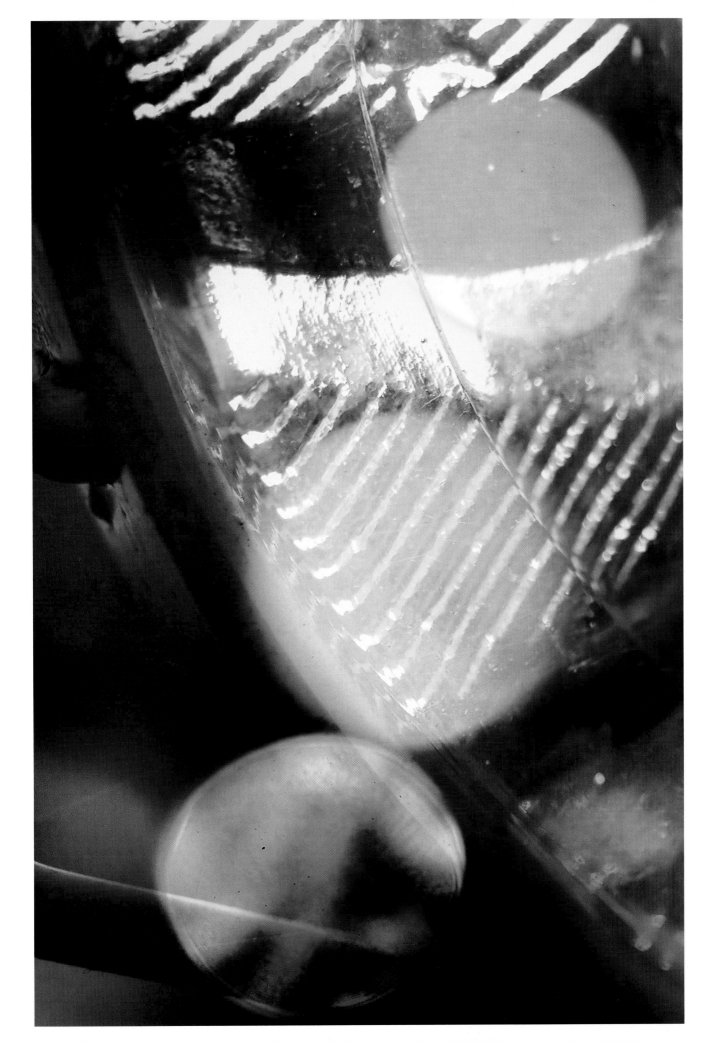

Whirly

These images were taken at a light festival. Colored lights were spun on weighted strands so that centrifugal force kept them fully extended. Different degrees of slow shutter speeds recorded varying spans in the spins.

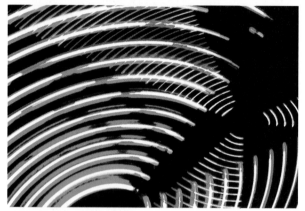

Here, two of the images were sandwiched together and the Vivid Light Blend mode was used to make both sets of colors look a bit painted or posterized.

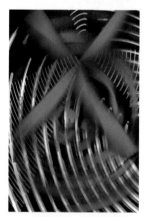

I added two new layers above the image and brush-stroked colors onto each of them, leaving the rest of the layer transparent. Each layer was then subjected to a KPT Blur effect from Corel's KPT Collection. The image was then rotated 90 degrees counter-clockwise.

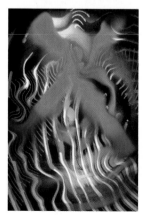

As a last step, the image was flattened, and then the Background layer changed to an ordinary layer and opened in the Liqufy filter. I increased the Twirl brush to its maximum size and dabbed it throughout the "painting" to give it the wavy distortions. Well, that wasn't really the very last step. I also used the Lighting filter to make the image look as though it had been lit by several spotlights.

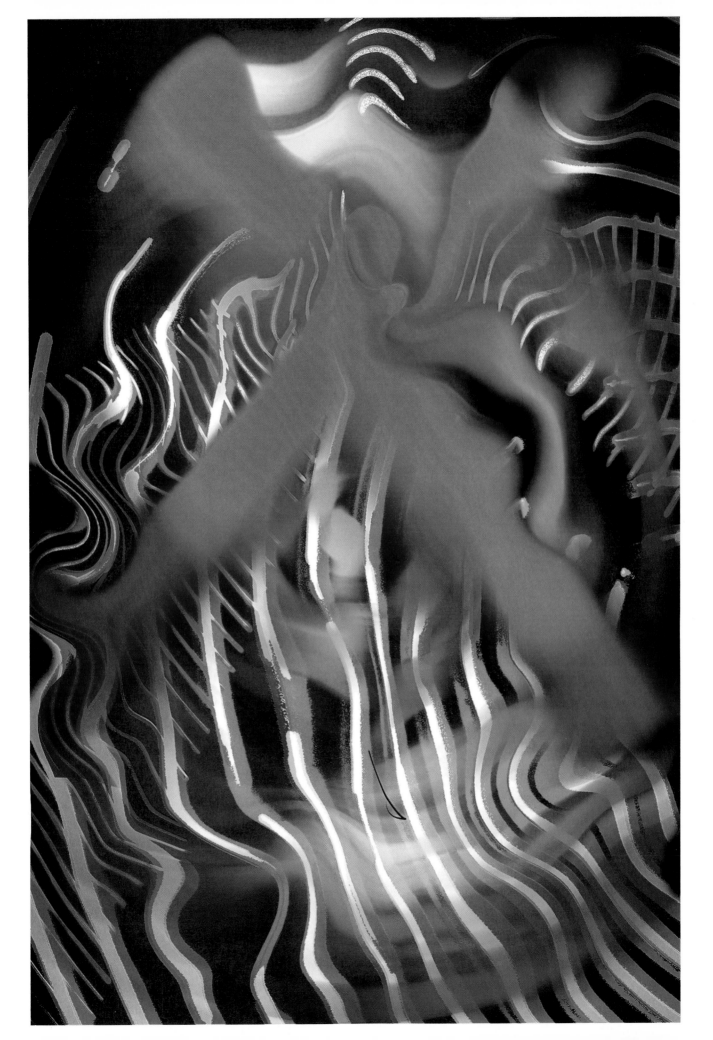

Sidewalk

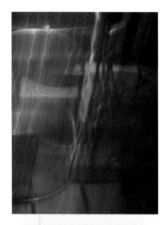

These are three images stacked to make the final result you see. Each was given a dramatic color balance change using the Channel Mixer.

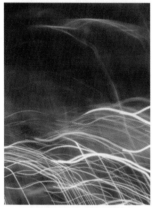

Here is the first result of stacking the three images. The top layer is in Saturation mode, the middle layer in Color mode, and the bottom layer in Normal mode.

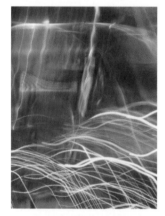

In this next version, the Blend mode of the top layer was changed to Lighten. There were certain areas in the top layer that were too bright, so I darkened those with the Burn tool while the two lower layers were turned off so I could more easily judge the effect of the darkening. Finally, all three layers were turned back on and Adjustment layers were added for Levels (to brighten the highlights) and Color Balance.

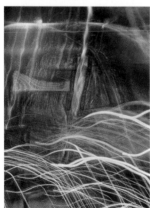

Next, the image was flattened and a Plastic Wrap filter applied—the adjustment of the Highlight and Detail sliders was critical in getting just the right texture for this look. Then, to really make the compositional dynamics pop, I added a Curves layer and the shadows were darkened to near black, while the highlights were raised just slightly.

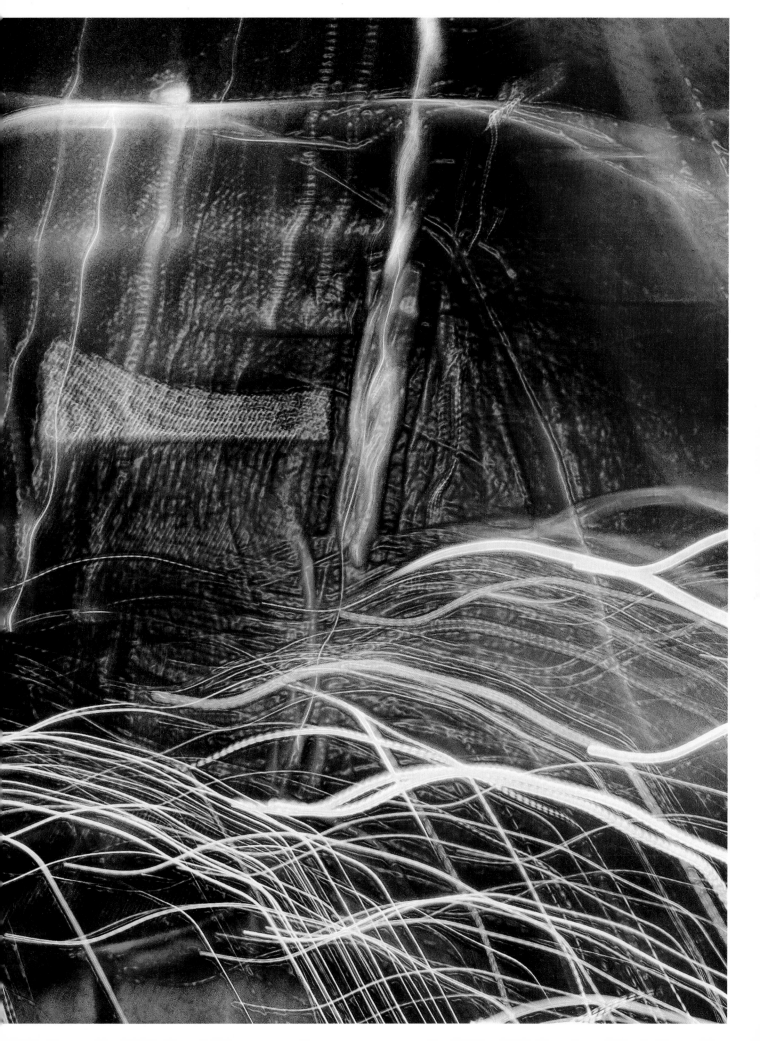

Eine Kline Nacht Musik

This is a sandwich of two images, one of Christmas tree lights reflected in a store window and the other a close-up of one of the photos in the next lighting abstract. The top layer was given the Lighten Blend mode. In this case, you actually wouldn't be able to tell the difference between the effects regardless of which layer was used on top.

I added a third layer, feather-erased around the edges so that they would blend, flipped the layer vertically, and then dragged it to the bottom of the composition to fill the dark area at the bottom. The Lighten Blend mode was used in this instance as well.

All that remained here was to add a Motion Blur to the neon rose layer and move it slightly up and to the left in the composition. Finally, I intensified the saturation and contrast.

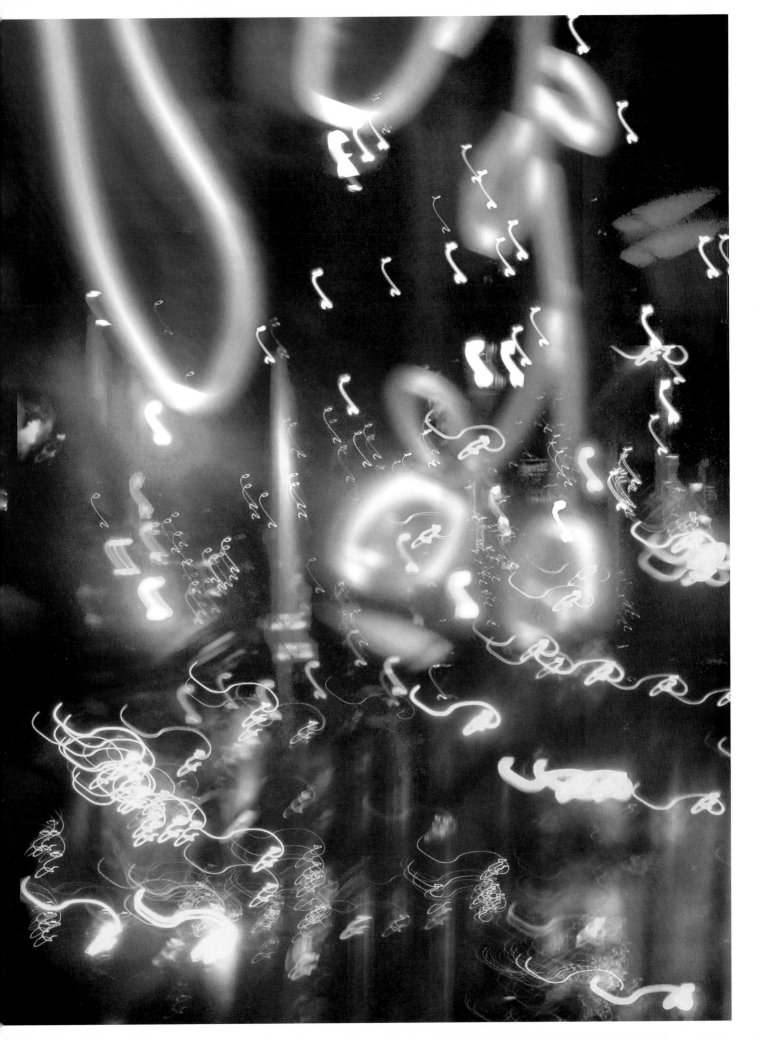

Lens Flare

This image started with an empty layer in a new file. In other words, there was nothing there. So here goes nothing... .

I made each of the elements in this composition by simply using different options in Photoshop's built-in Lens Flare filter. The placement of the secondary lights is controlled entirely by your placement of the brightest light source. Lens Flare filters are usually employed to create the illusion that a light source is be coming from behind an object, such as someone's head or a mountain.

So that I could also control the color of the light, I added another dark blue layer, put it into Lighten Blend mode, and then added another style of lens flare. I then used the Main menu version of the Hue/Saturation command to change the color of the new layer and its light. Had I used an adjustment layer for this, it would also have changed the color of the light in the original lens flare.

Just to prove that this could go on indefinitely, I added two more layers, using exactly the same technique as above. Of course, you could then add different kinds of light typically seen at night—advertisements, theatrical signs, even the sun, moon, and stars. Making images using this technique is an excellent way to make backgrounds for theatrical portraits. Oh—I used a Curves Adjustment layer to pop the contrast of the lighting as each new layer of lens flare added to the overall haze of the image. Of course, in another situation, you could use that effect to its own advantage.

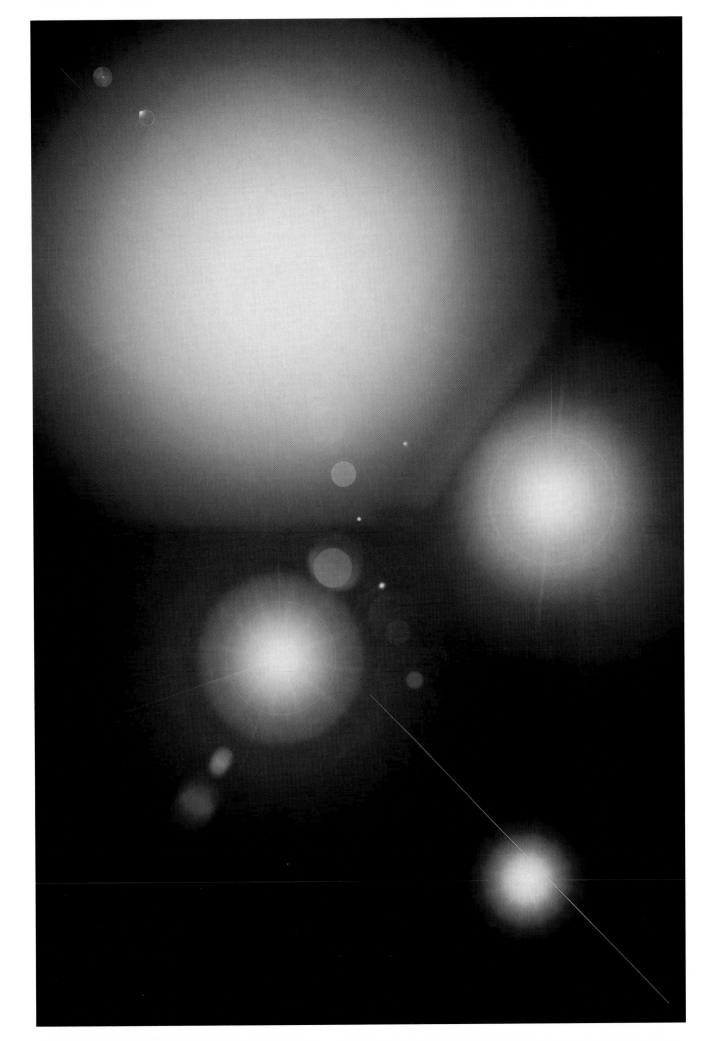

Liquids

Dying Lilies

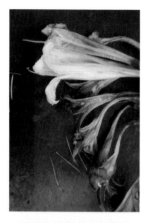

I loved the patina and texture in these dying lilies that were left lying around the studio for a couple of days after they were used in a light painting abstract. I took them outdoors on a foggy day and photographed them on a dark green table. I actually had to make several photos in order to get one in which all the plants were in reasonably sharp focus. I used Close-up filters in front of the 75mm lens in order to give me a macro-focusing capability.

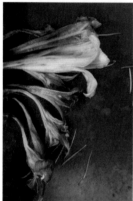

The image needed to be flipped horizontally so that the flowers would lead the eye from left to right into the composition. Also, I found the cropped flower at the very bottom of the shot distracting, so I cloned it out. Next, I selected and copied the white flowers at the top to another layer. The new layer was then placed in Multiply Blend mode to darken the exposure of the white flowers. This made them reveal more detail and also made the image look much sharper. Finally, effect sharpening was done in order to emphasize the veins in the flower petals.

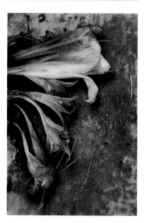

I removed the green table by using the Select Color command and then using the selection as a layer mask so that the area around the flowers would appear to be transparent. I then pasted one of the abstractions that I created by mixing and photographing colored liquids on glass (see the next page) onto a new layer. In the Layers palette, I dragged the new layer below the flowers so that it would appear as the background. Next, I duplicated the masked flower layer, filled the image with black in order to create a shadow, and then used the Gaussian Blur filter to dramatically blur the mask. The opacity of the shadow layer was lowered until the shadow seemed naturally transparent.

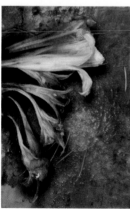

I felt that a more "antique" look for the background would be appropriate for these dying flowers. I created a new layer above the background and filled it with a medium reddish-brown. The Color Blend mode was then used to make the Brown layer "tint" the original layer. I reduced its opacity to 50% so that at least a suggestion of the original colors would survive.

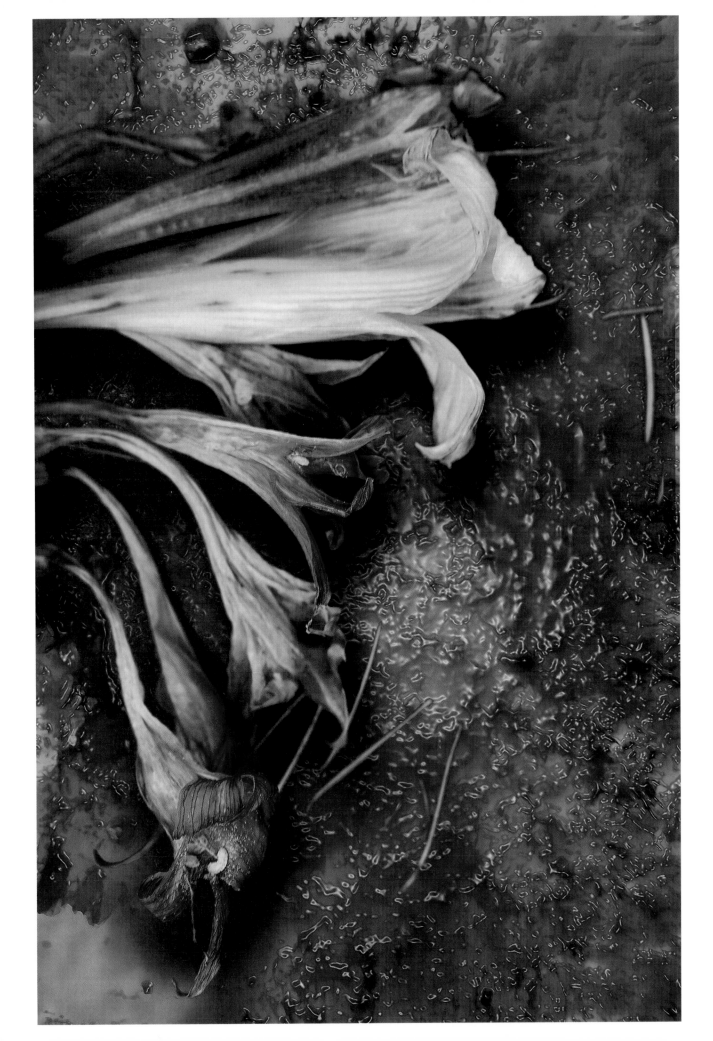

Branch Reflections

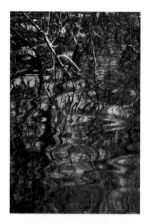

I was a bit proud of myself for staying so steady when I hand-held for a 1/20th second shot. Despite the fact that it was a bright part of the day, the combination of shooting in deep shade and wanting maximum depth-of-field to keep the other branches identifiable made the 1/20th second exposure necessary. Of course, I had no tripod, so I made one out of my knee, by sitting on the ground in a kind of half-lotus position. I raised my right knee so my foreleg was more-or-less vertical, rested the camera on my kneecap, and embraced my leg with my elbows. After transferring the image to the computer, I raised the color temperature of the RAW file to make the leaves look greener and bumped the saturation slightly.

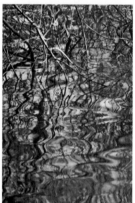

I used Neat Image to automatically profile and fine-tune the image for noise removal. Then the conventional corrective sharpening was performed using the USM filter. Finally I used the Highlight/Shadow command to open more detail in the darker shadows and add detail to the highlights in the branches. (I could have achieved a similar result by using a digital-range extension technique or one of Fred Miranda's plug-ins that does the same thing more quickly and efficiently.) Finally, I added a Curves layer to both brighten the midtones and to increase their contrast.

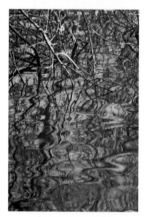

I wanted the make the image a bit more unusual and, therefore, more eye-catching; by changing the color of the sky reflected in the water, I was able to do that. I used the Replace Color command and raised the Fuzziness level to about 80%. I also spent a good bit of time adjusting the brightness of the color change so that the brightness of the reflection of the leaves and the brightness of the flowers was more similar.

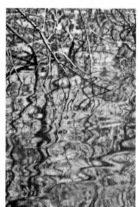

The image was then flattened and a Hue/Saturation layer added. I raised saturation to vary the colors in the leaves and modified the Hue slightly. To give a center of interest to the composition, I wanted to put the main branch and its reflection in sharper focus than the rest of the image. I used a highly-feathered Eraser at 100% to erase just the portion of the image surrounding the branch, but not the reflection. The reflection of the branch was then treated in exactly the same way, but I lowered the Eraser's opacity to 25%.

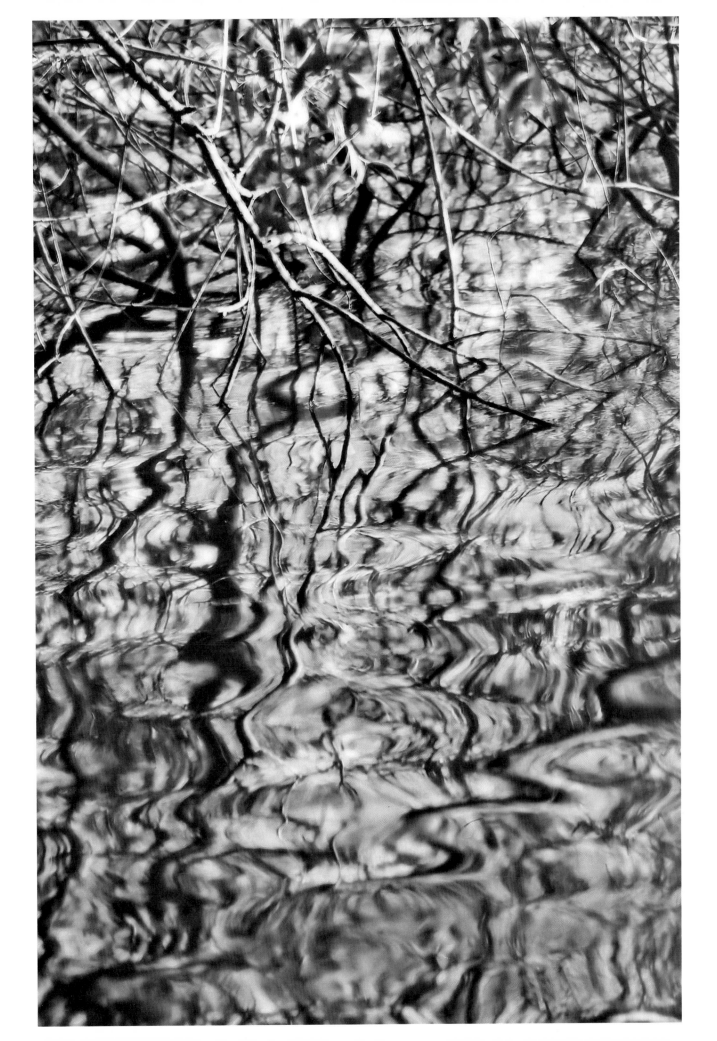

Creek Rocks

This photograph was taken with a 5MP point-and-shoot digital camera as a JPEG, so I didn't have the range extension capabilities normally afforded by RAW files. What I wanted to see was lots of detail over a wide tonal range, brighter colors, and extreme sharpness to reveal the gritty texture of the rock in contrast to the smoothly flowing water. Of course, especially since this was a JPEG, the first couple of things I did were to use Neat Image to remove noise and the USM to do initial sharpening. It turns out, however, that you have to be extremely careful about noise reduction when you have extremely gritty surfaces in an image. The program may turn your rock into velvet. It took a lot of experimenting to get the settings just right.

By starting with a Levels adjustment layer, I discovered that the tonal range could be extended quite a bit by moving the start and stop points of each color channel to the point where the pixels started to rise above the base of the histogram. Note that these Levels adjustments also automatically corrected the color balance of the image. I then increased the detail in the highlights and shadows with the Highlight/Shadow adjustment.

The Photo Filter adjustment was used to warm the overall colors slightly. Note that the color balance is now a bit closer to the original. An unwanted side-effect of the Highlight/Shadows adjustment was extreme emphasis of some previously unnoticed sharpening artifacts in the highlights. I had to use the Healing Brush and Patch tool to remove or sublimate those artifacts—tedious! Finally, I used the Hue/Saturation command to subtly boost the differences in the natural colors in the rocks.

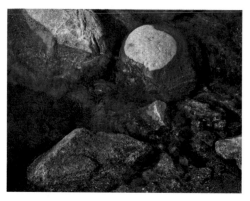

To make the water look more distinctly watery, and to establish a feeling that contrasts with the rocks, I imposed a custom color blue-green Photo Filter effect after the water was selected. As the Photo Filter dialog allows you to preview the effect, I just dragged the slider until I got the feeling I wanted, then clicked OK. Finally, I tweaked the contrast in tones one more time by topping off the layer stack with one more Curves layer and raising the mid highlights and lowering the mid shadows very slightly.

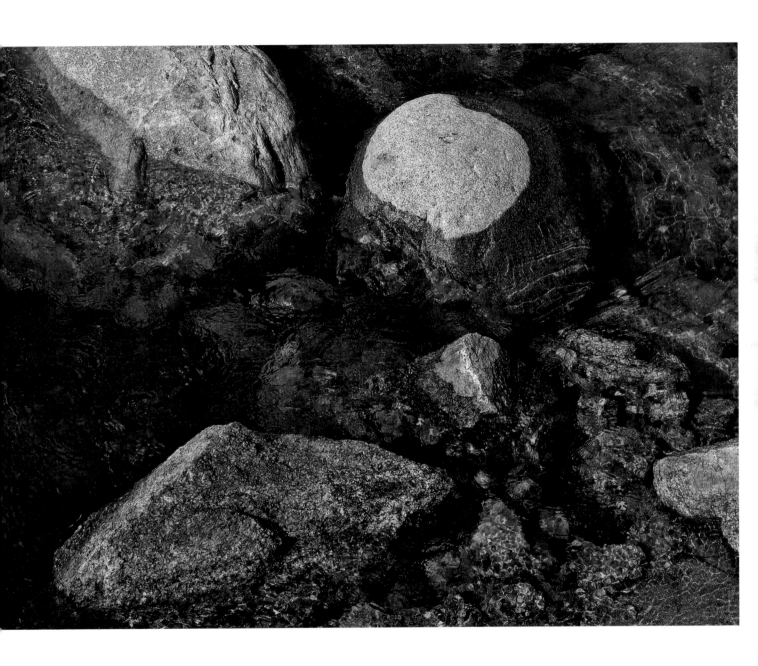

Oyster Beds

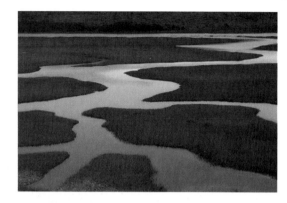

When I took this photo, I knew I wanted a lot of detail in the water, so I deliberately underexposed it to keep from blowing out the highlights. This is another of those images that called for great care while removing noise. I settled for some very minor adjustments, using Grain Surgery for noise removal because its interface is a bit simpler and easier to understand.

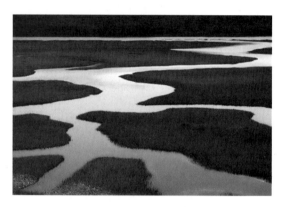

In order to get the strong graphic effect I wanted for this image, I used the Levels filter to bring up the full range of brightness in all three color channels, tweaked the contrast with a very slight S-curve, and then selected the distant background above the water and darkened it to near black. I then used Power Retouche to sharpen the weeds, making their texture as tangible as possible.

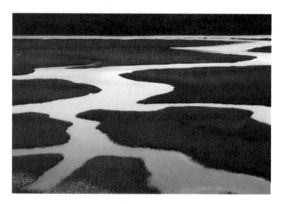

The water in the oyster bed just seemed to want even more emphasis, and I wanted a stronger sense of mood. I used the Select Color command to select the waterway, feathered the selection, and then created a new layer. As the layer was masked by the selection, I could fill it with any color and not have it affect the color of the vegetation. Once that was done, I changed both the Fill and Opacity levels to about 50%.

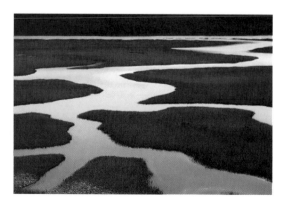

Now I really wanted to see the texture color and character of the vegetation. I added a Hue/Saturation layer just above the background and below all the other layers. Adjustment layers affect only the layers below them. Then I noticed that raising saturation also brought unwanted color into the distant background above the water, so I discarded the Hue/Saturation layer, re-selected that background portion, then re-initiated the H/S layer. This time, the background was automatically masked out by the existence of the selection. Then all I had to do was raise the saturation level.

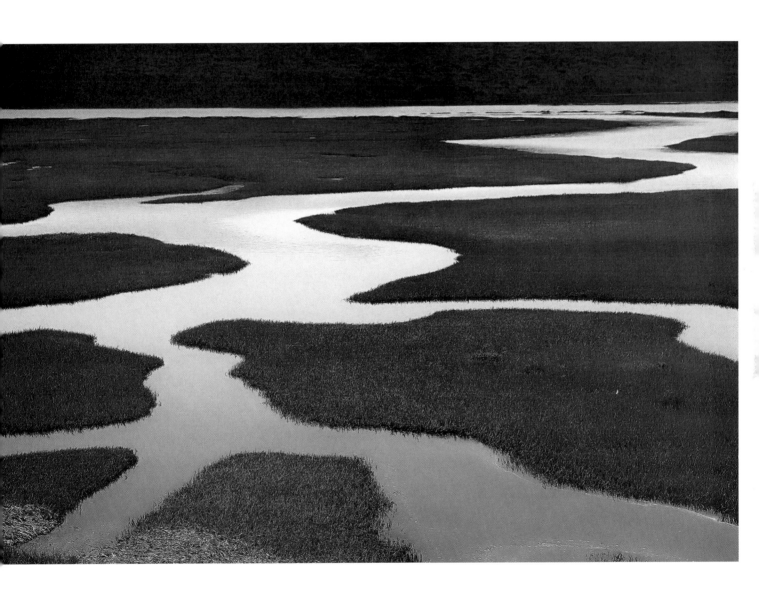

Dead Lilies II

The background here was the same food oil and food color mixture seen in "Dying Lilies," but this time the lilies were actually part of the photo. The original image was underexposed by a full f-stop because I needed a reasonable compromise between depth-of-field and shutter speed (I was hand-holding the camera). When hand-holding in these circumstances, I try to make several identical exposures so that I can choose the one with the least camera motion. Also, when shooting extreme close-ups like this, the slightest movement toward or away from the subject can blur it. Frankly, I was amazed at the overall sharpness I got in this frame.

I wanted to pick up more of the tan coloring from the lily on the right side of the image and place it into the background, so I picked up some of the tan with the Eyedropper tool, then used an ordinary circular Brush tool at 60% opacity to stroke it in, freehand. I then used Photo Wiz Focal Blade to dramatically sharpen the overall image so that the edges would show up even more graphically.

To get more punch and color variety, I duplicated the background layer and then changed the Blend mode to Overlay. I then chose the Eraser tool, reduced its Opacity to 50%, and made freehand erasures in various parts of the background to bring more pink into the blue background. Notice that this technique also really emphasized the veins in the flower petals.

Finally, I created the impression that the image was printed on burlap by using the Texturize filter. The size of the texture was set to 200% to make the fabric look as rough as possible. Notice that, because Photoshop "lights" the texture, the image itself seems slightly brighter or more faded, depending on where the lighting falls.

Fountain Macro

This is simply an extreme close-up of a detail in the fountain at San Francisco's Yerba Buena Center. I shot it because I thought it would be fun to experiment with after-the-fact coloring of the subject in Photoshop. What you see at left is the original photo after basic noise removal, initial sharpening, and preliminary Levels adjustments to extend color and maximize the brightness range.

I corrected the perspective with the Transform command and then cropped the image. Next, the Selective mode of nik Color Efex Pro was used to "paint" a different bi-color gradient effect into each of the streams of water coming from the fountain's edge.

To better prepare the granite surface between the waterfalls, I used another nik Color Efex Pro filter, the BW Dynamic Contrast effect, to paint in between the streams of colored water.

There were actually two stages in the final stage. First, I wanted to create the feeling of an "ancient" patina in the granite. I used a "scatter" brush style to paint various shades of mold onto a new layer, and then experimented with Opacity and Blend modes. Finally, I wanted an even more "watery" feeling, so I called on the Eye Candy 4000 Water Drops filter to create the feeling that the fountain is being viewed through a water-spattered glass pane.

Abstract Oils

The oils referred to in the title of this image were actually cooking oils, not paints on canvas. The color came from food coloring. The oils were all poured at random on a glass plate and then "finger-painted." Frankly, I think the image at the left, which has been fully adjusted in Camera RAW before opening in Photoshop, stands quite well on its own. However, one of the objectives of this book is to show just how much can be done with an image using digital processing methods and effects. I took this photo with a Fuji S2 Pro at ISO 200, with a 4+ macro filter placed in front of the lens.

I think you will agree that each stage in the creation of this abstract stands on its own. In fact, I am thinking about exhibiting all four of these images as a group the next time I have a show. The idea here is just to show that the more abstract the subject, the more possibilities image processing offers for making them even more abstract. Here the Photoshop Filter Gallery was used to sequentially apply three different artistic effects: Colored Pencil, Dry Brush, and Paint Daubs.

Special-effects filters can do all sorts of things, such as creating drips, water drops, flames, lightning, and rainbows. The list goes on and on. Here, I've set the bottom edge on fire, then made it appear to melt as a result. I did this by running two of the filters in the Alien Skin Eye Candy 4000 collection, Fire and Drip. Each of these filters was applied to the image in sequence.

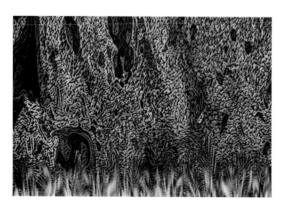

As it stood, the image seemed to cry for a bit of texture and patina. After experimenting with numerous texture programs (Painter, other KPT filters, and Andromeda's etching filters, to name a few), I settled on the Reaction filter in the Corel KPT Collection, from which you can choose an infinite number of pattern variations. I then blended the pattern with the image by using Photoshop's Fade command at about 70% and putting it in Overlay Blend mode.

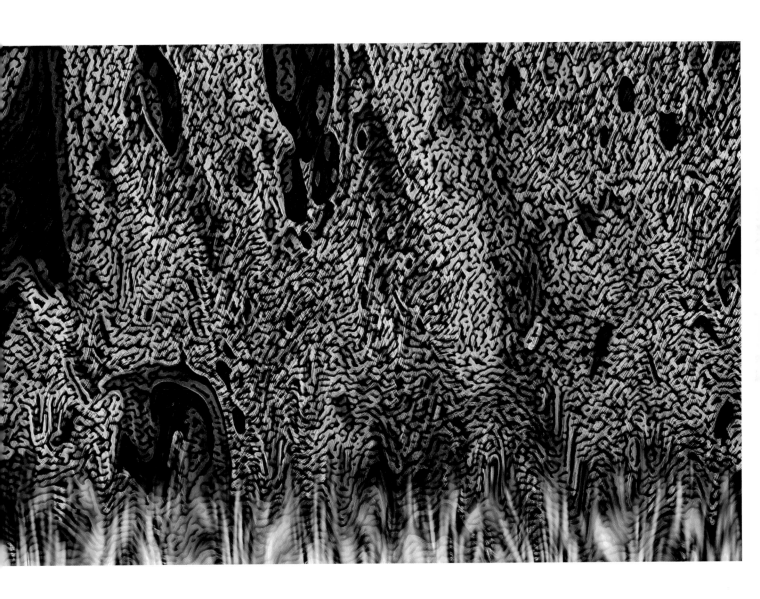

Spatterlay

With the exception of the background layer, each of the four photos in this abstract was shot as a mixture of oils on a backlit glass dinner plate. Each was then placed as a separate layer in Darken mode, so that only the darker tones were visible from each layer. As the tones became lighter, they became progressively more transparent. At left, you see the image that became the background layer, a mixture of food oils and color

Here you see the second photo, copied and pasted at full size, on a second layer just above the background. As is the case with all the layers in this image to follow, the layer mode is Darken. I could still see the darker colors in the background layer through the orange, so I highlighted the background layer in the Layers palette, changed it to a normal layer, and then used the Eraser tool to start erasing the colors that were showing through.

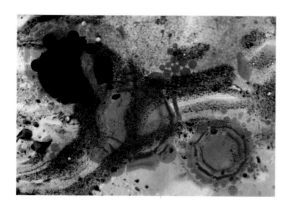

Here you see that two more layers of oil-spatter macros have been added. Nothing was intentionally done to make the color shift. It simply happened as a result of multiple overlaid Darken layers. I could have chosen to add a Color Balance layer; in this instance, however, I just felt the color shift added to the character of the image. When I added and scaled the orange in the lower-right corner, the edge of that image made a sharp line from top to bottom-center of the image. Again, the Eraser to the rescue!

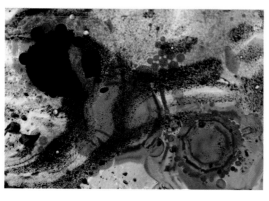

I wanted to darken the appearance of the lower-right corner of the background. I did so by adding yet one more orange blob. This time, I was getting a bit bored with the orange and really wanted a color more attuned to the colors in the background, so I used the Replace Color command to change the original color, also dragging the saturation slider down in order to desaturate. Finally, I used a Curves layer to intensify the image's overall contrast and flatten the image, and then did effects sharpening with Power Retouche Sharpener.

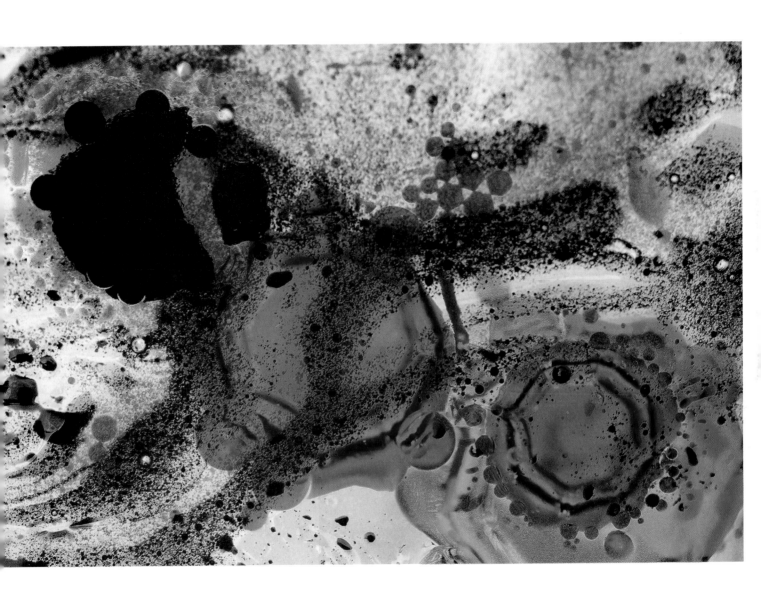

Floating Leftovers

The original of this image is intriguing as-is. However, there were certain aspects that I wanted to emphasize. First, I wanted to make it plain that the needles and other debris were actually floating on water, not just lying on a smooth surface. To this end, I wanted to make the water both bluer and more transparent. Second, though I really liked the natural lighting, I wanted to emphasize the highlight area. Finally, the image needed considerable sharpening, as it was shot at a wide F-stop and hand-held at a relatively slow shutter speed. So I wanted to make sure to get rid of as much noise as possible so that I could do an effects sharpening without unduly suffering "graininess" as a "punishment."

After running Neat Image and the USM filter, I made the water more transparent by carefully adjusting the Photoshop CS Shadows/Highlight advanced settings. You'll notice that there is much more detail in the submerged mud, thanks to careful adjustment of the Midtone Contrast slider. Next, I changed the color of the water by using the Replace Color command and simply dragging the Hue slider. I found I could make the water entirely blue, as long as I kept the Preview box checked and adjusted the Fuzziness slider. However, the transition between water and needles was more natural when I didn't make the color change quite as drastic.

Because sharpening was so definitely critical for this particular image, I tried three popular sharpening tools: Photo Wiz Focal Blade, Power Retouche Sharpening, and Photokit Sharpener. The one that produced the fastest effective sharpening was Photokit Sharpener, a relatively new script from a group of half-dozen recognized Photoshop gurus. I want to emphasize that I did not test all three products at every possible setting, though—results are, of course, going to vary from one image to the next. But Photokit Sharpener definitely produced the most dramatic results for this particular image.

This amount of serious sharpening really brought out the nearly microscopic dust on the camera's sensor, and it had to be spotted out with the Healing Brush. There was also a bright object in the lower-left corner that led the eye away from the center of interest. When I tried cloning over it with darker surrounding material, I discovered that layers left over from the sharpening effect kept me from darkening it effectively, so I first flattened the image, then I used the Clone Stamp. I used the Lighting Effects filter to "light" the sharpest portions of the image, further de-emphasizing the still-out-of-focus immediate foreground and the more distant objects. Once that was done, I "cheated" on the Lighting effects by using the Burn tool to further darken the upper-left and lower-right corners.

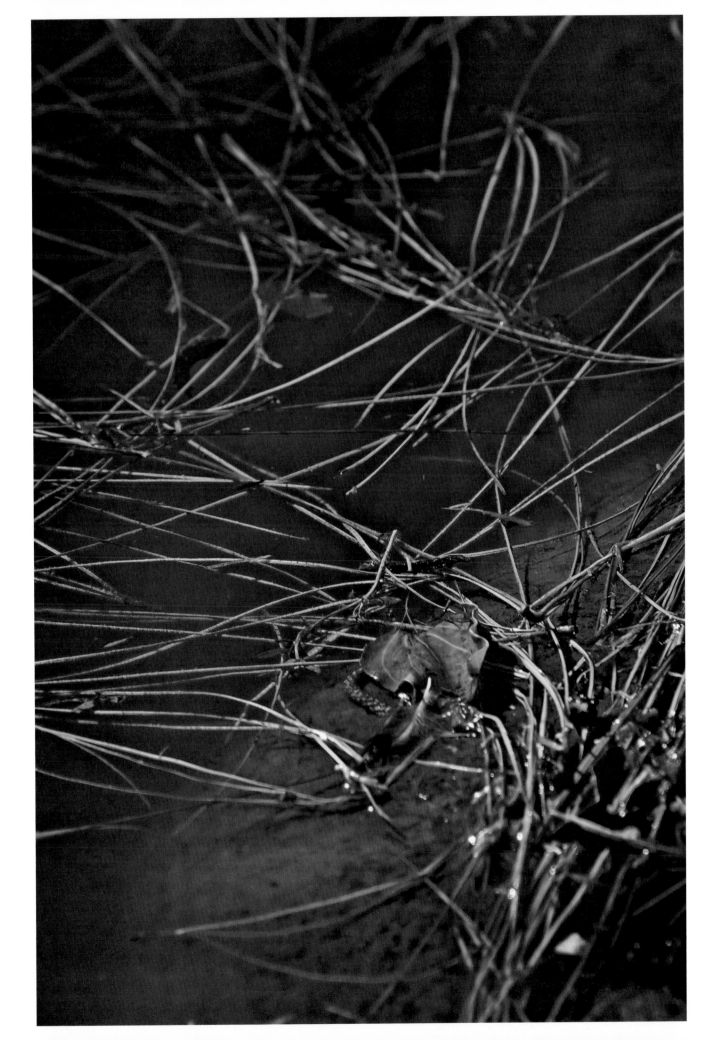

Collected Parts

Jumpers

I was struck by the backlighting around the edges of these kids' jumpers at a local farmer's market and pleased with the delicate pattern they made. However, even after I adjusted for a nice balance of color and exposure, there was too much bright and highlighted detail in the background.

I carefully selected the background and feathered it; then I darkened it with the Brightness/Contrast command but by lowering the contrast rather than the brightness..

Tourist Table

I took this picture because I was fascinated by the contrast between the dark area in which the typical diner condiments resided and the display of "Golden Era" memorabilia beneath the glass tabletop.

Once the raw file had been adjusted and opened in Photoshop, I noticed some discoloration in certain areas of the picture. After curing that problem, I cloned out the upper part of windowsill. To darken the display table, I selected and feathered the bottom and raised the contrast using a Curves layer. Next, I darkened the upper part of the windowsill even more and made the stamps more visible by using the contrast slider in the Brightness/Contrast dialog. Finally, I used the Hue/Saturation command to raise the saturation slightly, thus bringing out more detail and vibrancy in the overall composition.

Trashy Composition

In Berkeley, recycling is almost a religion, and sometimes my morning walk reveals some interesting abstractions in the contents of the bins sitting by the sidewalks. I always carry a camera with me on those walks. In this instance, the camera was the Fuji S2 pro. Luckily, it was a gray day, so there was lots of detail in both shadows and highlights.

This is how the image looked after I made some simple exposure and color balance adjustments in the Camera RAW converter. Nothing more has been done at this stage.

I wanted to change the contrast and color of some of the elements in the image. I added a Curves layer and masked the face by using the Magnetic Lasso and feathering the selection slightly. Then I played with the highlight and shadow sections of the curve until I saw some dramatic contrast in the face that would pull the viewer's attention into it. Once I did that, I realized that some of the lighter pieces of paper at the bottom of the composition were so light that they drew attention away from the face. They were also so light that you didn't see much in the way of texture or character. I selected them with the Magic Wand and then used Brightness/Contrast to both darken and punch up the texture. I also neutralized the color balance.

I knew that I was going to use filters to abstract this image even further, but before I got that far, I wanted to sharpen in and punch up the edges. After all, this picture was taken in early morning light on a foggy day, so exposure was a bit too short for razor crispness; Photo Wiz Focal Blade sharpened the edges nicely without creating undesirable edge artifacts. Next, I used the Xaos Segmentation to make the image a bit more abstract. Then comes the clincher: I used Photoshop's Extrude filter to extract the image into tiny pyramids, and then lowered the fill for that layer to about 50% so that what you see is actually a blend of the two effects.

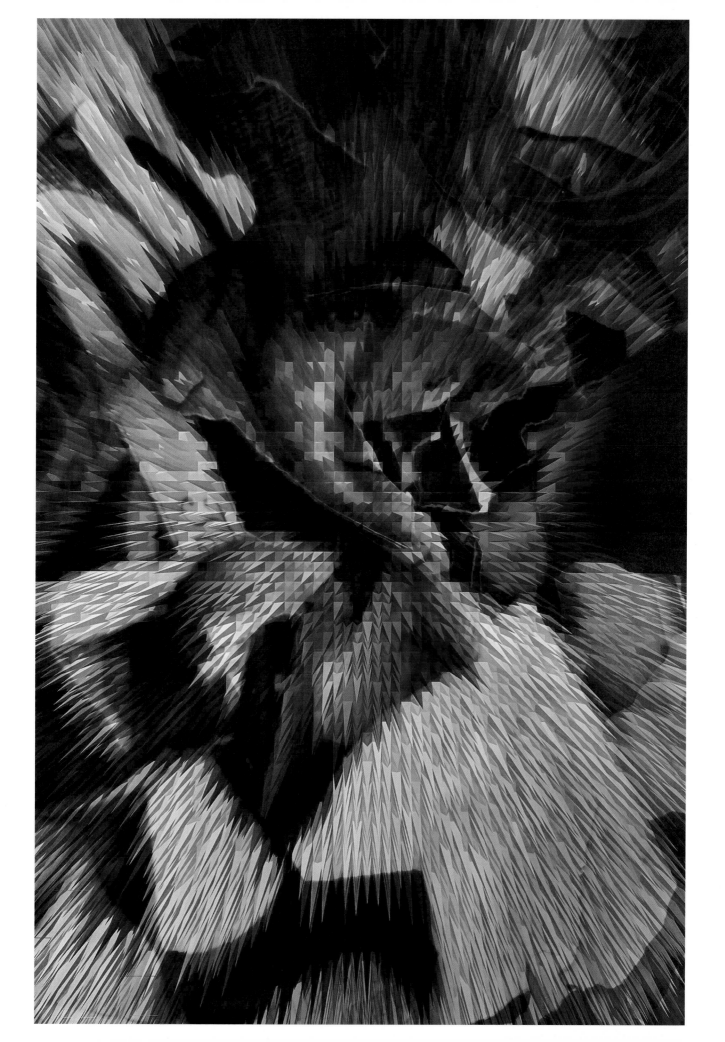

Bloody Sand

Due to all the similar colors, the histogram was spiked in the middle.

To fix the problem, I use the Camera RAW dialog to correct exposure and contrast in Photoshop. I used the Hue/Saturation adjustment to boost Saturation by about 25%. The idea was just to make this image more vivid. I was also able to bring more colors into the composition by dragging the Hue slider slightly to the left. I then tried several experiments with this image, but to me its allure lies in that this was the way nature and the beach made it. Messing with it seemed to lessen its impact, rather than increase it.

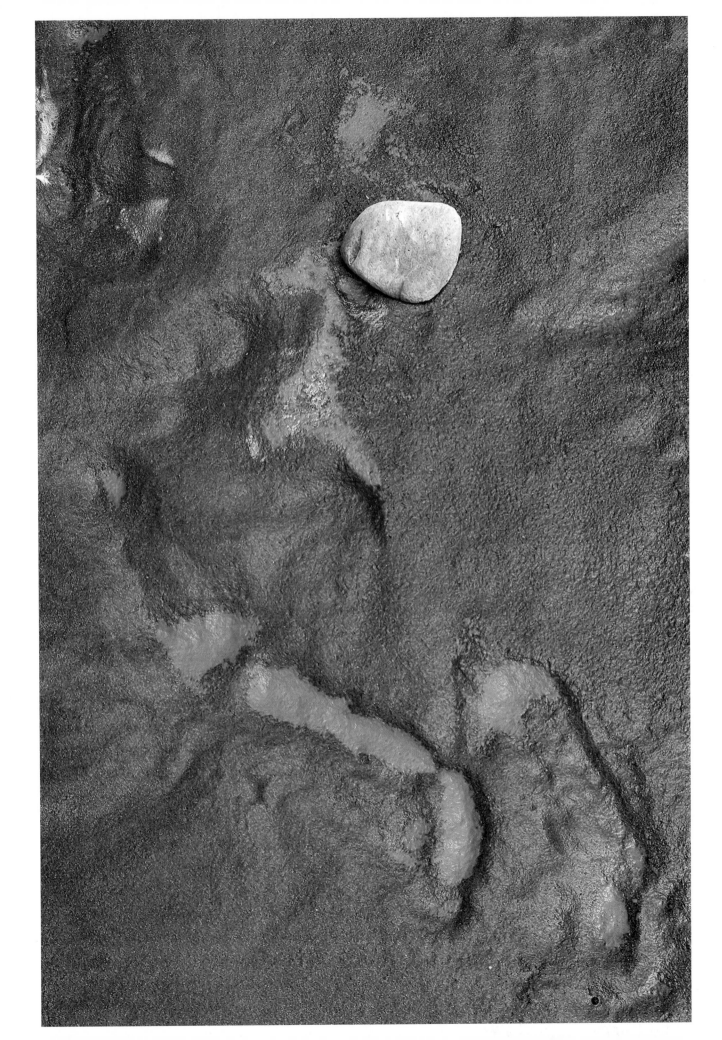

Natural Art

These are all bits of debris that I picked up at Drake's Beach in Point Reyes National Seashore. The arrangement won't compete with British environmental artist Andy Goldsworthy, but in keeping with his philosophy, I photographed it because I was sure the arrangement wouldn't last through the next storm.

I wanted more sharpness in the image, so I resorted to the old High Pass filter in Overlay mode trick after duplicating the Background Layer. I then used the Curves adjustment layer to give the beach junk more shape, depth, and texture. The last thing I did to bring the image to the stage in which you see it here was to use the Select Color command to isolate the background. After feathering the selection for a smooth blend, I used the Brightness/Contrast command to darken the background.

As it was a foggy part of the day when the original photo was made, and as I had just done a lot of fiddling with the brightness range and saturation, the background boards kept getting more and more blue-green—a clue that the whole image was out of proper color balance. I used the midtone eyedropper in the Levels command to fix that. Then I used PhotoWiz Focal Blade to do an extreme overall sharpening that really lets you "feel" the textures.

I was still not quite satisfied with the tonalities in the image. First, I darkened the edges to help the viewer focus on the objects. Then I lightened the upper-left part of the background because the brightness of the left and right sides of the image don't match. Then came the *coup de grace*: I flattened the image, duplicated the Background layer, and then used one of the Color Infrared filters in the nik Color Efex Pro series. I then used the Luminance mode on that layer after lowering the Fill opacity to about 50%.

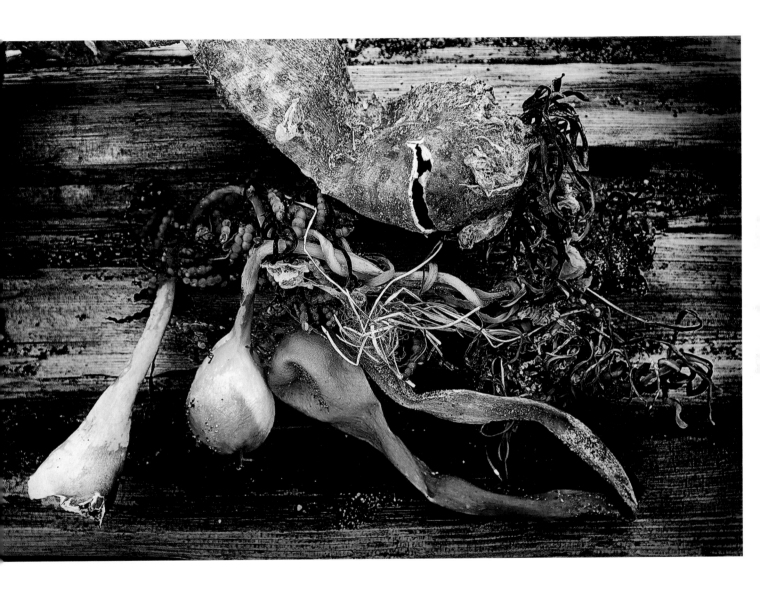

Flutterby

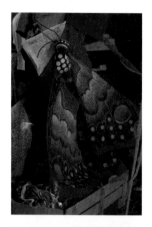

This is stuff that was collected by somebody else; I just liked the colors and the composition enough to want to photograph them. Like with the "Trashy Composition," it struck me that image could lend itself to some heavy manipulation and distortion. That's why I'm starting out by showing you the original RAW file, completely untouched and unmanipulated. Before I sent the file on to Photoshop, I made adjustments that would show the widest possible range of detail, knowing that I would subsequently be able to use Photoshop's controls to brighten and darken specific areas of the picture.

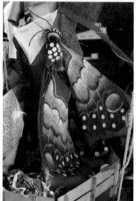

The first thing I did was open the Levels command and make sure that the histogram starts and stops at the brightest and darkest information in the image. Most of what you see at left is the result of that one adjustment. However, I added a Curves adjustment layer and used it to darken the dark shades and brighten the brighter ones. I also used Neat Image to reduce noise, and Power Retouche Sharpener to give me some interpretative sharpening.

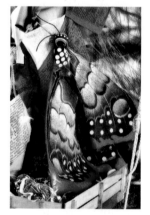

Now I wanted to make the image a bit more mysterious. I opened a portrait of a model and used it as the source image for the Clone Stamp. For the cloning, I choose a "natural media" brush, introduced several types of jitter, and then dabbed in the model's bright blue eye and cheek. Then, to really punch up the image, I used the KPT Equalizer.

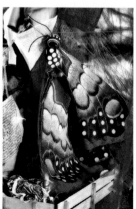

I flattened the layers and then used Xaos Tools Paint Alchemy to create a very abstract version of the image using large, blotchy brushstrokes. The overall tonality of the Paint Alchemy abstraction is quite high-key, with a few darker areas of brightly colored brush strokes. When I used the Hue Blend mode and set the Fill opacity to about 60%, I got pretty much what you see at left. The rope in the lower-right-hand corner bothered me, so I simply painted over it with a partially transparent natural media brush, then used the Add Noise filter to match the grain in the painted portion of the image to the grain in the rest of the image.

Rockpile

Now, here's a work of art that really was inspired by Andy Goldsworthy. Now we're seeing rockpiles almost everywhere they're likely to attract the public's attention. It's amazing how gray and dreary this sculpture was before the RAW adjustments were made, thanks to the grayness of the rocks and the asphalt that surrounds them.

This pile is made entirely of the elements of nature, and I wanted the representation of the abstract to be purely photographic, so that the viewer would really feel in touch with those elements. I also wanted to emphasize the curves, play of light, and texture. I first used the Extract filter on a duplicated background layer in order to separate the rocks from the background. I then added both Curves and Levels adjustment layers and turned both Adjustment Layers into Clipping Layers so that they would only affect the rock pile, not the sidewalk under them. I then chose the sidewalk layer, made a rectangular selection of the bottom third of the image, feathered it 200 pixels, and darkened its contents with the Brightness/Contrast adjustment. I thought that would be the end of it, but then I realized that I want more "grit" in the texture of the rocks, and more color. To achieve this, I used the KPT Equalizer with every other slider raised to maximum.

Next, I duplicated the image so that I could experiment without destroying what I'd done up to this point. After all, I did like it and might have wanted to go back to it. Then I felt free to turn the duplicate into a sepia tone. I could have done this by making a duotone in Photoshop, but frankly, it's quicker and easier to simply apply the nik Color Efex Pro Sepia Tone filter—so that's just what I did. Finally, I did a bit of burning and dodging to get exactly the tonalities I wanted in the lightest and darkest portions of the rock stack.

Beach Flowers

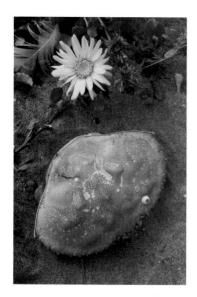

The picture you see at the left is pretty much what the camera saw. Only very minor adjustments were made in the Camera RAW dialog. I actually like this just the way it is, but the image also looks like a good candidate for something I call "computer-generated hand-coloring."

I wanted the program to sketch the edges of the principal shapes, so I used the Glowing Edges filter on a duplicated layer—not because I wanted colored edges, but because I could control the width of the edges and could reduce the number of strokes in a highly textured image by increasing the smoothness of the edges. Because I really wanted black and white strokes, I used the Threshold adjustment to simultaneously change the image to monochrome. Then I could use the Threshold command's slider to interactively include more or fewer lines until I liked what I saw.

Next, I did the "hand-coloring." First, I changed the Blend mode of the edges layer to Darken, so that the image behind the lines was revealed. Then I duplicated the background layer again and changed its Blend mode to Screen. Then I lowered the opacity of the Screened layer to 25%. What you see is what you get. If you wanted an "artier" look, you could export the image to Painter and use a watercolor, clone oil, or palette knife brush on that layer. I'm sure I'll do that on more than one image before you finish reading this book.

People's Park

The original, straight out of the RAW dialog. A powerful commentary on modern times and past history, precisely because its content consists of the symbols of the sixties and of the early 21st century. This image was intentionally underexposed to insure highlight detail, especially in the Drug Free Zone sign.

I brightened this by using the Levels command, but not as much as I would have if I'd wanted to leave this as a stand-alone photograph. It was going to be the background for another scene from a recent anniversary celebration in Berkeley's People's Park, but as it turned out, the theft of my laptop computer resulted in the disappearance of the photos from the People's Park anniversary celebration. So I'm going for a whole new interpretation here.

I raced off to Fairfax and found this peace symbol mounted on a redwood building. I immediately took the photograph, then added it as a layer above the photo of the People's Park memorial. I gave the peace symbol layer a Pin Light Blend mode. The result worked, but the white peace symbol simply stood out so much that it totally took over the composition rather than just being part of it. So I used the Color Replace command inside a Magic Wand selection to change the color to what you see here. Interestingly, changing and darkening the color of the peace symbol also allowed the background to blend through it, so it becomes even more integrated with the overall composition.

I finished off the composition with another photograph of the same wall, taken at the same time, but showing a group of typical Berkeley-student bicycles lashed to a sidewalk bike stand. These were extracted from their original background with the Extract filter. They look totally natural in the composition because they were shot in the same lighting conditions, from the same angle, and in front of a nearly identical background.

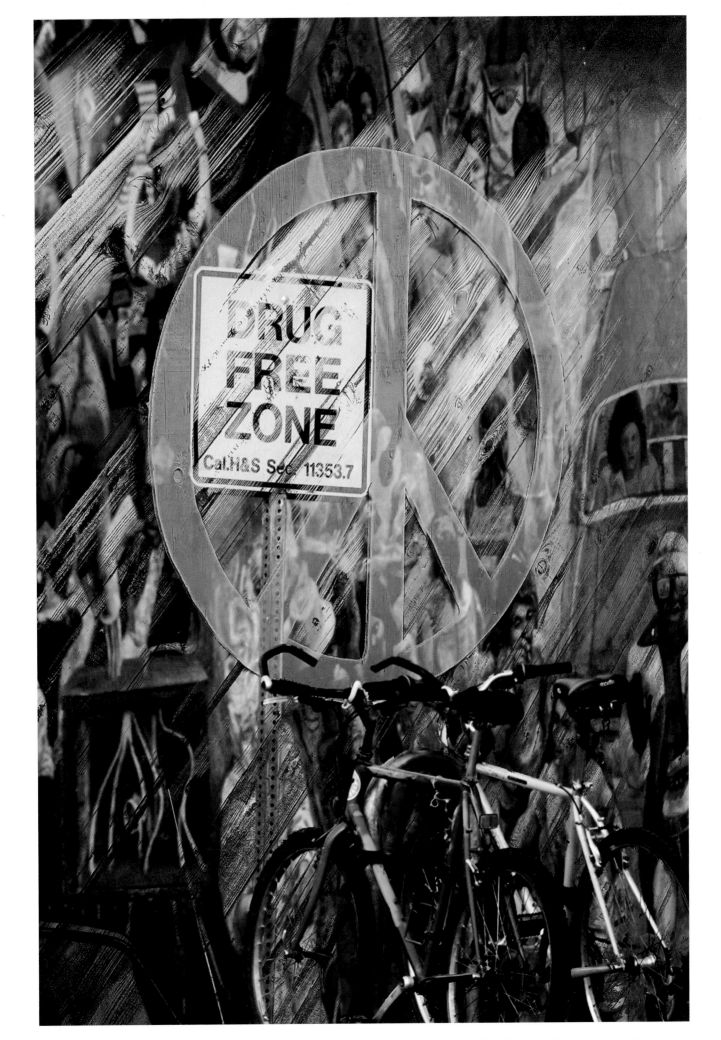

Lost Rock

I loved the shapes and textures in this rock. In the RAW file, seen at left, they just seemed to flatten out. So before I brought it into Photoshop, I corrected the exposure and color balance.

In Photoshop, I used both the Curves and Level commands to snap some life into the base image. I then found another photo—taken on the same day and in approximately the same location and lighting conditions—of a clump of seaweed. I used the Extract filter to lift the seaweed from its original background, then the Move tool to drag it into the same window as the rock. It continued to look "pasted" into place until I duplicated the layer, locked its transparency, filled it with black, then unlocked transparency and used the Gaussian Blur filter. Then I dropped its opacity so that the "shadow" became transparent. If need be, you can also use Transformation to make a shadow's perspective match the background's.

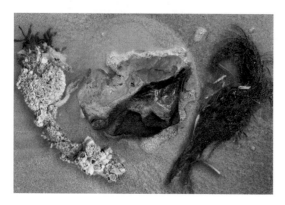

I added another bit of beach debris, using the same technique as above. Then I rotated the image just because I liked the circular, meditative composition that it created. Finally I really cranked up the saturation, just to reveal more color and texture.

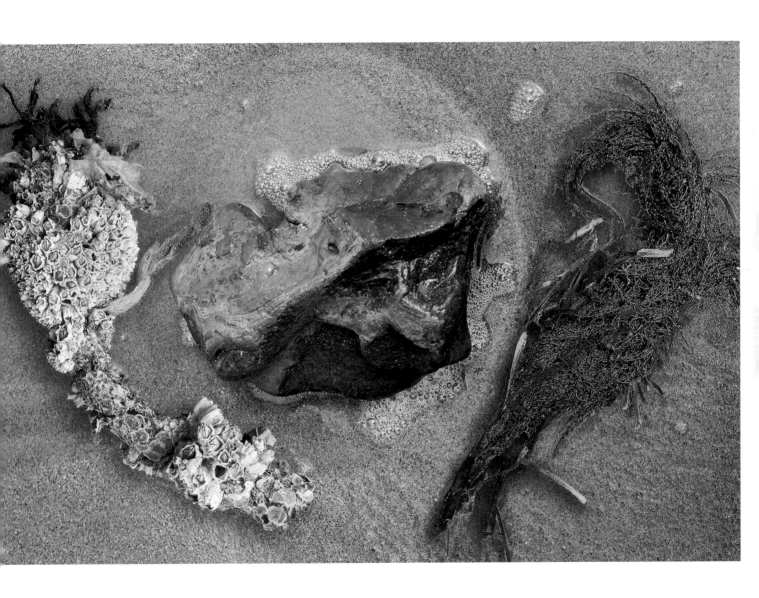

Unmasked

This image is one of several of a collection of Mardi Gras masks that were being sold at a local mall before Halloween. I wanted all of the masks in focus, and the extremely short depth-of-field of an Olympus C-5060 camera, with its 7mm (28mm equivalent) lens, gave extreme depth-of-field, even at its widest apertures.

I took a picture of a friend's eye, using a point-and-shoot camera set in macro mode. I then opened it as a separate file and used the Clone Stamp to copy that one eye into various positions in each of the eye holes in each of the masks. The same friend then remarked that he'd rather see the red mask in another color that was more compatible with the colors in the other masks. I selected the red mask and used the Replace Color command to change the color of the mask to yellow. The Burn tool was used to darken the blue mask in front.

Now I wanted to make this image more plastic and "pop art." First, I brightened and smoothed the highlights by using the Flaming Pear Glow filter. Then I applied the Photoshop Plastic Wrap filter. This gave the whole image an other-wordly look and texture. I liked it, but I felt it still didn't have enough power.

After duplicating the original layer, I started experimenting with the nik Color Efex Pro Pop Art filter. Then I started experimenting with Photoshop Blend modes and ended up settling on Vivid Light. Now, I'm getting excited. I still want that bubbly, Plastic Wrap texture to be look more like stretched Saran Wrap, so I lowered the Opacity of the blend layer to 60%. Now I see what I was after.

Blurs

Speedo Bike

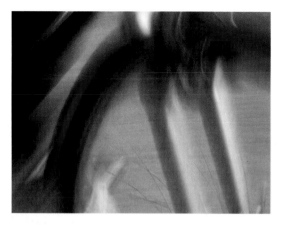

Caught on the fly at 6:30 on an October evening, when it was dark enough to permit a slow shutter speed. Shutter speed was about 1/8 second at f-5.6 with ISO rating set at 400.Shutter lag from the Oly 5060 in RAW mode was enough to make the timing pure guesswork. Again, taking chances cost me nothing and gained me everything. In the Camera RAW dialog shadows were darkened, midtone contrast increased, and saturation boosted slightly.

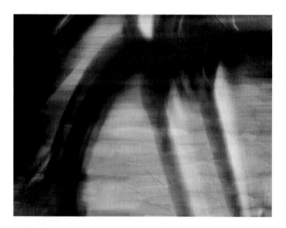

I like the simplicity of the image right out of the camera. But again, one of the purposes of this book is to show off many of the creative possibilities inherent in digital photography and digital processing. As I looked at this, the first thing I was inclined to do was to introduce some color as a way of adding excitement. I did that by creating a new layer, brush-stroking it in bright colors, and then adding a dizzying motion blur. Then I lowered the Fill of the bike layer to 55% so that I could see the colors, and then added a Curves adjustment layer to bring the values in the bike closer to those in the original.

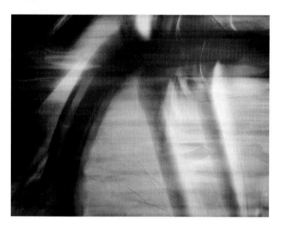

I'm liked the progress, but I felt it needed a bit more speed and excitement. I chose the color layer and applied the Andromeda Velociraptor filter to it to blur the colors even more. Then I useed the Photoshop Lighting Effects filter to brighten portions of the image to make the background look more photographic.

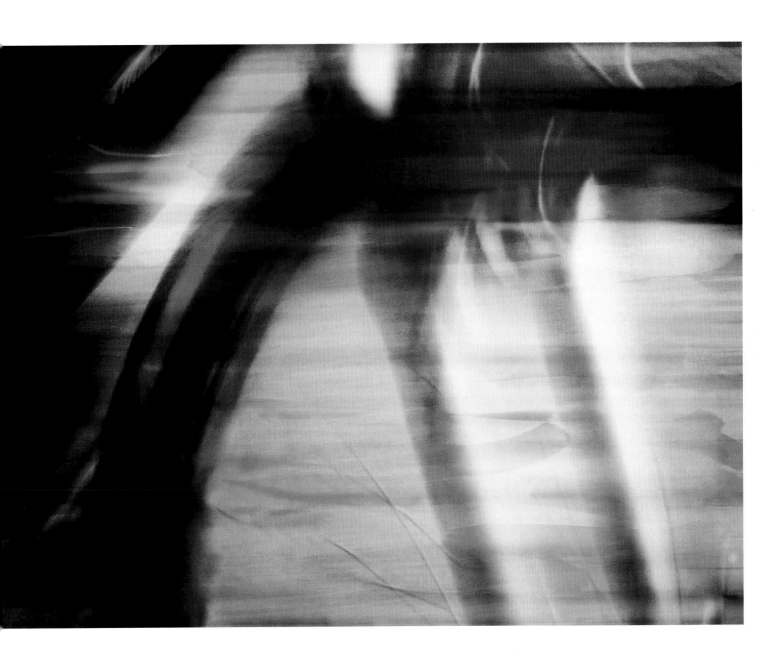

Riff Raff

This close-up of a jammin' guitarist was shot in a club, using a long lens and available light. The slow shutter speed and resulting blur just came naturally. This is how the RAW file looks before any processing was done. ISO 400, 1/6 second at f-5.0. with 188mm zoom equivalent.

I wanted a more exciting, hard-rock feel and more of the excitement that a good night out at a hard-rock club brings to the libido. I took a photo that was shot at an all-night party, boosted its color saturation and contrast, and then dropped it as a layer atop the guitar photo. Then I used the Liquify filter to squish all the people and lights in the dance floor scene beyond recognition. Then I put the layer in Linear Dodge blend mode and used the Eraser tool to reveal more of the guitar.

Finally, after flattening the image, I added a Movie Prime Lens Flare in the upper-left corner of the image. Of course, a Curves layer was added to adjust the overall gamma and contrast of the image. In my opinion, it rocks!

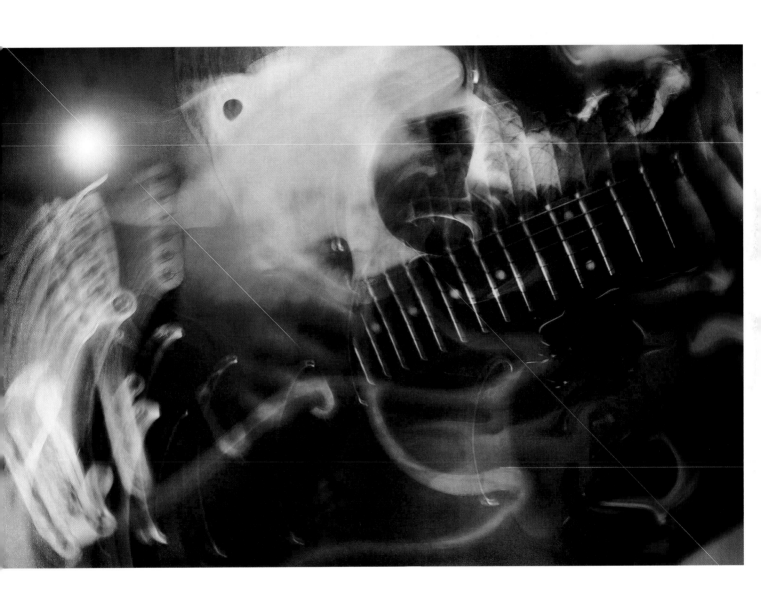

Airborne

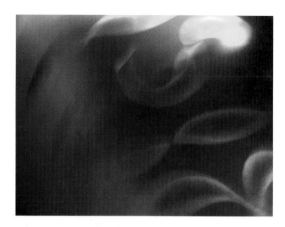

When I photographed these lights in a store window at nighttime, I intentionally twisted the camera rapidly during the exposure in order to suggest motion. Shot at 1/15 second at f-3.5 at ISO 400.

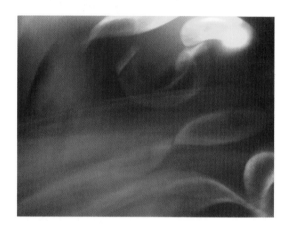

I actually shot several frames of the same window at different shutter speeds and moved or wiggled the camera in different ways. Then, when I downloaded the images to my computer, I had several images to pick from. Often (as you've probably learned by browsing this book), the composition of an abstract can be improved by sandwiching layers. In this case, I just built the feeling of overall movement into the image. I didn't use a Blend mode—I just lowered the opacity of the incoming image and then added a Curves layer to control overall contrast.

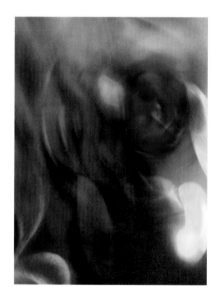

Then I set out to give the image a dramatically different approach. I took an image from the same shoot—but one of a blurry scene that's mostly blue and gold—and placed it on the layer above. Then I blurred it considerably with the Spin mode of the Radial Blur filter, changed the Blend mode to Vivid Light, and used a Curves adjustment layer to control overall contrast and specific areas of brightness. This covered up some nice compositional elements in the original design, so I used an Eraser at 50% opacity to reveal those elements that I want the viewer to see on the layer below. I realized that there is better compositional balance if I rotate the image to a vertical position, so I do that last.

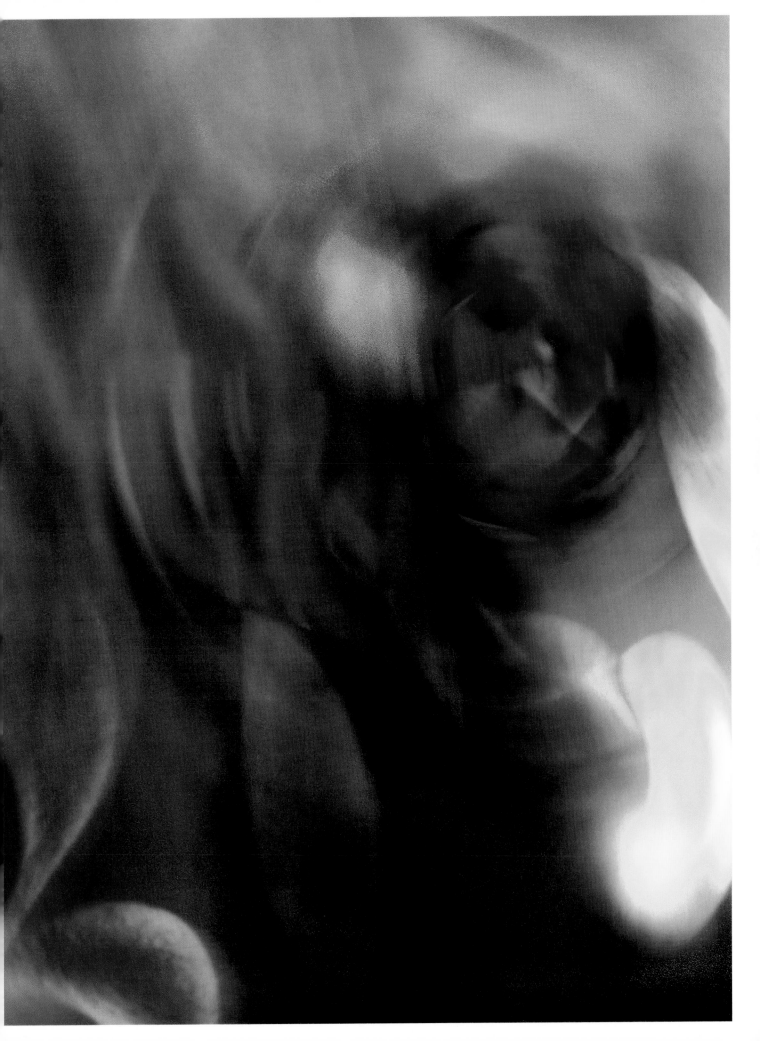

Ion U

Bulletin boards are often great places to look for abstract shapes and color. Try shooting them blurred at slow shutter speeds or intentionally out-of-focus (for the latter, it helps if your camera has manual focus). In this case, the image was forced out-of-focus.

The Andromeda Etch Tone filter made the image much more dramatic and gave it more shape. The filter allows you to vary the spacing in the etching and the degree of transparency and contrast.

I put the Paintbrush in Multiply mode and picked colors from the Swatches palette to change the colors in various portions of the image.

I still didn't see the drama in the composition I visualized when I first photographed this image. So I duplicated the layer and then ran the Glowing Edges filter on it. In the process, I went for a very wide edge. Once the new layer was rendered, I experimented quite a bit with Blend modes. The version I liked best for this instance was the Difference mode. And there you have it.

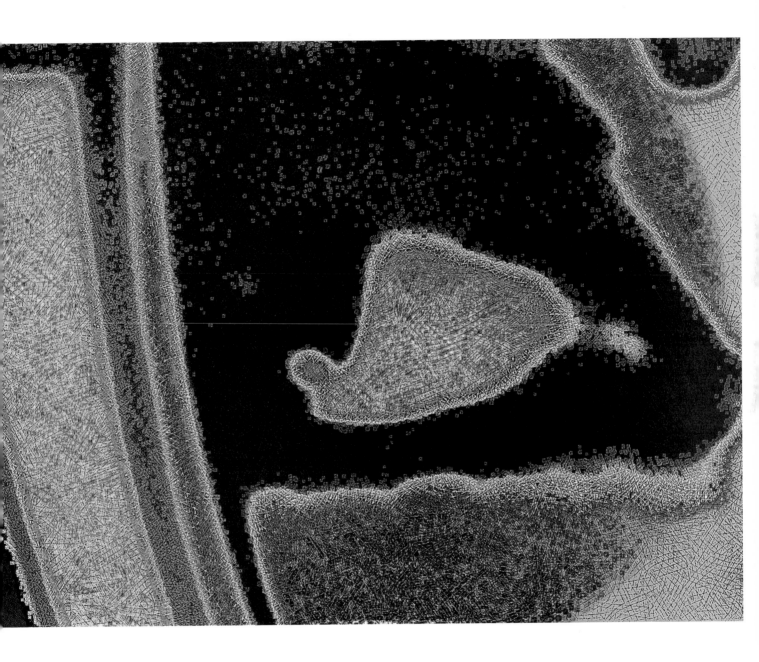

Night Bike

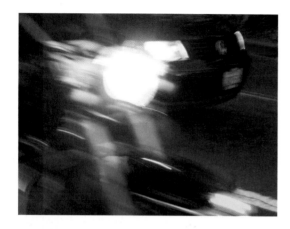

I knew I wanted a close-up of blurred passing headlights, and I lucked out when the cycle and the VW just happened to both be black, just happened to overlap, and just managed to time the camera's considerable shutter lag to coincide with their passing. The photo was hand-held at 1/8 second at f-8 at ISO 100 on an Olympus 5060.

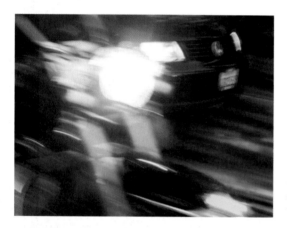

I created a new layer and then painted it with streaks of various colors taken from the Swatches palette. The result was blurred with the Motion Blur filter and then (to blend all the colors more smoothly) with the Gaussian Blur filter. Next, I made a loose Lasso selection on the vehicle layer, and then feathered it by 100 pixels. I pressed the Delete key to erase the contents of the selection so that the blurred colors showed through. Finally, I made a Curves adjustment layer that allowed the details in the black areas to show up a bit more. Then I used a layer mask in the curves layer to exclude the bright lights, which would otherwise have been a total washout.

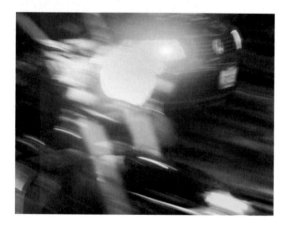

I still wanted the mood of this picture to be a bit more explosive. I decided to use a Lens Flare filter when I realized that the one in the KPT Collection provided many more choices for colors, aspect ratio, burst rays, and so on. So, using the KPT Lens Flare, I changed the color to match that of the VW headlight on the left side of the car. The one thing that still bothered me was the "ghosting" along the front edge of the VW, so I cloned it out to match the streaks in the street.

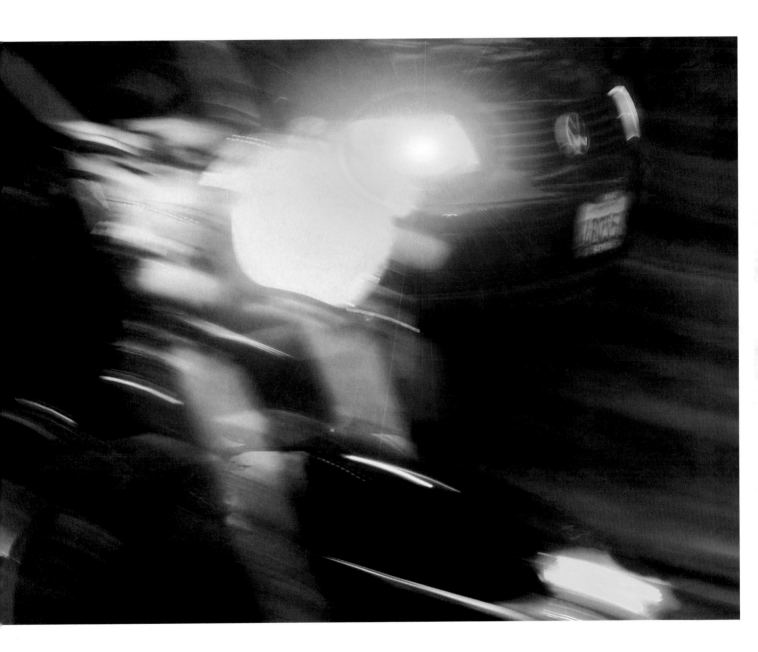

Disco Dancers

The image on the opposite page was made from a series of images that I shot during a rehearsal for a rock band that would be performing later that evening in a large gymnasium-turned-dance hall. What little light was available came from the engineers, who were just setting up and testing the lighting. I just concentrated on trying to get blurred silhouettes of the dancers—all girlfriends of the sound crew. At left, you see the shot that I decided to make the "feature" figure. Very important: As I knew that the figures would have to be placed off-center and re-sized, I enlarged the canvas of the original image so that I could make the images overlap to whatever extent would be necessary.

As I pieced the images back together, I erased away overlapping parts of the image with a large, fully feathered, semi-transparent eraser so that the overlapping portions of the image would blend together. Of course I would need to do a bit of retouching and cloning as the process moved along.

Once all three dancers had been positioned and their borders blended, I flattened the image and drastically changed the color balance with the Hue/Saturation command. I did this by simply dragging the slider until I liked the balance and dynamism of the colors—realism isn't really the point here. Because the D.J. was hidden in the course of overlapping the images, I re-opened the original image in which he was visible, re-sized him to put him further away, and then simply cloned him into place.

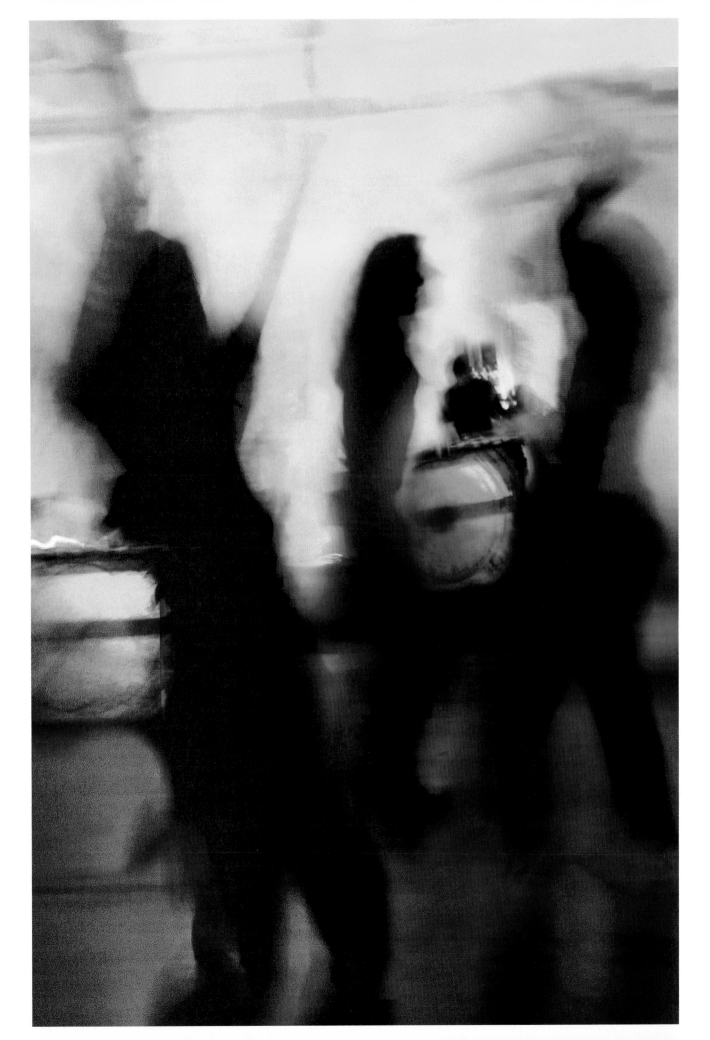

Coaster Blur

One of the reasons I included this picture (beside the fact that I think it works so well) was to stop people from e-mailing me to ask why I want to prove that every digital photograph deserves endless Photoshop manipulation. What you see here is exactly what I shot, exclusive of minor exposure and color balance adjustment in Camera RAW.

Well, okay. The other side of that argument is that there probably isn't any image that can't stand at least a wee bit of fiddling. So I burned in the lower-left corner with the Dodge tool. I timed it: seven seconds. You can see that it does to a lot to tighten the composition and pull your attention to the kids' faces.

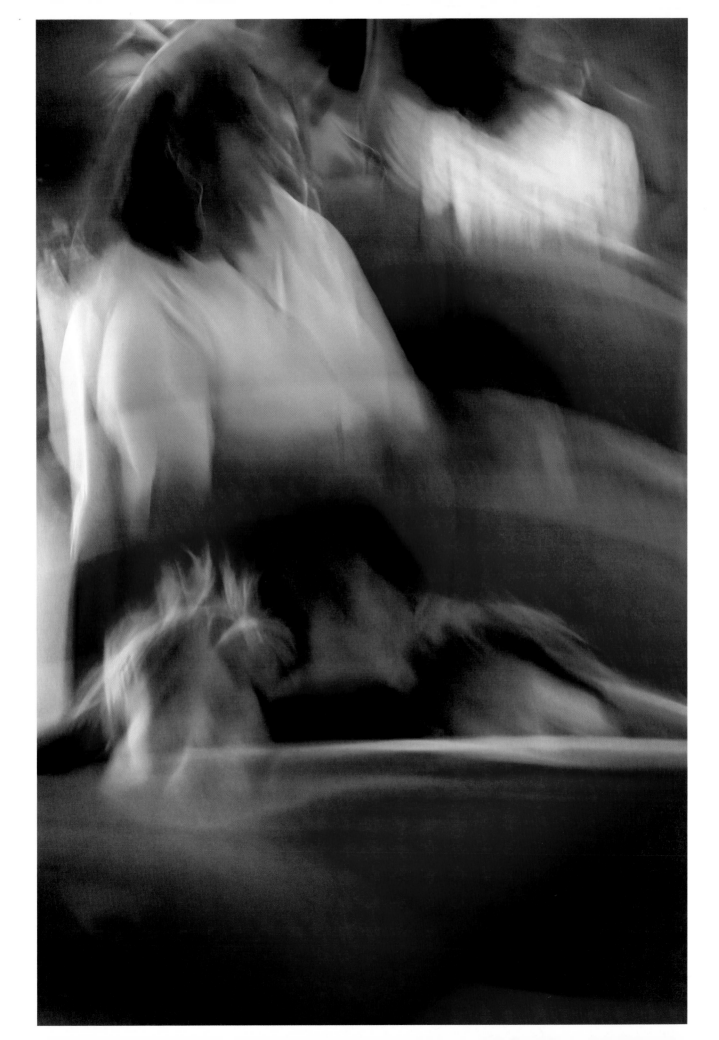

Flying Chairs

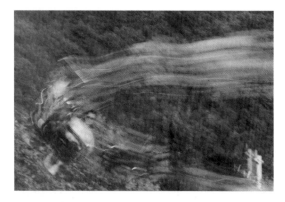

Amusement parks and county fairs are great locations for shooting blur abstracts. Always remember that a digital photo is free until you save or print it. Don't be afraid to experiment. If you don't like what you see when you preview or download images, just erase them. Nobody wants to be bored with your vision—least of all you. Sometimes, however, you can make something special—like the moment captured in this photo—a lot more special. As far as I'm concerned, there's just not enough contrast between the folks in the flying chairs and the background.

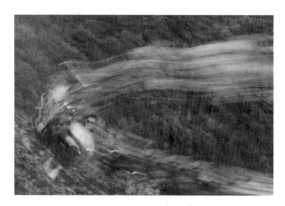

I wanted the blur to go to the edges of the frame on both ends. As it doesn't, I made a selection just outside the edges of the upper portion of the blur, feathered it by about 40 pixels, and copied the contents of the selection to a new layer. Of course, the rest of that layer was transparent, so I could re-position that blur to any place within the image. After I put it where I wanted it, I flipped it horizontally, so it's moving in the direction I want. I then Free Transform it so that its shape matches that of the blur at the bottom of the picture. Then I used the Erase tool to blend the edges of the blur with the surrounding image and then flattened all the layers.

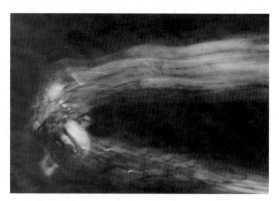

I started by Lasso-selecting the background slightly outside the blur, feathering the selection 100 pixels. Then I hid the selection without de-activating it so that I could see what happened when I used the Brightness/Contrast adjustment. I both darkened the background and flattened the contrast. Then I used the Motion Blur filter to add to the feeling of movement as well as to help disguise the shape of the trees. Finally, I continued to blend the blur with the background, using the Clone and Burn tools. Now I really like this image, but….

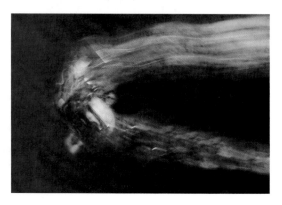

I increased the height of the canvas size by about 20%. Then I simply cloned in background and blur so that there is a little space left over at the bottom of the frame. Then I used a proportional marquee to crop the image to the same dimensions as the original. Then I realized that there wasn't enough space at the left, either, so I repeated the same process by making a little space on the left and cloning. It would've been a lot faster to add space on both sides at once.

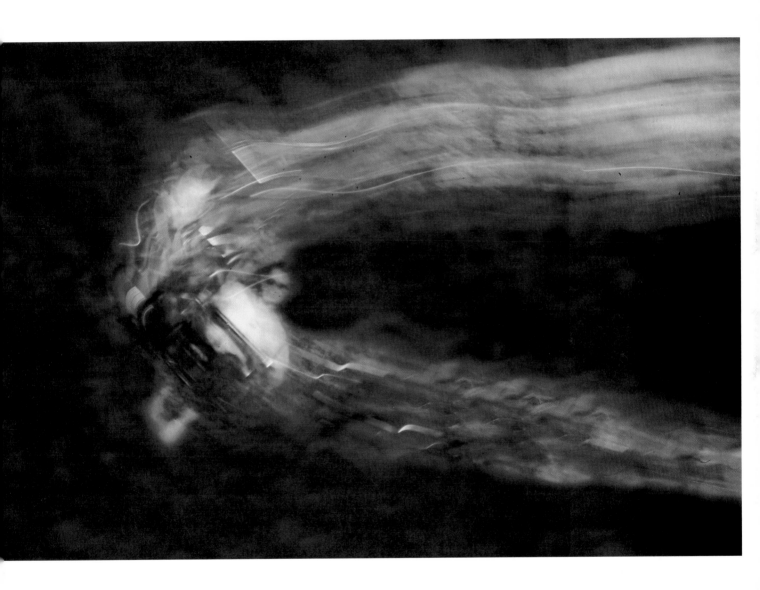

Rainy Day

This is what my camera saw as a "correct" exposure. Focusing on the moisture outside the windowpane required setting the camera on manual focus. Otherwise, the camera would have automatically focused on the background. The photo does do a nice job of demonstrating that blurring is a good way to focus interest on small details or textures. Thank goodness this was a RAW file—it would be easy to make exposure adjustments without losing any useful image data.

See? This image is purely the result of making the RAW histogram begin and end at its outer limits by reducing exposure. This retrieves all the detail in the highlights that would otherwise be blocked.

I wanted to make the water drops more obvious, so I tried using Quick Mask to paint a mask that reveals only the running drops. It was just too hard to see what I was doing, so I invented another method: I created a new, transparent layer and just painted over the water drops in black, using a maximally feathered brush. I then blurred the layer to make it blend even more and then cut the image to memory and threw away the layer. I then created a blank layer mask for the Brightness/Contrast layer, selected the mask, pasted in the layer I just cut, and then inverted it. Bingo! Most of the image's contrast returned to normal, while the water streaks became much more pronounced.

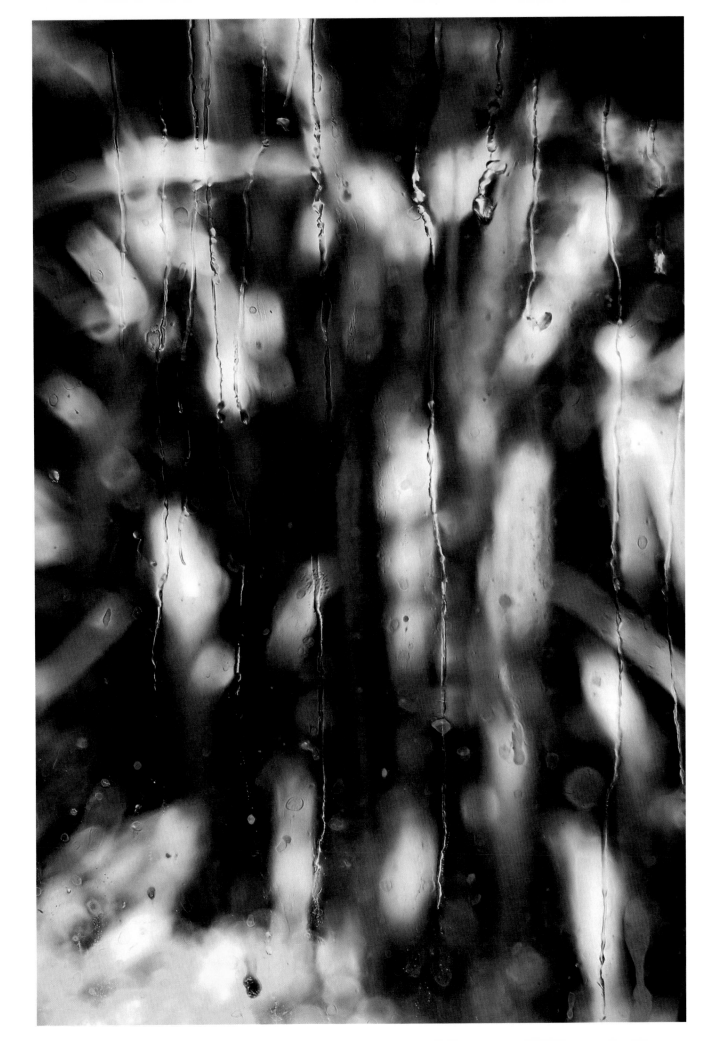

Blur Stack

The lovely thing about blurs is that they can easily be abstracts all on their own, without you having to do another thing to them. On the other hand, they really lend themselves to being composited with one another in endless ways. I picked this particular technique because it gives you a better idea of how the mechanics might work. I just randomly picked four different images, all of which were deliberately shot out-of-focus in order to provide possibilities for making abstracts or for combining images. The first thing I did was stack all the images into layers in a single file, and then re-size each so that they frame one another as I made each successively smaller. Nothing has been done to any of these images to adjust their colors or tonalities.

It struck me that they might be more interesting compositionally if I re-arranged their stacking order and sizes. Then I re-transformed the layers so that their borders would be even on all sides. I also changed the Blend mode of each layer until I liked what I saw.

Now, to give the image the look of frames within frames, I used two different tools. The square-cut frames were made with the Styles Layer capability in Photoshop. The frame with the rounded outside corner was made with the Rounded Rectangle tool, and the resulting path was turned into a selection so that the layer could be cropped to that shape. Then I used the Eye Candy 4000 Bevel Boss tool to give the look of a raised frame within the frame.

Bodies

ATM Inside

It is the body at the lunch counter, relaxing and watching TV, that seems to speak so eloquently about the message of the ATM inside. The original was shot with the Fuji Finepix S7000, a point-and-shoot digicam, at ISO 200 at 1/220 second at f-4.5 on the evening of a cloudless autumn day.

Working with a beta copy of Photoshop Elements, I had more appreciation for the value of organizing my workflow around the Elements Organizer; being organized made it easier to keep track of the various stages of image production. When you choose the image, it immediately opens in the Camera RAW dialog. Exposure, shadows, and saturation were my first adjustments to the image. In the Elements Browser, I applied all Smart Auto fix choices, which brought up a great deal more contrast and brightness in the shirt, as well as a great deal more detail in the restaurant's interior.

I wanted the neon ATM sign to be red, so I masked the ATM sign, then created a new layer and filled it with red. Then, in the Layers palette, I changed the mode to Darken, which resulted in a very natural-looking red neon sign.

The bright, napkin holder and menu at lower-right are visually distracting. I placed a Lasso selection around the area, feathered it about 200 pixels for a very wide blend with the background, then used the Brightness/Contrast command to darken the area to the maximum. It is possible to re-balance the color and tint, but doing so makes it less obvious that we're looking through a tinted plate-glass window.

Loving Clowns

This RAW file was shot during an art party. It took me a couple of seconds to realize why these guys weren't moving—they weren't party-goers, but a pair of costumed mannequins being shown as works of art. As they weren't moving, I was able to shoot hand-held at very slow shutter speeds until the preview monitor showed me that I captured a reasonably readable image. Once back in the studio, I made adjustments in both the RAW converter and the Photoshop Elements 3 Quick Fix mode that brought up quite a bit of additional detail in the shadows. I also adjusted the color balance enough to reduce the overall redness in the image.

To give the image a more textured, painterly feeling, the Filters Gallery was simultaneously applied to the Colored Pencil and Plastic Wrap filters. At this point, there needed to be more motion and excitement in the images.

I added a new layer above the background image. Then I chose a very large and highly feathered paintbrush and painted on the layer in bright colors. A feeling of motion resulted when I used the Motion Blur filter, set to blur across about 400 pixels. Finally, I set the yellow-painted layer to the Screen Blend mode.

The image looks a bit more "underground," with the ripped edges that I created with the Alien Skin Edges filter.

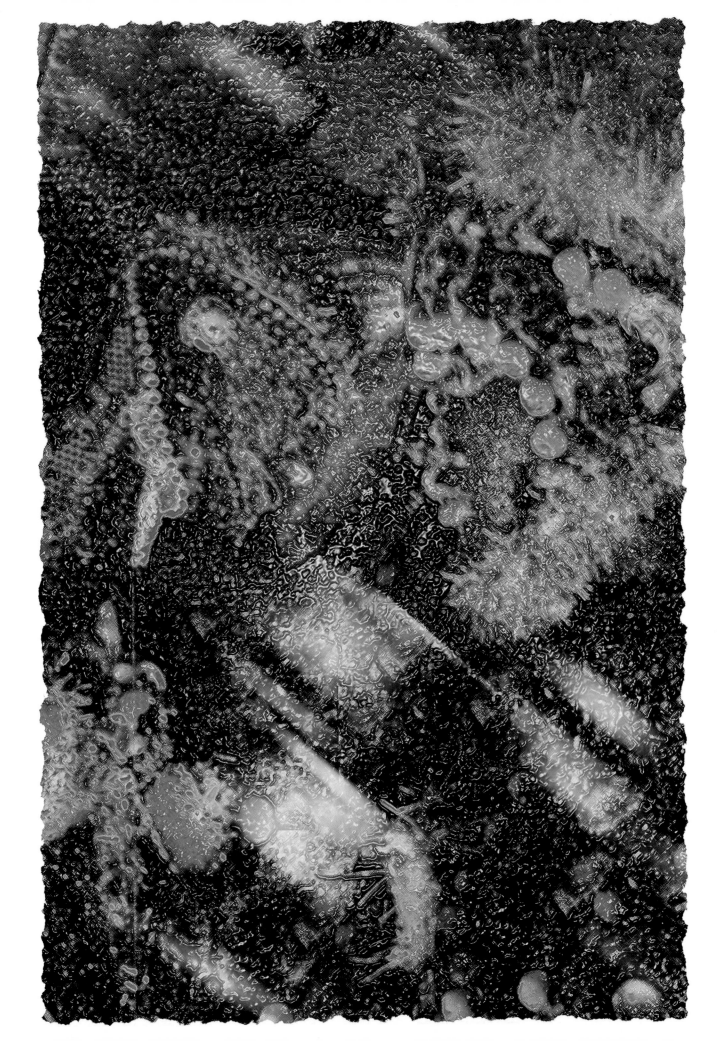

Arm in Arm

This is the way the untouched RAW file looked after it was shot, hand-held, at the same party as the mannequins in the "Loving Clowns" picture.

Here is the same image, after careful adjustments in the RAW editor. Now it looks a bit "Rembrandt-ish."

I saved the image in Photoshop and re-opened it in Corel Painter. To make the image look like a classic Impressionist painted it in a hurry, I used the Camel Hair Impasto Cloner. After quite a bit of experimentation, I export the image back to Photoshop to get the colors I wanted. There, I duplicated the layer and filtered it with Chalk and Charcoal (background and foreground colors taken from the painting). I duplicated the background layer again, and then used the Hue Blend mode on the Chalk and Charcoal layer. Next, I merged the top two layers and erased through portions of the image to let the Painter image show through. I also retouched the thin red streak that was in the two images you see above.

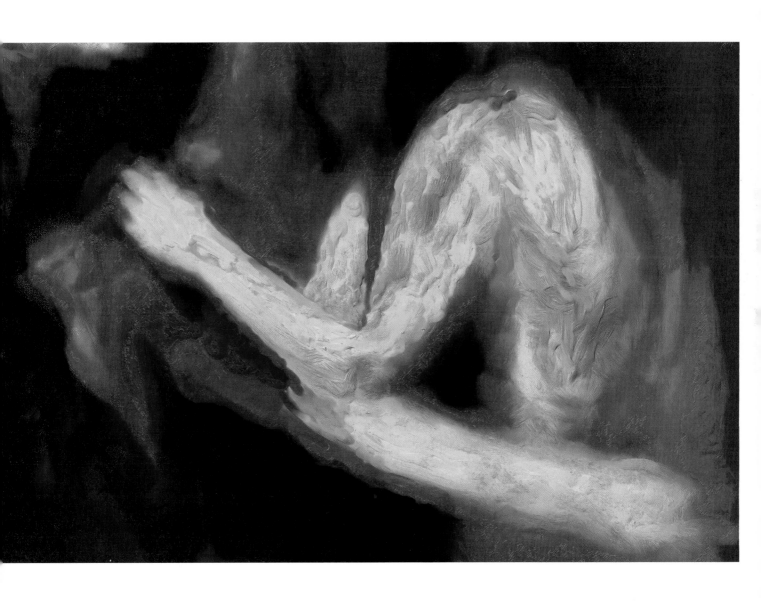

Backtoo

When it comes to abstracting the human body, I must confess that I have a fascination with tattooing as a means body decoration. This abstraction started life as a snapshot taken at a street party. As far as I was concerned, the first step to making this an abstraction was cropping the photo and retouching it so that all you see is the feminine blonde hair and the tattoo.

Here you can see the result of my cropping the image as much as I could without losing too much of the tattoo that was going to be the point of this abstraction. I then used the Brightness/Contrast command to darken the top portion of the image within a highly feathered selection. I still wanted much more graphic drama in this image.

I duplicated the layer above, used the Equalize command, then inverted the image to a color negative, and then used the Difference Blend mode on the duplicated layer to unify the colors and shapes. Now I had a much more cohesive visual. I just wanted to smooth the skin tones.

First, I used the Dodge tool on the darker skin tones to bring them up to the same general brightness as the lighter skin tones. I then duplicated the Background layer and changed the new layer's Blend mode to Soft Light.

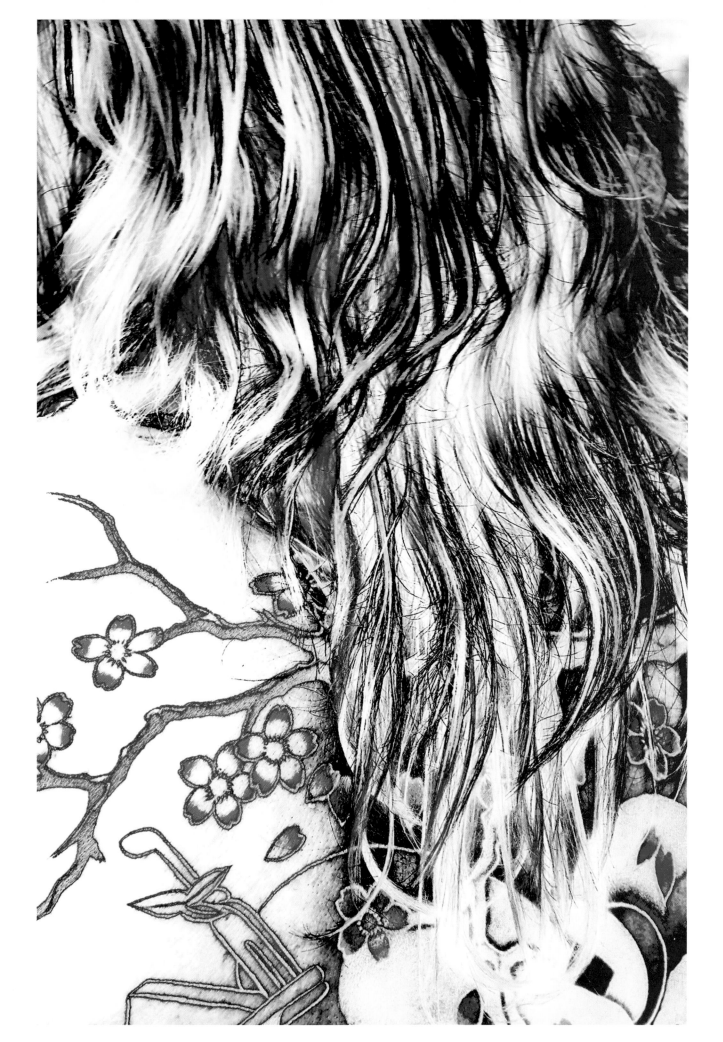

Salsa

I was walking down the beach boardwalk in Santa Cruz when I come across a small, outdoor beer bar where an outdoor salsa-dancing lesson was taking place. I was immediately fascinated with the idea of turning this scene into an abstract symbol of the spontaneity and energy in dance. I wanted to see this expressed in bodies, not faces, so I used what I call "decapitative cropping." Here's the frame that seemed to get across the idea that this was a crowd, rather than a pair or two of dancers. It also captured that feeling of energy and spontaneity that I was looking for. Of course, in this state, it would be stretching it to call it an abstract.

To make the image more of an abstract graphical study, I used Buz Pro's watercoloring capabilities, and applied a Curves adjustment layer to add contrast and apparent saturation. There still was not enough painterly abstraction here to serve my vision.

I just kept tweaking. It is more graphical to add some edges, so I created a new layer and then treated it with the Photoshop Charcoal filter. Then I used the Darken mode, so that only the charcoal outlines are seen over the original image—but there were so many dark colors in the background image that they hid too many of the charcoal outlines. To fix that, I lowered the Fill of the Background layer to 50%. Then, of course, the colors were too washed out, so I used the Curves and Hue/Saturation adjustment layers to get the result I was looking for—though I'd still like to see a few more "freehand" outlines. Before the image was finished, I had to use six layers: the white background, the image, Charcoal, the added lines, Curves, and Hue/Saturation.

Here's the final result. On the same layer that I used to add the black "charcoal" lines, I airbrushed in a bit of white to lighten the foreground and to pull your eye into the dancing feet.

Climbing the Wall

The "rock" patterns on the climbing tower and the depth of the late-afternoon shadows cried out for me to do more to make this image an abstraction. I was also impressed by the intense concentration this young climber was putting into his ascent. What I didn't like was the fact that the shadows were so intense that they left very little detail.

First, I used the Shadow/Highlights command in Photoshop CS to pull more detail into the shadows. I had to do a pretty fair amount with the Tonal Width, Highlight, and Midtone Contrast sliders to get the visual effect that I was reasonably happy with. The black section of the image to the right of the climbing wall also detracted from the composition and pulled the viewer's eyes away from the climber. I simply used a very soft-edged brush and cloned other sections of the wall over the gap until it no longer existed.

To make it a bit more of an abstraction, I decided to make the image black and white. Then it struck me that the sepia-tone effect would be even more appropriate, so I decided to use the nik Color Efex Pro Paper Toner filter and then choose the sepia-tone sample.

I thought it still needed more in the way of abstraction to make the drama come from the patterns of light and shadow. I could have used natural media painting tools to do this, but there are already so many images in this chapter that have been treated that way, and this subject was so photographic, I decided another tool, a highlight blurring filter, would be more appropriate.. However, when I tried that effect, I discovered that I lost too much of the pattern that defined the climber. So I first made a highly feathered selection around the darker portions of the climber, then used Brightness/Contrast. Now the use of the Andromeda Scatter Light filter is far more effective than before the climber was excluded from the effect.

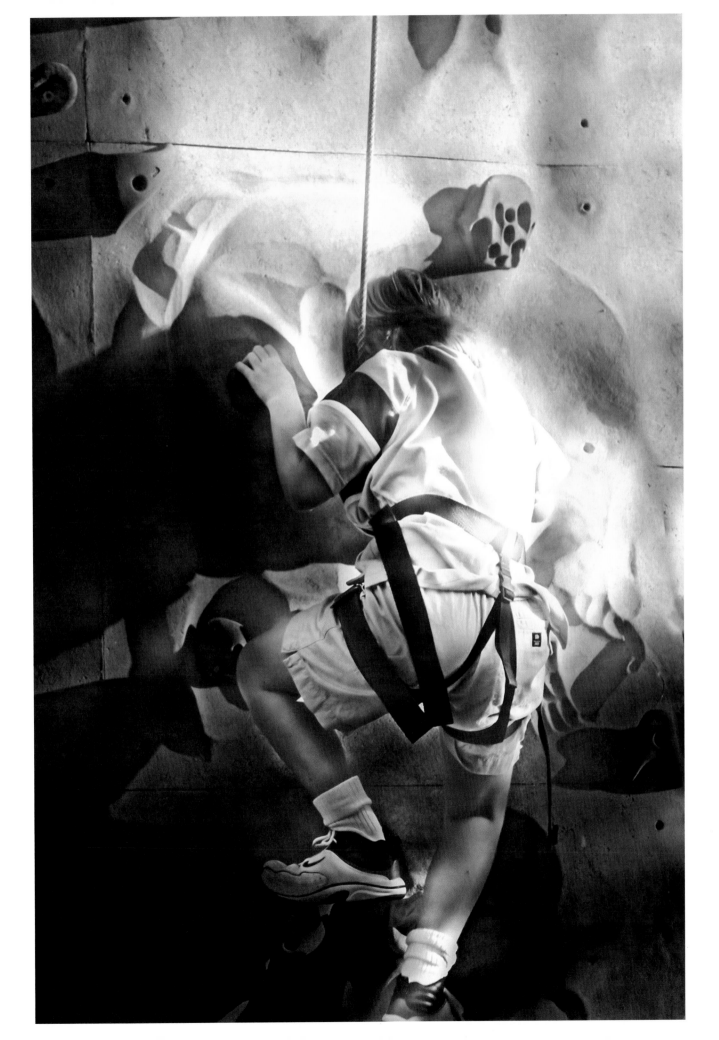

Foto Gal

When I work on abstractions of the human body, I usually focus on the intensity of the activity that the body is engaged in, and on "body language." Those messages come across with more strength when the identity and personality of the individual whose body is expressing that language is not a factor. Abstraction helps with that. In the case of this image, identity was not a problem because my photographer friend's face was hidden by her camera. The painting is typical of the sort of underground events we often photograph.

I used a very slow shutter speed and wide-open aperture at ISO 1600 because of the very dim nightclub lighting conditions. When I opened the image in Photoshop, the photographer was still in deep shadows. I used the Magnetic Lasso to precisely select her body, then feathered the selection by 40 pixels so that the adjustments I made on the selection would blend smoothly with the surroundings. Then I used Auto Adjust to properly handle color balance, brightness, and contrast in a single click.

There are times when the Curves command is just too clumsy to get the subtleties in contrast that I want to impose on various parts of the picture. At those times, I find the Equalizer filter in the Corel KPT Collection to be a lifesaver. The Equalizer filter looks like an audio equalizer with sliders for each of nine regions of brightness. You can interactively see the result of adjusting these sliders, so you know when you're happy with what you see. Here's the result.

Next, I used the Buzz Pro plug-in to make the above version of the image strongly resemble a watercolor painting. However, I did so knowing that the feeling of a watercolor was not the end result I was looking for because it didn't give me the "pop-art" feel of the event I was covering. I duplicated the watercolor (Background, in this case) layer and then used Photoshop's built-in Find Edges – Color filter and immediately used the Equalize command to give all the edges an equal amount of color intensity. The result was interesting, but too abstract, so I used the Overlay Blend mode on the top layer to get just the mix of edges and watercolor painting that I was looking for. The "pop-art" painting you see at left is the final outcome.

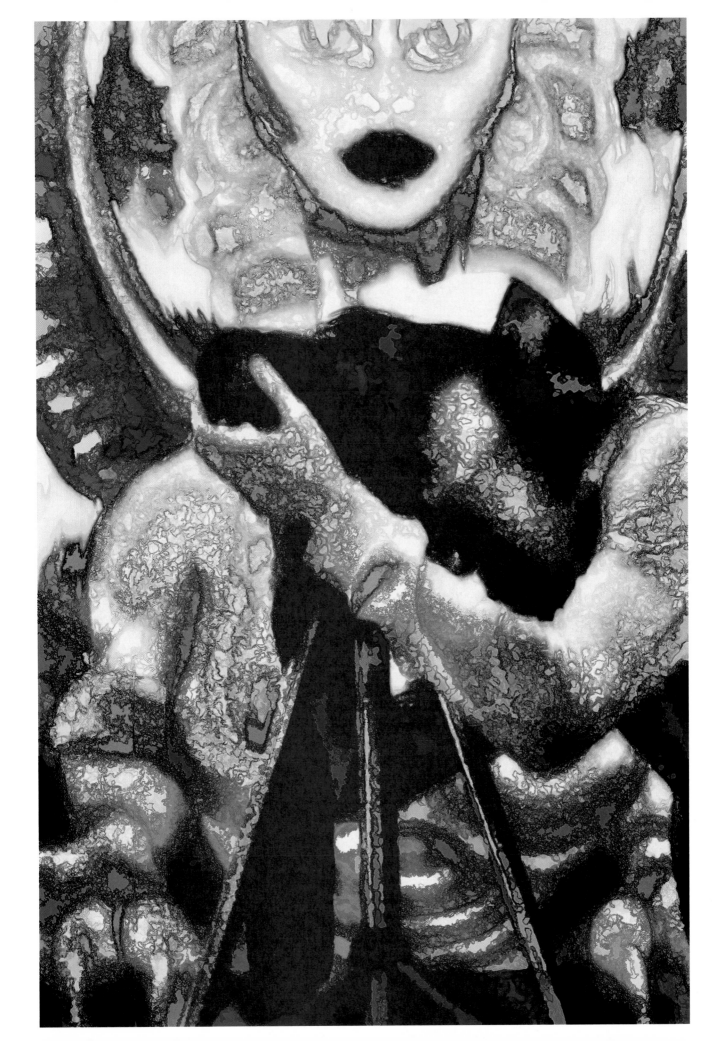

Lion Arm

The haircut, earring, watch, jewelry, and sleeveless t-shirt all paint a strong portrait of this person, even though we can't see his face. I wanted to abstract the photo in order to emphasize each of those elements in a more dramatic manner than the photo alone would suggest.

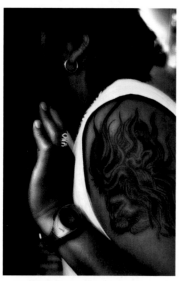

I used the KPT Equalizer to dramatize tonalities in the image. It really makes the tattoo speak to the viewer. I also used the Motion Blur filter to "smear" the image behind the subject's head.

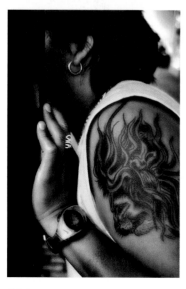

I was looking for still more drama and a bit more refinement, but I definitely wanted to keep this image photographic rather than "painterly." The subject is so gritty that the most effective way to communicate the feeling I wanted from viewers was to emphasize that grittiness. I added a Curves layer, with the result you see at left. The only downside was that the t-shirt went stark white on me; I just used the Eraser tool at 100% with a soft-edged brush to "paint away" the top layer.

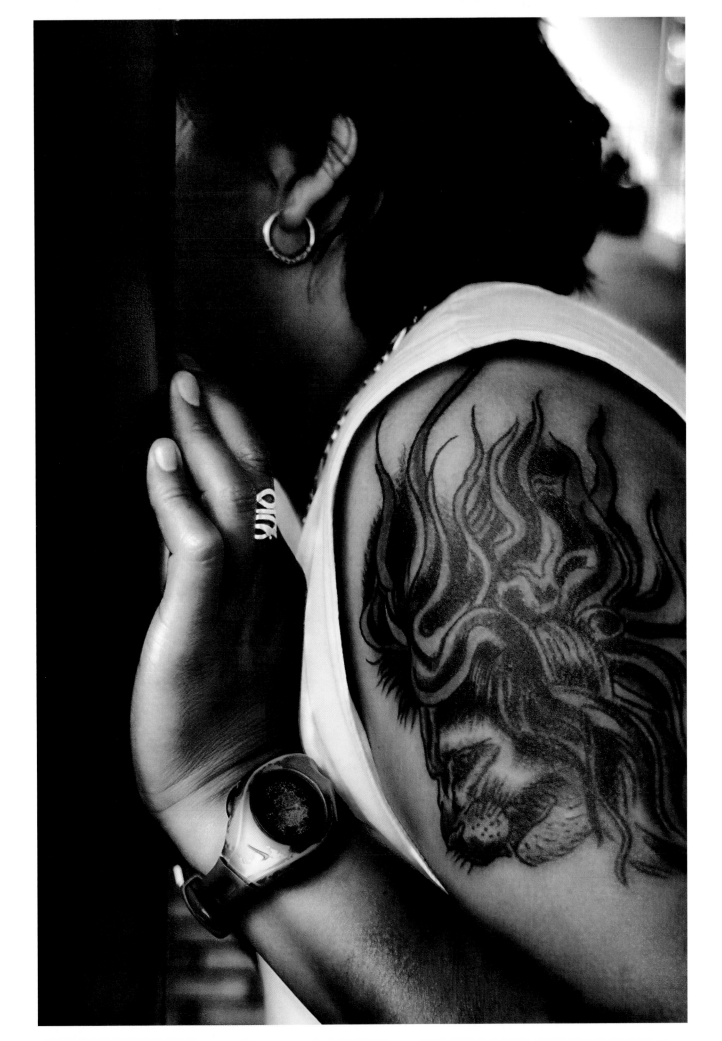

The Rub

Talk about body language: The strength of the masseuse's hands and the effort she is putting into relaxing the muscles of her client are all very apparent. Once again, the message has nothing to do with personages or personalities. Mainly, I wanted to emphasize the lines, textures, and both the strength and grace of the composition.

The first thing I did was to experiment with the KPT Equalizer filter's contrast sliders. I also wanted to darken the white blouse and lowered the highlight sliders to give me a start in that direction.

To bring out the texture of the image—and especially the strength of the hands—I re-used the KPT Equalizer. This time, however, I used its Contrast Sharpen capability to make all of the edges stand out even more graphically. Also, found the white blouse pulling my eyes too strongly toward the upper right of the image, so I used the nik Color Efex Pen tools (for use with pressure-sensitive tablets) to "paint" the blouse an orangey-tan color that seems to make the masseuse's arms more an extension of her body.

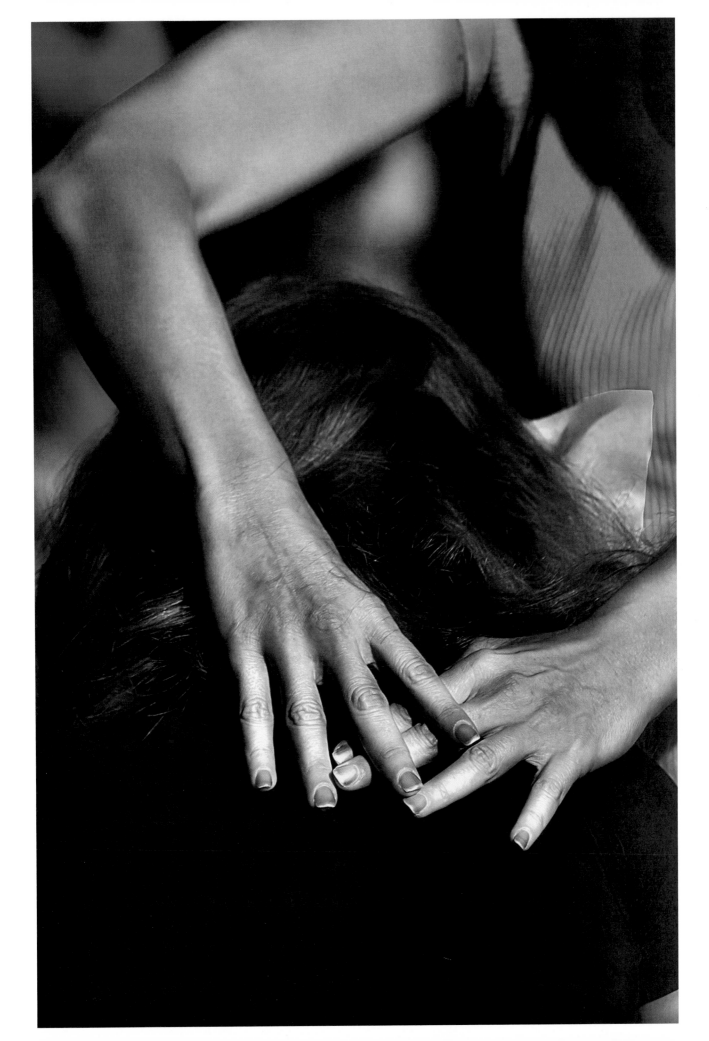

Chow Down

The shape of the body, the quantity of food, and the relaxed sunset lighting all contributed to my desire to document and illustrate the wholesome appeal of dinner at a street-side farmer's market.

I used a pre-set in the KPT Equalizer called Notched Blur to simultaneously over-sharpen and blur the image. The result was intensely graphic while being almost dreamy in its grittiness.

To make this image even more graphic, I used a plug-in from Xaos Tools called Segmation. Segmation creates smooth-edged color reductions that strongly resemble watercolors; this is somewhat like you get with Buzz Pro, but you also have the option of having the program outline the individual segments for a very different look. Once the Segmentation image was created, I copied it to the clipboard and added it as a layer above the image you see above. I reduced the transparency of the Segmentation layer and then used the Eraser tool on that layer to show the food more realistically, as a contrast to the rest of the image.

In Her Arms

It was the feeling of love and care that I wanted to get across in this abstract—the warmth and softness of the puppy's mistress' skin and body in contrast with the softness of the animal's textured fur.

After using a Curves adjustment layer to strengthen the tonal values, I used the Extract filter on a duplication of the background layer to separate the woman and dog from the other sideline spectators. I then played with the Gaussian Blur filter on the background to give it just the degree of softness that I wanted. In the process of doing this, I noticed quite a few freckles on mommy's skin, which I decided to take out with the Healing Brush. I also selected the blurred background layer and darkened it with the Brightness/Contrast command. Finally, I painted the woman's shirt blue to match her jeans.

To put the emphasis on the dog, I ran the Diffuse Glow filter on a duplication of the background layer after flattening the image. Of course, this completely removed the texture of the hair (as well as the character) of the dog. But as I'd preserved the background layer by duplicating it, all I had to do was use the Eraser tool to erase through to the original image of the dog. The Diffuse Glow filter considerably lightened the blue shirt, so I darkened it a bit with the Dodge tool. I also used the Patch tool to remove a wrinkle in the woman's neck and used the Dodge tool to darken her chin slightly.

Finally, I helped the viewer focus even more on the dog by placing a dark vignette around the outside edges of the image.

Bride of Death

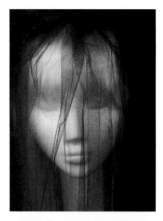

This was a pre-Halloween window display for a clothing store. It seems appropriate that this image was taken at night. The colors seem appropriate, too.

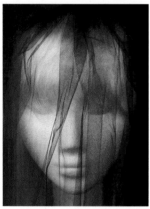

The first thing that struck me was that I wanted to fill the frame with the face; I first straightened the image with the Free Transform command. Then I cropped the image to the same size as the original by stretching the transformation handles *outside* the original image frame. When I finished the transformation, I selected the entire image, then used the Crop command to trim all the image information that has been dragged outside the boundaries of the original image. Then, since transformations always result in some softening of the image, I used Photo Wiz Focal Blade to increase overall sharpness.

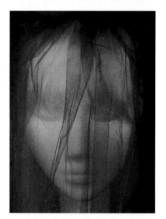

Next, I created a new, transparent layer above the background layer. I then chose a large, soft-edged brush and set its Opacity to around 30% so that I would still be able to see through the colors. I picked different primary colors and dabbed one color in each quadrant of the image. The result was pretty, but not quite eerie enough, so I simply dragged the Hue/Saturation dialog's Hue slider back and forth so that I could interactively watch the transformation of colors. When I found this combination, it felt just right.

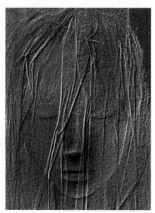

Next, I wanted to make this really abstract—as though it were carved on a tombstone. I selected the original layer, chose the Emboss filter, and really cranked up the sliders for an obvious effect. I then dramatized the effect even more by using a Curves adjustment layer with a very steep S-curve. I also added a Hue/Saturation layer to the top of the layers stack so that it would to affect all the other layers, cranked up the saturation, and tweaked the Hue slider a bit more. You can see the result at left and on the facing page.

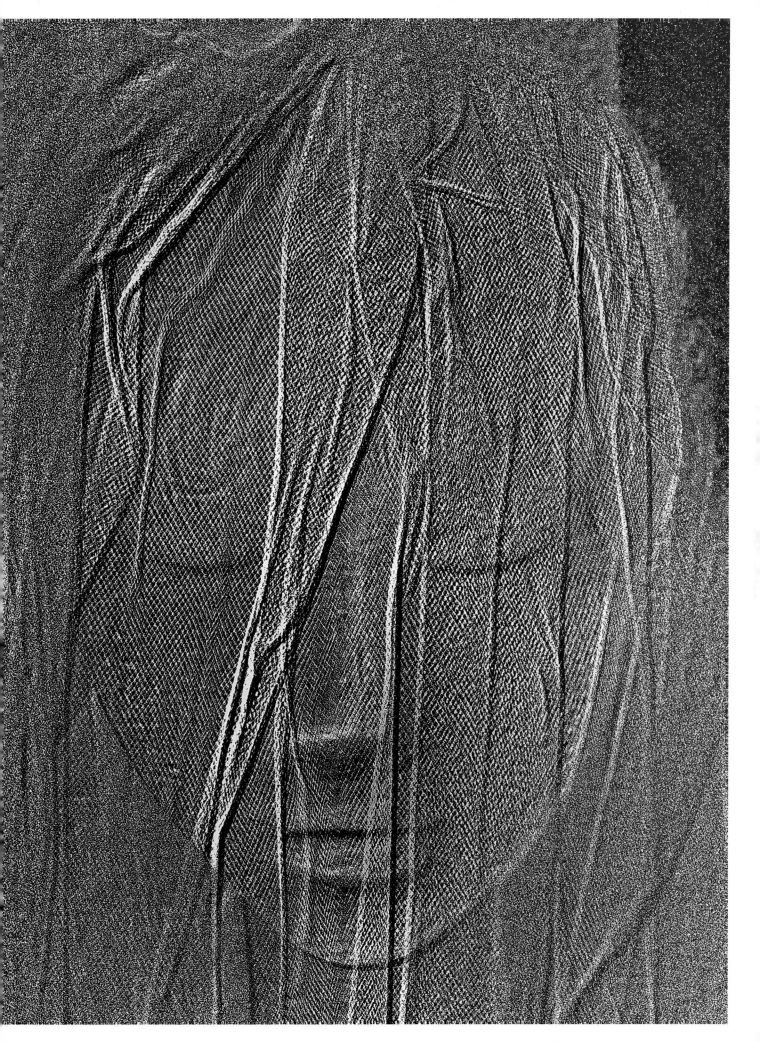

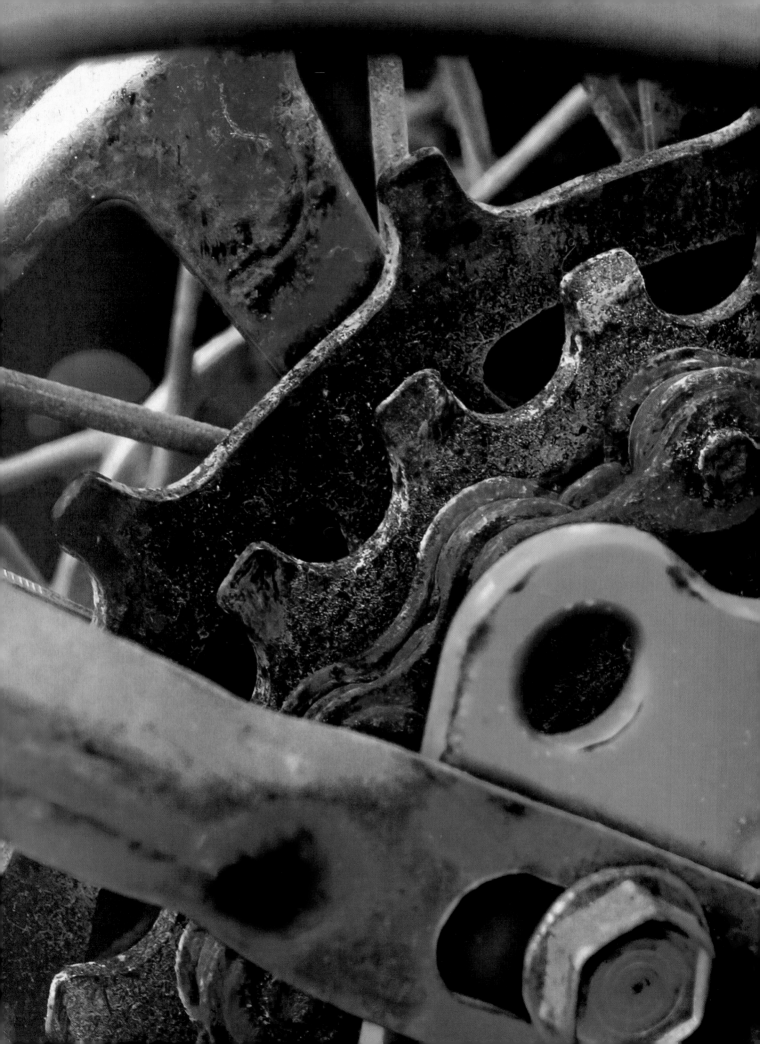

Macros

Lily

You could spend an entire photography career (and probably make good money) hanging out at sidewalk flower stands and photographing the beautiful flowers. You'd find an endless variety of colors, compositions, and workable treatments. You wouldn't have to spend a lot on travel expenses, either. To make this photo, I used the Casio EX-P600 in macro mode, hand-held at 1/20 second at f-3.8 zoomed to a 100mm film equivalent. Using an actual full 35mm frame at this f-stop would have resulted in an almost entirely out-of-focus image, except for the center pistil. Unfortunately, the picture had to be considerably underexposed because I couldn't imagine holding steady at any slower shutter speed. The image at left was corrected with a Levels adjustment layer. It was a big improvement, but somewhat lacking in contrast.

Next came the standard noise removal and sharpening. I then added a Curves adjustment layer to boost the contrast in the image. Also at this stage I made a Magic Wand selection of the two light blue segments in the upper-right corner and darkened them with the Brightness/Contrast slider. Then I used the Clone stamp to carefully blend the edges of the selection so that it looked totally natural.

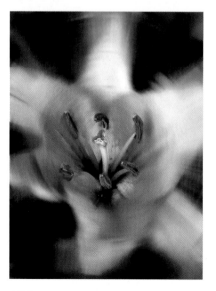

To give the image the truly "in your face" impact that I wanted, I used three of the filters in the KPT Collection of plug-ins. First, I duplicated the background layer twice and turned off the top layer so I could see what was happening when I used the Spin Blur on the second layer. I then used the Eraser to erase the central part of the blurred image. Next, I selected the top layer after turning it back on and applied the Zoom Blur. On this layer, I erased everything but the outermost portions of the layer. The effect was that the spin seemed to zoom as it reached the outer edges. Next, I flattened the entire image and applied the KPT Equalizer.

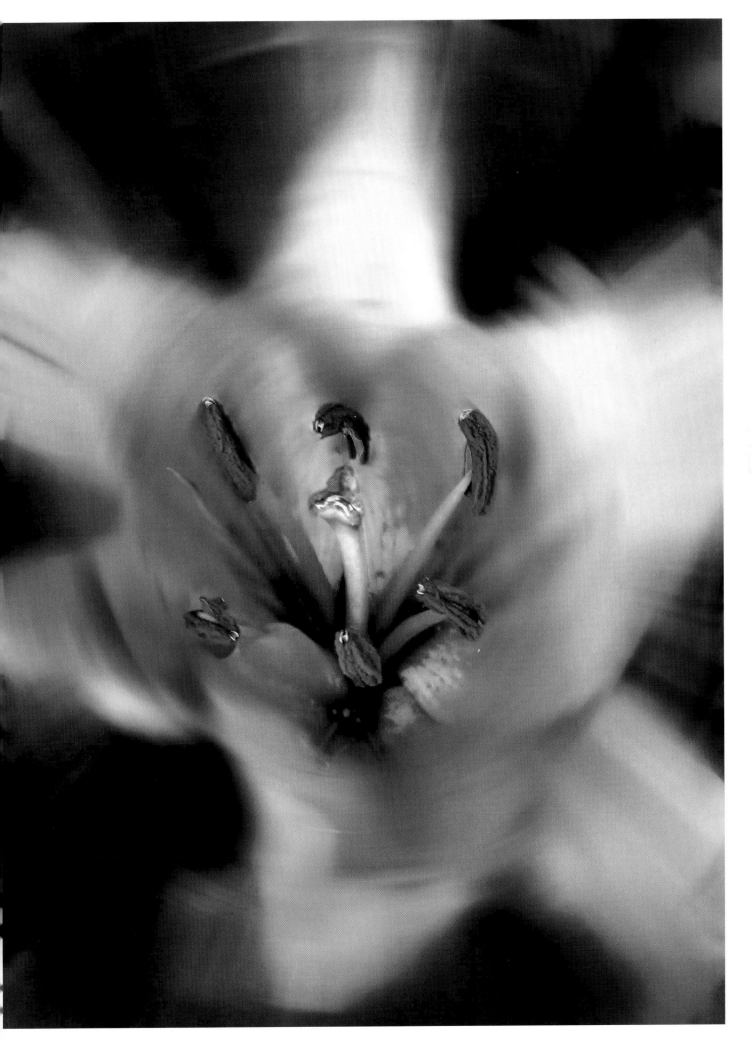

Gerbera Daisy

This is another Casio EX-P600 photo shot in macro mode. I strongly recommend that you shoot macros with the camera mounted on a tripod. This was in perfect focus, but it's very difficult to keep the camera at the same distance when distance is so critical. So, despite the 1/250 second shutter speed, the image is more than a little on the soft side. I did reduce noise, using nik Dfine, then sharpened with Power Retouche Sharpener. I also adjusted contrast and brightness with the Curves command.

I still didn't think the image was crisp enough to stand on its own. I was tempted to see what happened when I used a Find Edges filter—then I discovered something much better: Power Retouche Edgeline. It's like having a Find Edges filter that lets you control the thickness of the edges in combination with a Threshold filter. You can make the adjustments interactively until you like what you see, and then apply them. Here's the result. Before I applied this, I duplicated the Background layer and applied it to the duplicate. I checked the Transparent Background box, so you can see the underlying layer.

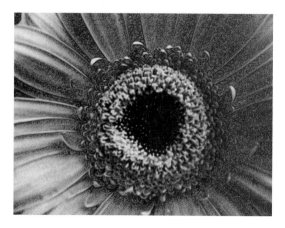

Believe it or not, this is the same image after I added the Saturation Blend mode and a steep Curve layer. As a finishing touch, I flattened the image and cloned some texture from the petals into the two dark holes at the left. I also placed a feathered selection around the light circle of pistils at the center and gave a big boost to contrast with the Brightness/Contrast adjustment

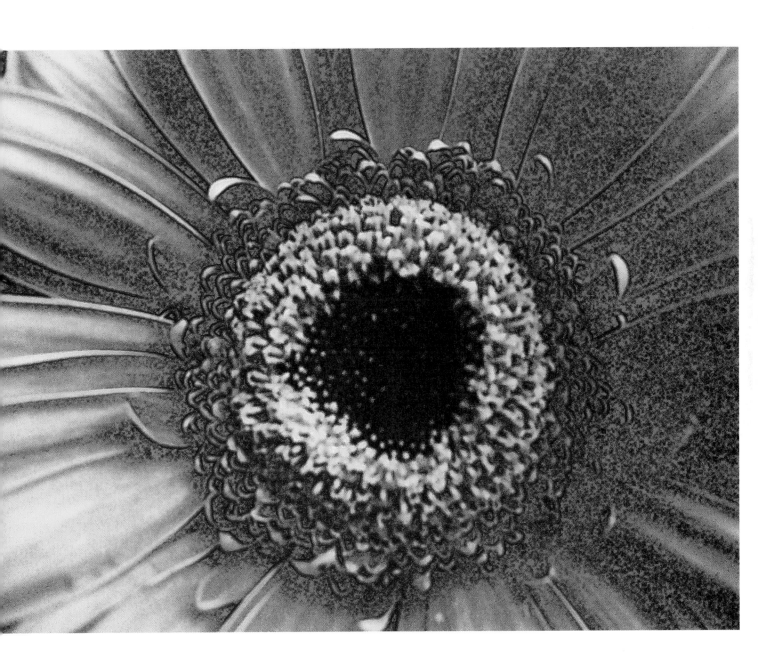

Leopard Leaf

This is the original image from the JPEG file. This crisp and detailed macro was a hand-held at 1/200 second at f-3.7 and an equivalent focal length of 89mm. On the one hand, it's amazing how much depth-of-field there is at such close range, particularly considering the wide aperture. Still, the hard thing about shooting macros hand-held is maintaining a steady distance from the subject. Even with extended depth-of-field, focus is critical.

I loved the texture and warm colors in the leaf, but the background was so bright that it drew attention away from it. So first, I selected the shape of the leaf with the Magnetic Lasso tool, then I feathered the selection by 30 pixels and inverted it. Next, I created a Brightness/Contrast adjustment layer and both lowered the contrast and darkened the background. Then I selected the Background Layer and used the Burn tool to darken some of the small berry buds that surround the leaf. I also did a bit of cloning here and there to cover colors in the background that were distracting. Finally, I just wanted a bit more apparent separation between the left edge of the leaf and the background. I entered Quick Mask mode, filled the mask with Black so that it shows a solid red mask (rubylith), and then carefully painted along the edge with a thin, white brush. In normal mode, I could see the selection and could adjust the edge contrast with the Brightness/Contrast command.

Environmental Clash

This is trash left on a sidewalk after the recycling crew had come and gone. I took the photo because I felt there was a message in the rough, hard concrete and the remnants of nature and man that are tangled together here. I had to do a wee bit of burning to even the brightness of the sidewalk concrete after I made the usual adjustments in the Camera RAW dialog.

Just to boost the feeling of environmental unfriendliness, I used the Extract filter to separate another macro photo that I actually took a few feet further down the same sidewalk. I then used the Transform command to reduce the cigarette to the right scale for this image. I made the shadow by duplicating the cigarette layer, locking its transparency, then filling it with black, which creates a silhouette of the cigarette and the tobacco. Then I used the Move tool to drag the shadow away from the cigarette in a direction that matches the rest of the shadows in the image. I then lowered the opacity of the layer's fill so that the black shadow shows as much of the sidewalk as the other shadows in the picture.

The last stage was to add grit and color to the pavement. I made the sort of loose selection around the edges of the image that one might make for a vignette. I saved the selection so that I could use it twice. First, I used it as a Layer Mask for a Hue/Saturation adjustment layer. The Saturation was bumped about halfway up so that you start to see color in the granules in the sidewalk. The Hue was changed slightly to make the color even more obvious. Brightness is brought down so that the image also becomes slightly vignetted. Next, I selected the Background layer and recalled the original selection, then duplicated the contents of the selection to a new layer. First, I put the new layer into Overlay mode. I then used the High Pass filter and dragged its slider to the right until the edge sharpening of the grains was really exaggerated. And there you have it.

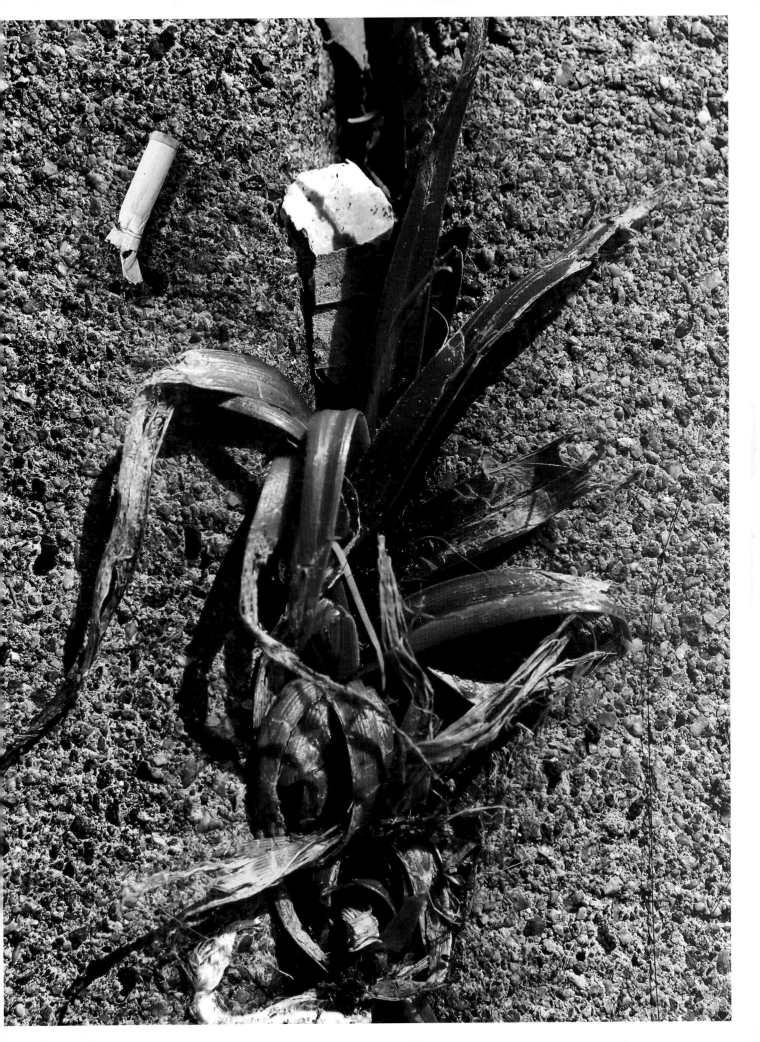

Sticky Business

These are the thorny edges of cactus leaves, photographed at a distance of about four inches (my guess—Olympus' C-5060 didn't record focusing distance metadata). A 4X close-up lens was attached to the filter holder. This time, the camera was on a tripod and I used no sharpening at this stage. I mention that because you can see how much crisper the image is than the hand-held macros that precede it in this chapter. Even when hand-held images look crisp, they suffer by comparison. Speaking of sharpness, most of what appears to be heavy grain or digital noise is, in fact, the texture of the leaves themselves when they're in very sharp focus.

To intensify the dynamic range of the image, I used a Levels adjustment layer, dragging the Highlight and Shadow sliders to the point where that end of the histogram starts to rise. Then I brightened the image by dragging the Midtone slider. Then I added a Curves adjustment layer to dramatize the difference between the tones in the image. I also selected, feathered, and darkened the leaves in the background at left after I realized that they were brightened by the Curves layer.

This image felt a bit surreal to me, and I wanted to add to that feeling without losing image sharpness or the strength of the graphic lines. First, I used Flaming Pear's Glare filter to both put a brightened glow along the most "dangerous" edges and to increase the image's overall color saturation. Then I used The Imaging Factory's Color Equalizer to bring a purple haze into the scene.

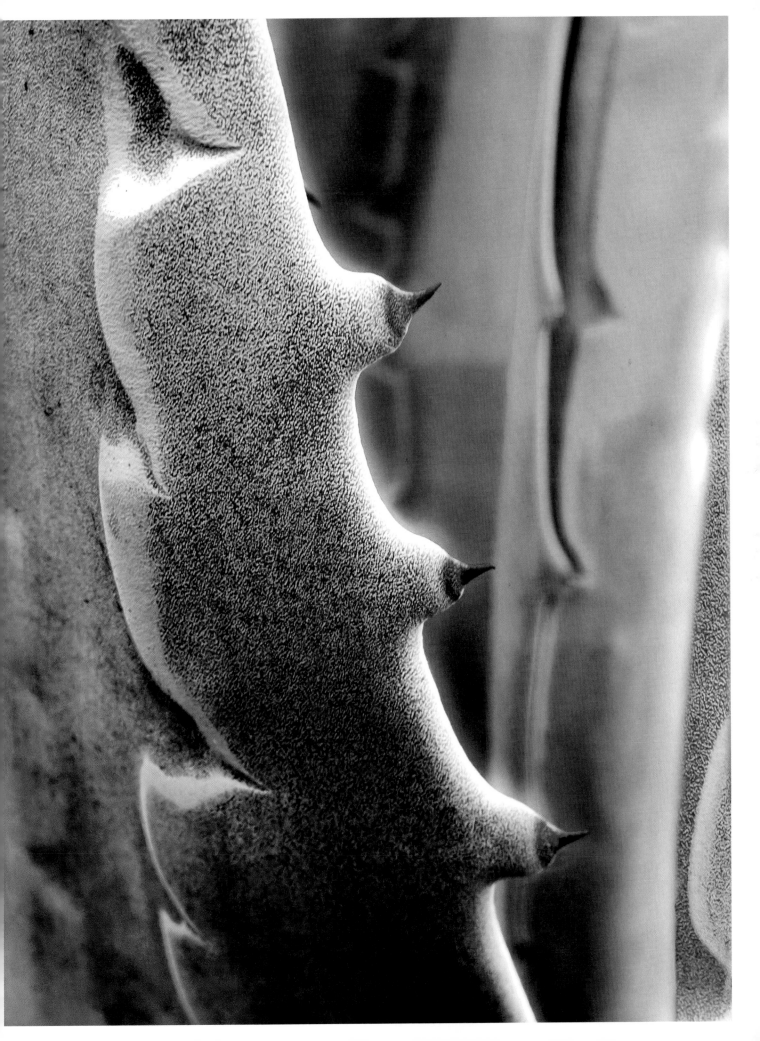

Succulent

This delicate looking succulent was also photographed with a tripod and a 4+ close-up filter. What you see here is little modified from the original. I did use a Curves layer, however. I loved the shapes of these leaves and the lighting, but I was not happy with cropping, composition, and background.

I used the Free Transform command to rotate the image and then enlarged it beyond the original borders until there were no gaps showing. Then I used the Select All and Crop commands to trim the result to the image's original size. Also, because I lost sharpness in the process of making the transformation and because I wanted to emphasize texture and shape, I used Power Retouche Sharpener to snap things up a bit.

Next, it was time to substitute a more interesting background for the boring green wall that was there. I used a close-up I made of the textures in another cactus taken at a different time and location. I simply used the Extract filter to knock out the current background wall, then dropped the other image in place as a layer and scaled it to show only what I want the viewer to see. The background image was also darkened and blurred, both to separate it from the foreground and to hide mismatched grain and noise patterns.

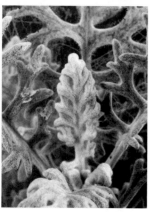

Next, to give the image a bit more depth, bounce, and texture, I used the KPT Equalizer. I then placed a selection around the most distant part of the leaves, feathered it 40 pixels so that the next step will blend smoothly with the surroundings, and used the Lens Blur filter to throw the big leaf in the background a bit more out-of-focus so that it didn't compete with the smallest part of the leaf (which actually looks like a miniature of the whole structure). Once that was done, I also used the Burn tool to darken the background in order to make the foreground stand out even more.

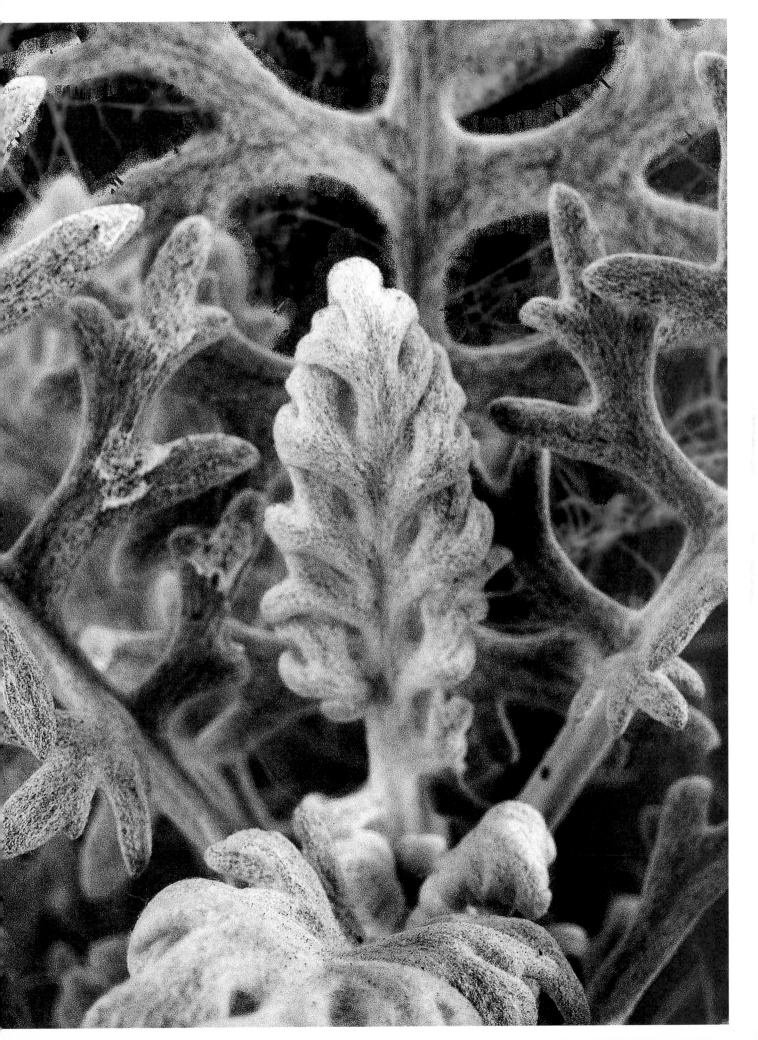

Gears

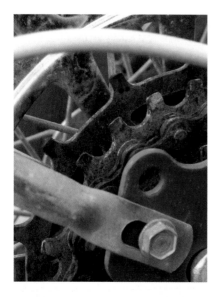

Gears and flowers seem to have a lot in common with modern wheel covers. I just realized that. Maybe that's why I'm so attracted to all three subjects. Anyway, this was just a funky old bike, anchored to a bike stand, where it had probably been sitting since its owner won the lottery.

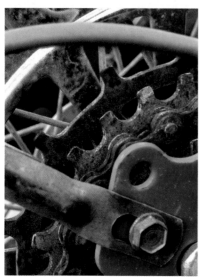

I liked the picture and the composition, but found that there's very little in life that you can't improve on if you have Photoshop and the time to think about it for a while. Here's a quick rundown of what I did: Darkened the two chrome pieces in the foreground, tweaked with Hue/Saturation, isolated the gears with a selection and ran the KPT Equalizer on it, and then used Quick Mask mode to mask the green background that you can see between the spokes and darkened with Brightness/Contrast.

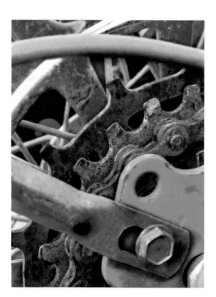

Now I really made it pop! I duplicated the layer and ran the nik Color Efex Pop Art filter on the image. I actually liked the painting it made, but I wanted to keep this image more photographic. I put the Pop Art layer in Color Dodge blend mode. Then I did a bit of painting on the blended layer to make the colors behave exactly as I wanted them to.

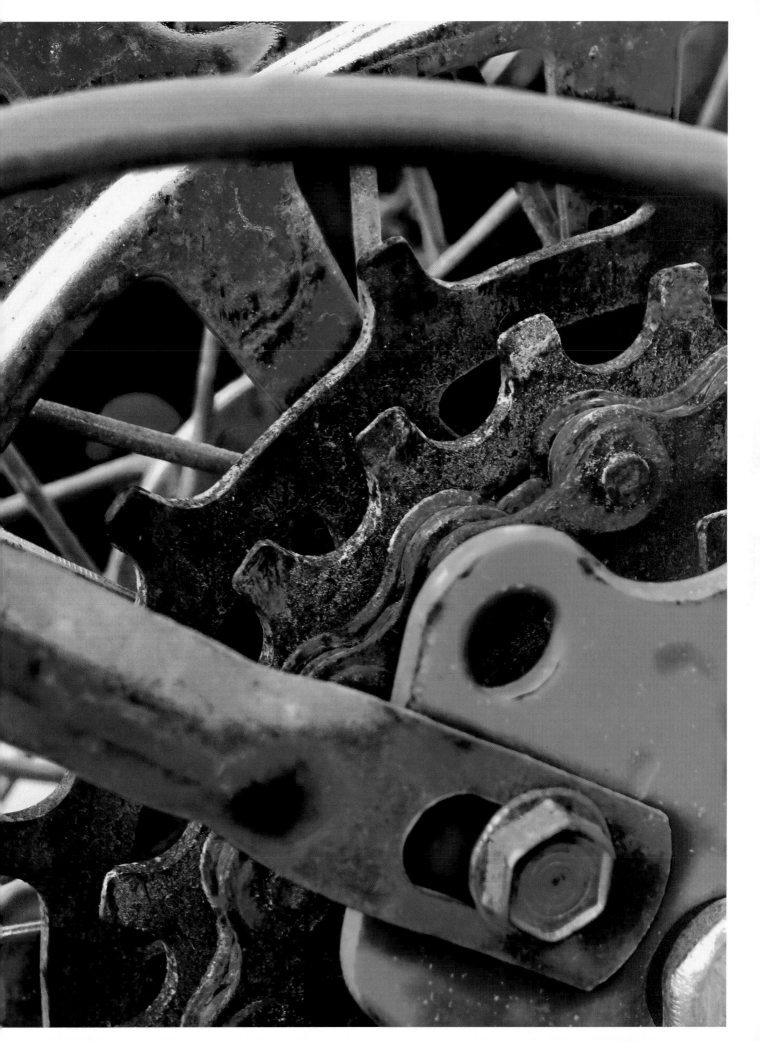

Fallen Maple

Here's a maple leaf that must've had a good life before falling into a sidewalk hedge. I have to admit at first being attracted to the leaf because it would have been easy to set up the tripod right in front of it and at very close range. This image was also taken with the Olympus C-5060 with a close-up filter attached.

All of the changes here were made using everyday Photoshop tools and Power Retouche Sharpener. After I'd run Power Retouche Sharpener (the result really makes you want to stroke this image, doesn't it?) I simply used the Burn and Dodge tools to model the lighting a bit more and to suppress the background so that all you really pay attention to is the texture of the maple leaf and the shapes that its curves and shadows make.

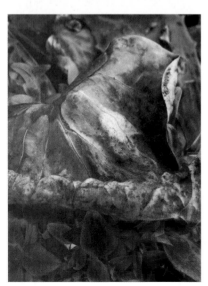

Sometimes little things mean a lot, and the ordinary things in life are what count the most. I finished things off with a very gentle S-Curve in a Curves adjustment layer. I set that operation apart in this particular image, just so you can see (1) that you don't always have to struggle with fancy steps or spend big money on third-party tools to get a professional result, and (2) what a huge difference one simple operation can make—especially if it happens to be a Curves adjustment.

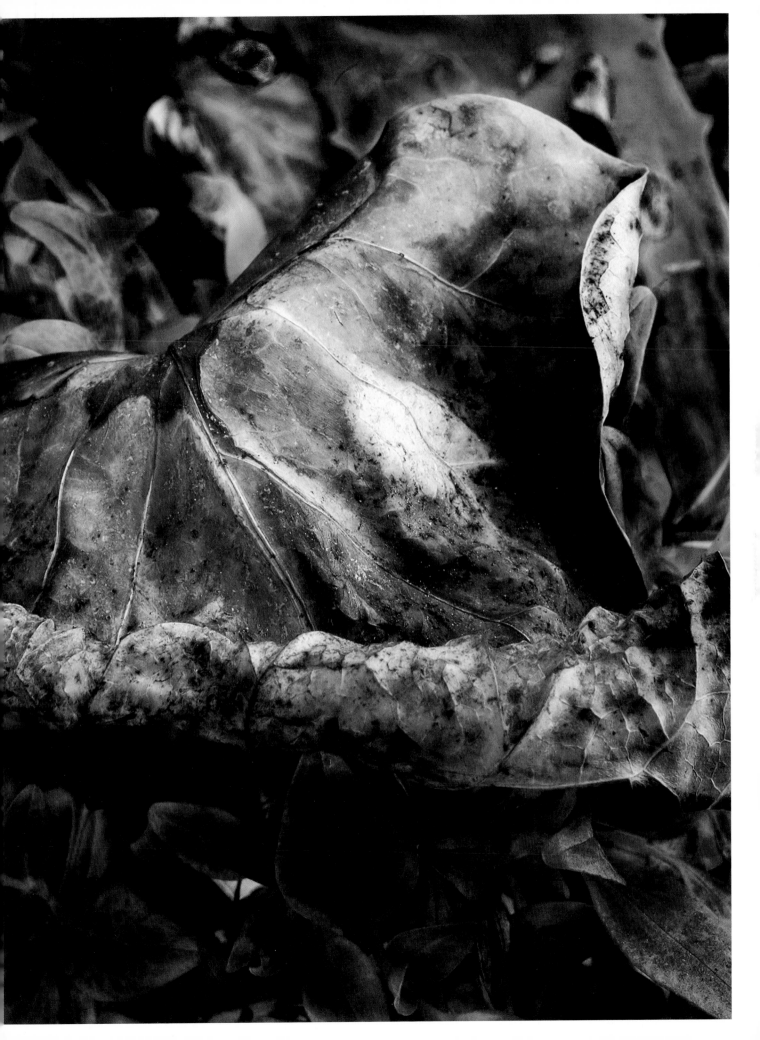

Trampled Maple

In case you haven't guessed by now, maple leaves really fascinate me with the beauty of their shape, the color changes they undergo as they progress through life, and the fact they're so beautiful even when dead. I thought this one was especially beautiful in the way that it seemed to blend and become one with the concrete of the roadway. So I just knelt down with my 4+ close-up filter and used my knees to brace the shot. It still fascinates me that so much detail can be captured with such a small digital camera—the Olympus C-5060 at 1/250 second, f-3.5.

A couple of hours earlier that day, there had been a light mist or sprinkle. I was fascinated by the contrast in textures produced by the droplets of water and whatever the texture of the objects they fell upon. I was just too chicken to expose my little digital jewel to those weather conditions and I didn't have the underwater housing for the camera. Then, that morning, Eye Candy 4000: Nature arrived in my mailbox. It's not quite the effect I saw in nature, but the program gives you incredible control and certainly got across the idea I had in mind.

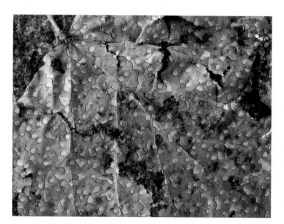

I wanted to make the texture and tones even richer, so I grabbed my old friend the KPT Equalizer, dragged a few sliders, and was very pleased with the result. Pleased and *inspired*, because suddenly I could see that changing the color and character of the background concrete would turn it into an even yummier abstraction—so I selected the background spaces with the Magnetic Lasso (but I'm not sure it wouldn't have been faster to paint a mask in Quick Mask mode). Once the selection was in place, I lifted its contents to a new layer and directly applied the Hue/Saturation slider. Then I burned in a few areas that were just too light.

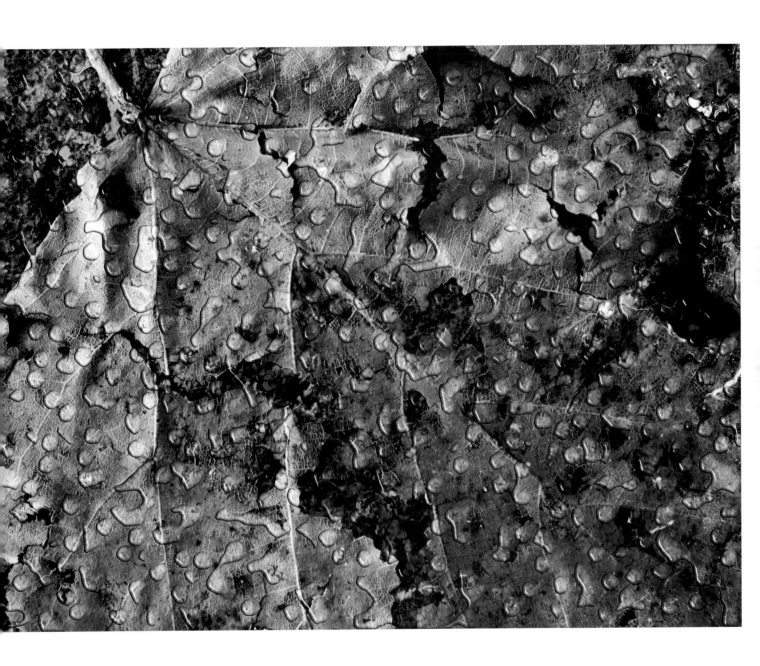

Slurp

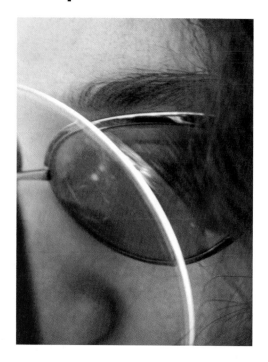

Not every macro wants to be razor sharp. I wanted to capture the pleasure in Thaiza's eyes as she drank her favorite smoothie. I also like the combination of curves made by the glass and the glasses. But this picture, as it is, didn't suggest the mood I wanted at all.

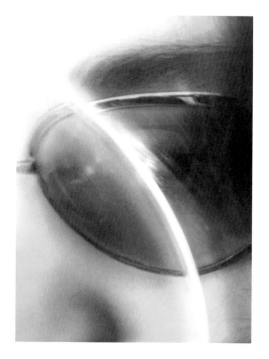

The solution was really easy and very effective as a glamour technique: after cropping the image to eliminate as much of the face as was irrelevant to the image's message, I blurred a duplicate layer with a glamour blur. One of my favorites is the Photoshop Diffuse Glow filter. However, Andromeda's Scatter Light gives you both more control and a much wider variety of effects. In this instance, I used a lot of glow. I also did a fair amount of dodging after the effect was applied. Then I used the Eraser with 15% opacity on the "glow" layer in order to blend it with the underlying original layer. This brought out the sharpness of detail in the glasses and the eyebrow.

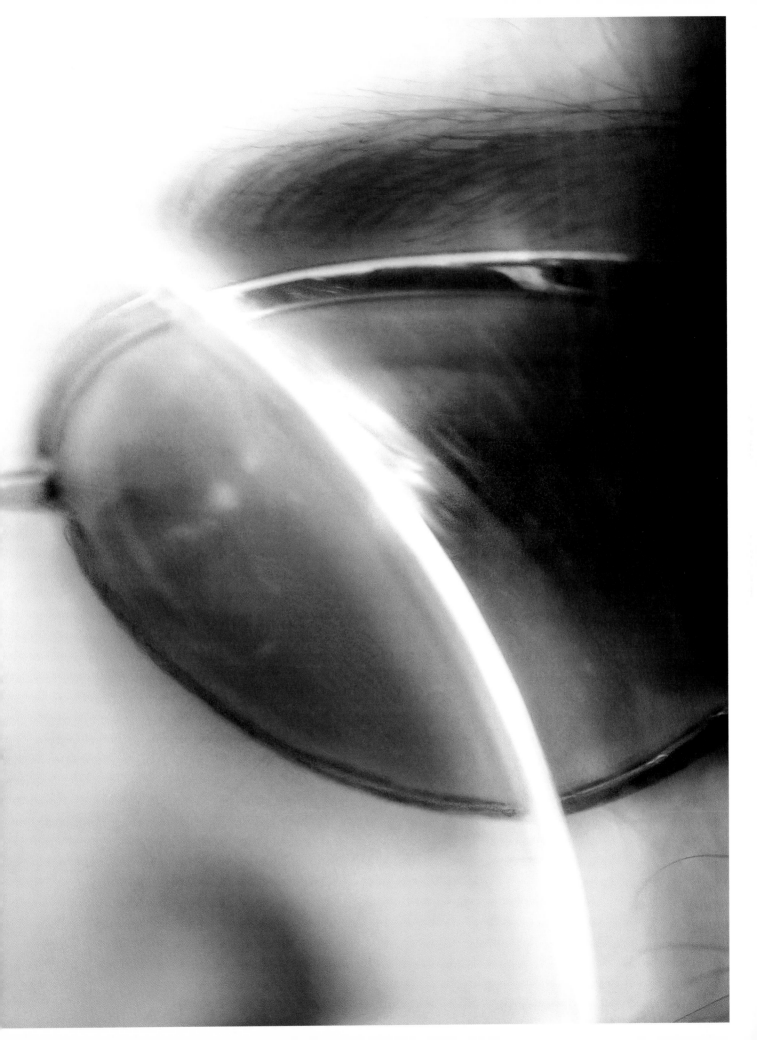

Scantasma

Jungle Fighters

This was a collection of kids' water pistols. Something about them made me think they should be eating one another, so I simply arranged them that way on the scanner's flatbed, set the resolution I wanted, and let the scanner do the rest automatically. I did place a piece of deep red construction paper in the background. One of the big advantages of working with a scanner is that you can set resolution high enough to scan a 35mm frame, so you can afford to do serious cropping. Also, the closest parts of all objects are on the exact same focal plane, as they are all lying on the scanner's glass.

I added a new empty layer and dragged it below the original layer. I used the Elliptical Marquee tool in Circle mode to create circles of various sizes. Then I filled each circle by using a Brush, employing different Swatches colors for different circles. This layer was then given a Bevel and Emboss Effects layer. I created another layer and filled it with the color of the original background and dragged it beneath the polka-dot layer so that it could be seen in the transparent spaces between the dots. Moving up to the original scan's layer, the Magic Wand was used to select the original background color, but not the deeper shadows. That selection was then feathered by 40 pixels and I erased its contents by pressing the Delete/Backspace key, revealing the polka-dot layers below.

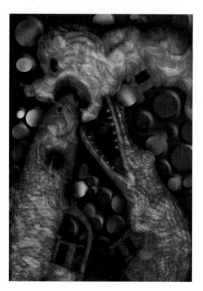

The animals layer was duplicated and dragged to the top of the stack. The KPT Fiber Optix filter was then applied to the layer. It is possible to make an infinite variety of filter textures. I then blended this textured layer with the Pin Light Blend mode and independently adjusted the layer with the Brightness/Contrast filter. Now the animals have a bit of an "ancient Orient" flavor.

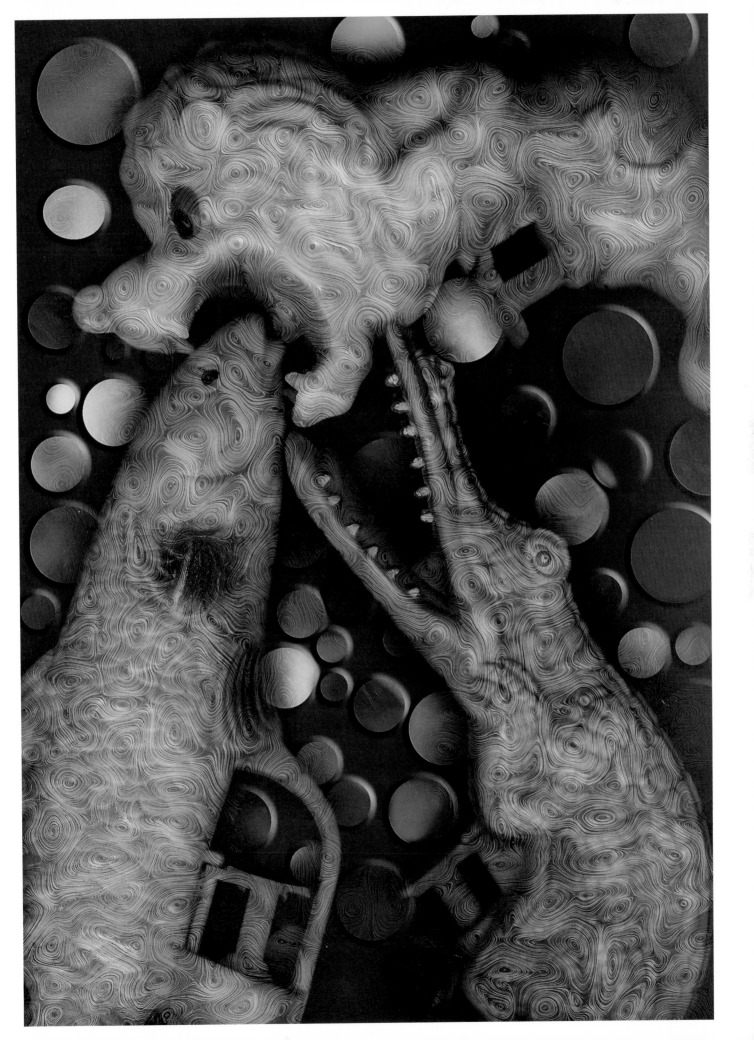

Dead 'n' Dry

These leaves died when my hedge trimmer took them off the hedge surrounding my deck. They'd been dead a good long time when I dropped them on the bed of the scanner, fussed with the arrangement of the leaves a bit, and then placed some blue construction paper behind them for a background. Nothing else at all had to be done to the image to make it look like this. But of course, it's my job to mess with it anyway, right?

To make the background look more textured, the Colored Pencil filter was applied after the background was isolated with the Select Color command and the edges of the selection feathered just enough to avoid a halo.

I wanted to dramatize the shapes and textures in this scan, so I resorted to one of my favorite Photoshop filters, Buzz Pro, and applied the Edges Colour effect. Buzz will let you use many different layers of watercolor effects, but it's often wise to keep things simple. In any case, I just stuck with this one layer. Before I applied this effect, I was pretty certain I'd want to blend the result with the original image, so I duplicated the original image's background layer. The effect you see at left was then applied to the duplicated (top) layer.

I duplicated the image several times and tried different blend modes on each so that I could compare the results. I finally chose Color Burn for one image and Overlay mode for the other. Both images were then flattened and the Overlay image cut and pasted onto the Color Burn image as a new layer. Next, I placed the top layer in Pin Light mode. I then used the Eraser tool, set at 50% opacity, to partially erase the background, with the result that the background was darkened considerably.

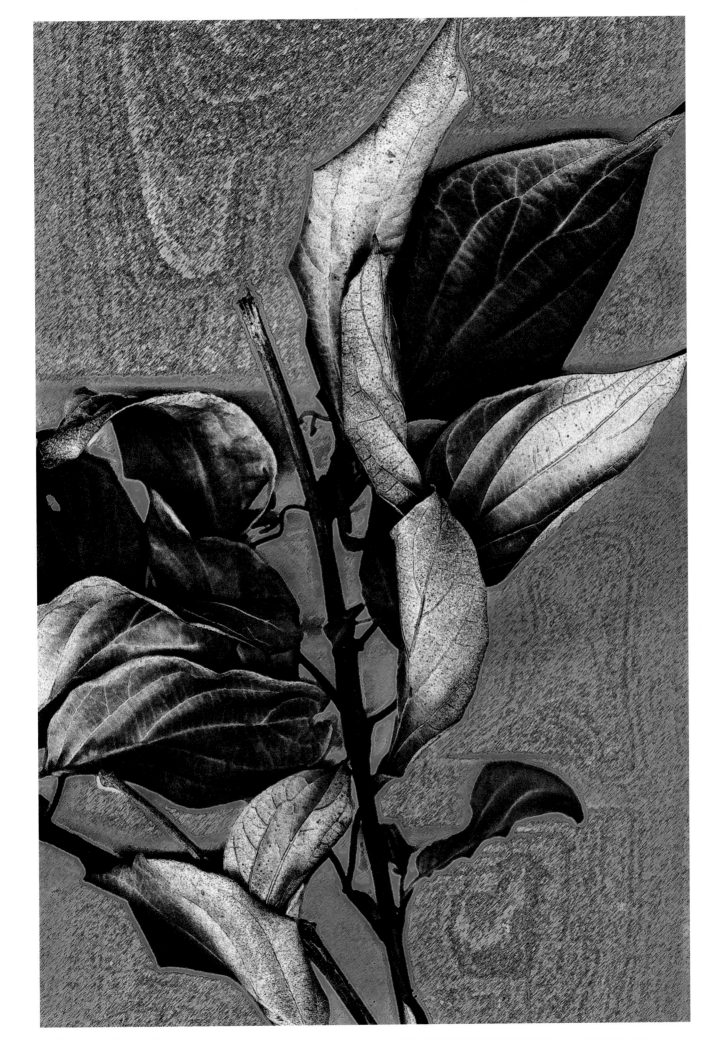

Age and Beauty

There is all sorts of symbolism in this image, which is a scan of the palms of a 69-year-old man of mixed European descent and that of a 25-year old Brazilian woman of mixed African and native Brazilian descent. I rather like the image just as it came off the scanner, but let's see what happens when we apply a few effects to it. Both hands were simply placed palm-down on the scanner bed and scanned in Automatic mode. Colored construction paper was used as the background

The Photoshop Sepia Photo filter was used to produce a sepia tone that gives this image a traditional or "heirloom" look.

The background was removed using a combination of the Magic Wand, Magnetic Eraser, and the History Brush. Then I opened a watercolor "splotch" (I can't call it a *painting*) and pasted it in as a separate layer. I used the Brightness/Contrast adjustment on the painting layer to darken it in relationship to the hands. I also wanted to cast a shadow behind the hands, so I duplicated its layer, locked its transparency, and filled it with black. To soften the edges of this "shadow" layer, I used the Gaussian Blur filter, dragging the Blur slider until the shadow edges looked realistic. I then lowered the transparency of the shadow layer in order to make the shadow transparent.

Finally, I used the Zoom Blur filter on the background to pull the viewer's attention into the center of the image. The Dodge tool was also used on the background layer to darken the corners of the image slightly so the viewer's attention would be drawn more toward the center of the image.

Watercolor

This image started out as a sheet of white printer paper. I took a child's watercolor kit and just made freeform blotches of color. The "painting" was set aside for a couple of hours so that it could dry thoroughly, then it was scanned. Here's how the image looked when it first came into the computer.

Simply because most of my frames follow 4:3 proportions, I chose the Rectangular Marquee selection tool and used a 4:3 fixed aspect ratio. I then dragged the marquee to cover as much of the frame as possible and kept repositioning it until I liked the composition. Levels and Curves layers were then used to make the colors snappier and more intense.

I decided I didn't really like the white paper showing through, so I made a new layer and filled it with a darkish blue. I then chose the Select Color command, selected the white areas of the painting (top) layer, and deleted the contents of the selection.

Whoa! What happened? Not all that much, actually. First, I thought a bit of a Van Gogh effect might be a nice touch. (This is an abstract, after all, so it doesn't have to mean anything specific.) I just opened the painting in the Liquify filter and used the Twirl tool to "spin" the color strokes. I then intensified the colors through the use of a Curves layer and then changed the colors totally with the Hue/Saturation sliders.

Working Girl

Here's just the straight scan.

As the paper I had available for background use didn't cover the entire background because it had to be placed behind the shoes, I selected the areas that weren't colored, chose the Color painting mode, picked up the background color with the Eyedropper tool, and then simply painted over the background areas that weren't covered by the construction paper. I also discovered that when so much of the image is this dark, tiny dust spots on the scanner surface really stand out in contrast. Healing Brush to the rescue!

I wanted a little of the atmosphere that surrounds this gear when it's out and hard at work. It's hard to get that on a scanner, but it's very easy to clone from one image to another. In this case, I just used a large, soft-edged brush so that strokes would blend together easily. Then I opened several of the files I was considering using in the Patterns and Textures chapter and simply painted them in over the background. It's a very effective technique that could be used in a great variety of situations.

Scrappy

Sometimes the best scanner abstracts come from just playing around. Scanning is so quick and easy that it encourages experimentation. To start this image, I randomly cut out scraps of construction paper, dropped them on the scanner bed, spread them around until they filled the space, and then scanned them. Then I scrambled them again and started over until I got an arrangement that I felt I could work with. Of course, one could do this with an endless variety of random object collections.

One of the great advantages of working with abstracts is that you can't always be sure which side is up or what should face right or left. That's a good thing because you can just rotate and flip the arrangement until you see the orientation that works best. In this case, I rotated the image 180 degrees, and then flipped it from left to right (Flip Horizontal). I also wanted to "paint" the edges of each piece of paper, so I used the Magnetic Lasso to select the edges of each piece of paper, converted the selection to a path, and then used the Paths palette commands to stroke the selection. For each piece of paper, I choose a different brush size, style, and color. Actually, what I thought would be an automatic procedure took forever, so I just painted the whole thing manually.

I didn't think that the colors were dynamic enough or that the result looked very "painterly," so I tried duplicating the base layer and then tried a variety of Blend modes before I settled on Hard Light. I knew I wanted a brush-stroked look over the whole thing, so I flattened the two layers in order to maintain the hard-light look. Then I used the Sumi-e technique.

Bloom Squash

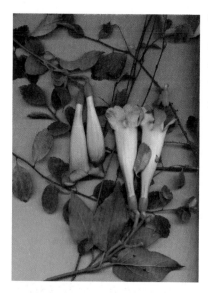

These are flowers from my hedge, squashed onto the scan bed, with orange construction paper in the background. Much as I liked the background color, I immediately wanted to put a more interesting texture in its place, so I selected it with the Select Color command and then modified that selection with a lot of hand-retouching in QuickMask mode.

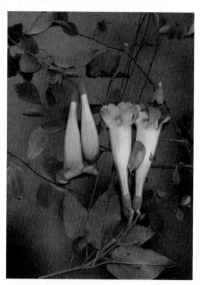

After the background was knocked out, I added a photograph of a totally out-of-focus window as the new background. The two images weren't the same size, but as this was the background, image detail and distortion were of no consequence. I simply re-scaled the new background to match the original photograph. The image was then treated with the Crosshatch filter that comes with Photoshop and Photoshop Elements.

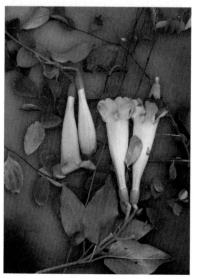

I made a shadow for the flowers by duplicating their layer, locking it so that the transparent areas wouldn't be affected, then filling it with black. I then unlocked it and used the Gaussian Blur filter to greatly blur the black silhouette. I then lowered the transparency of what was now the "shadow" layer, dragged that layer below the original layer, and moved it so that the shadow seemed to be cast with the right angle of lighting. Levels and Curves layers were then used to add snap and to bring up the brightness of the more important elements of the composition.

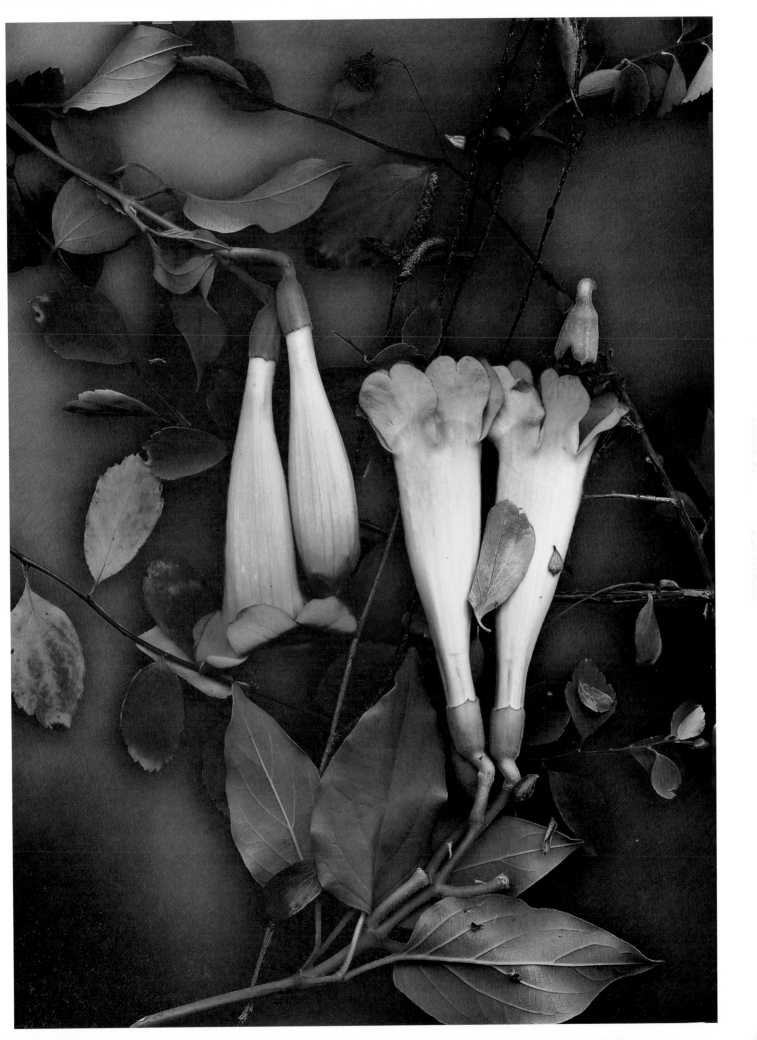

Pocketful of Miracles

This is everything that happened to be in my pockets at the time, covered by a black garbage bag. Sorry, no shoes to match. As usual with single-button scanners, there was no way to preserve detail in reflective highlights or in the deepest blacks. Using both Levels and Curves layers did help to reveal additional detail, though. I also used the Color Balance adjustment—very sparingly.

I thought the image would have a more abstract feel if it were toned and painted. I used nik Software's Color Efex Pro Styling filters and colored an overlying duplicate layer with the Burnt Sienna effect. I then chose one of Photoshop's natural-media brushes for the Eraser and lowered the tool's Opacity setting to about 50%. I also set the Brush Options so that opacity, size, and several types of jitter would vary with the pressure of the Wacom pen. Then I did a little random brushwork to give the image the feeling of time-travel—from ancient sepia tone to contemporary full-color.

I wanted the color to look even stranger, more artistic, and more outer-space-like. So I created a new layer that utilized the Alien Skin Diamond Plate texture. This Alien Skin filter simply makes the layer look like a highly polished steel diamond plate, leaving nothing of the original image. I really liked the effect I got when I blended this layer with the layer below, but then I discovered that it was even more effective to use the Motion Blur filter to make the pattern of the diamond plate tougher to recognize. Next, I raised the Brightness/Contrast sliders on the diamond plate layer and created a Hue/Saturation Adjustment layer to add overall intensity to the colors.

I wanted to turn the whole thing into a more "painterly" abstract. I thought the Photoshop Colored Pencil filter might be perfectly appropriate for this image. As this filter uses the foreground and background colors for many of its strokes, I used the Eyedropper tool to lift color from the version of the image you see above. I made the Paper Brightness (background color) fairly dark, so that it would dominate the image. I also made the Pencil Width quite thick, so that the viewer could really see the strokes.

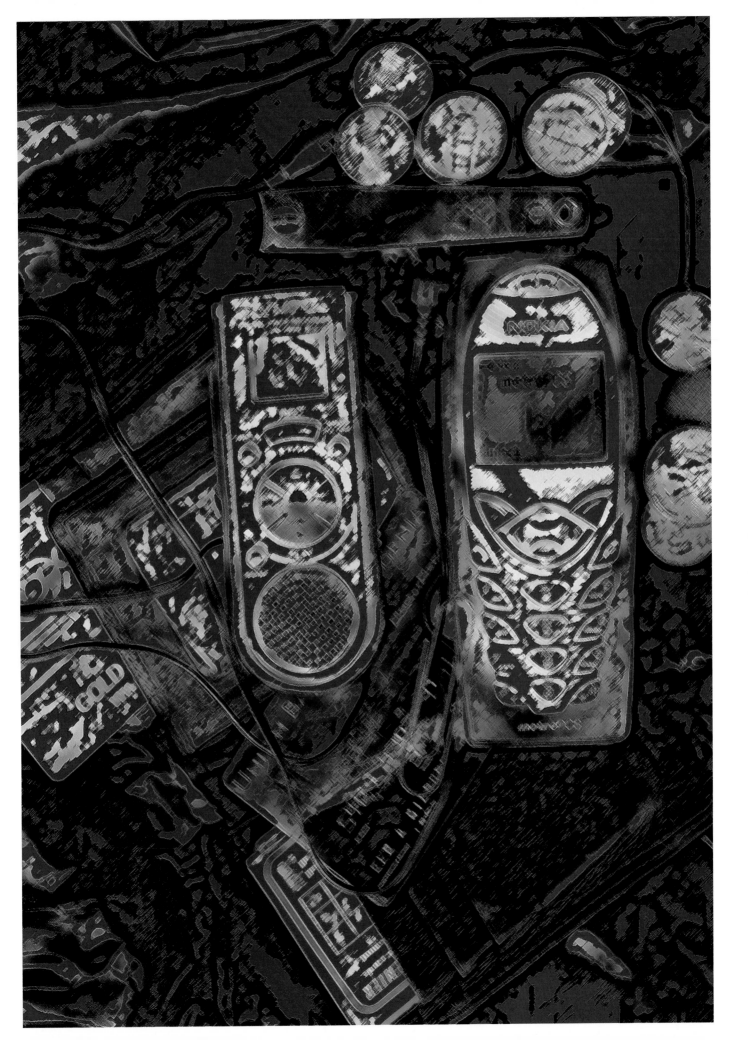

All the Marbles

One of the problems with not being able to control contrast when using a one-button scanner is that dust becomes highly visible. If the dust is white, even the tiniest specks—seemingly millions of them—get vividly recorded. If you're going to use the picture, you're going to have to do what I did: spot out each and every one of them with the Healing Brush. Actually, I used the Photoshop Elements 3 Spot Healing Brush in the beginning because it doesn't require continually indicating anchor points. Instead, it automatically takes color and texture from the immediately surrounding area. For areas near borders, you must use the traditional Healing Brush.

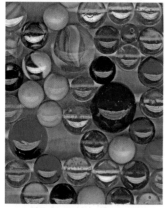

Using the Curves to brighten the contrast certainly did a lot to bring the image to life. I didn't feel that it was enough, though.

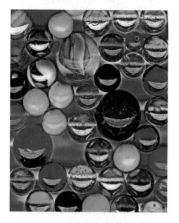

First, I flattened the image above because I knew I wanted to add more color to the background. I then used the Select Color command to blend the gray into a new background color. To make the selection blend, I feathered it by 30 pixels, then pressed the Delete/Backspace key so that you could see through the gray parts of the layer. I then created a new layer for the new background color, filled it with a medium blue, and dragged it below the original. Finally, I duplicated the layer with the marbles and placed it in Overlay mode in order to intensify the colors in the marbles.

Finally, I flattened the image again and ran the Andromeda Scatter Light filter. The result was a very soft and dreamy image in which the blue was much more predominant. I then duplicated that layer and used the Photoshop Chrome filter on it. The Chrome layer was then given a Linear Burn Blend mode. The end result is, I think, stunningly beautiful.

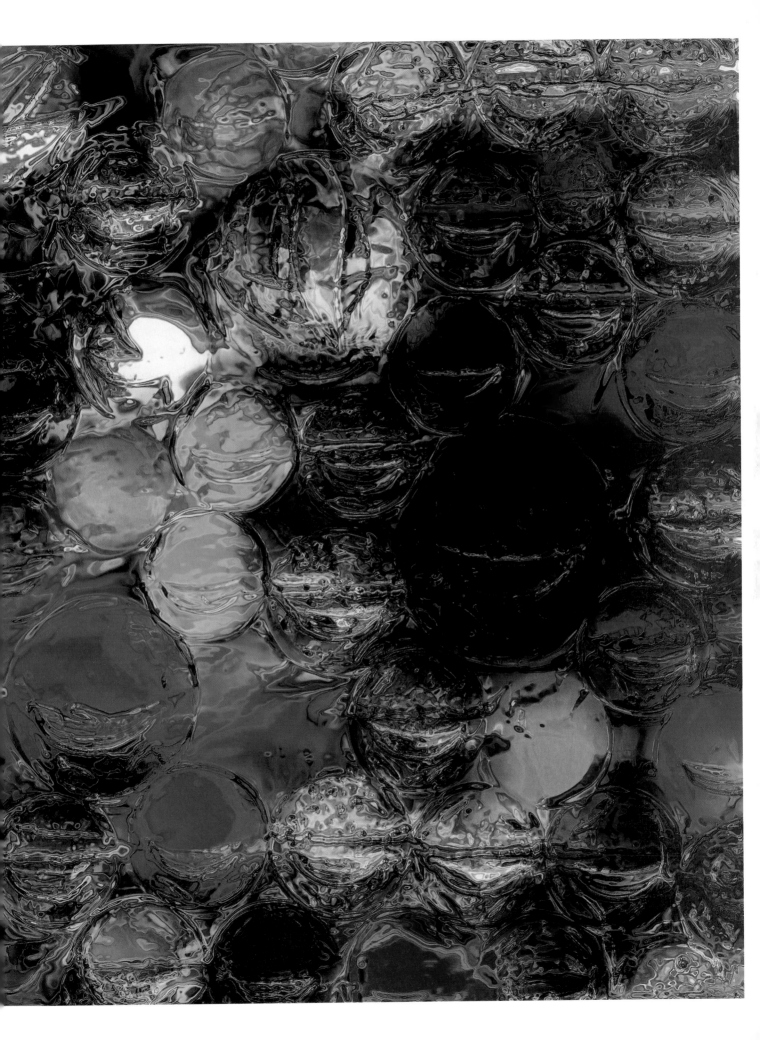

Color Massage

Massage oil and food coloring do mix—if you're persistent enough. The technique used here is very similar to the technique used in Chapter 5, "Liquids," where colored oils were poured onto a glass dinner plate and then backlit. A different texture and lighting effect is produced, however, when you use a scanner instead of the camera. For one thing, the light moves as the image is scanned and the object being scanned casts a shadow equidistantly in all directions.

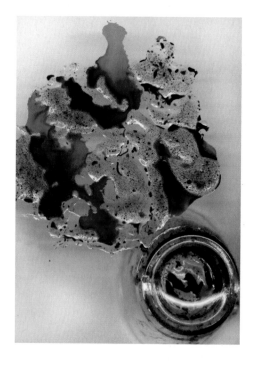

One big advantage of the scanner over the APS-sized sensor in most pro digital cameras is that you can scan at very high resolutions over a large area. You can then crop into virtually any small portion of the image. This was about a 3×4-inch area of the scan bed, but had I raised the scanning resolution to its maximum (on this scanner) 2800 dpi, it could easily have been one-fourth of this size without any loss of resolution or definition. Here, all I did was clone out the black edge on the lower-left of the image and boost saturation and contrast.

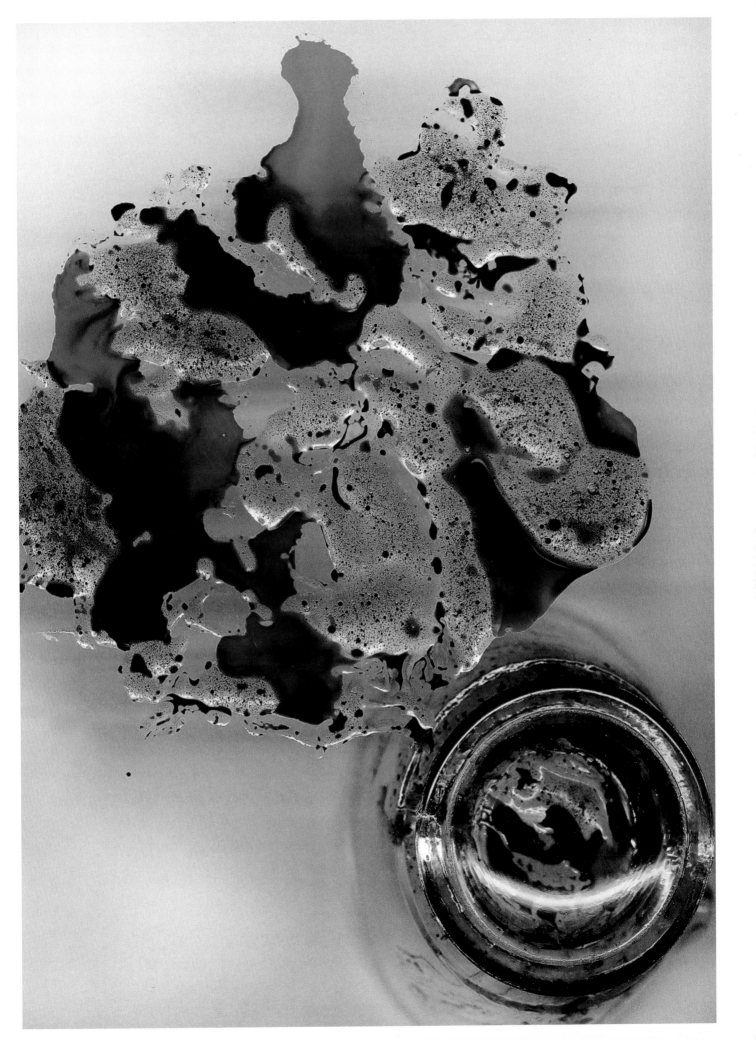

Patterns and Textures

Driveway

This was a small section of a commercial driveway in the Hayes Valley neighborhood of San Francisco. If you look closely enough, you can find endless fascination in the textures of driveways, or virtually anything else that's developed a patina from the abuses of time, weather, and usage. This image was photographed at 1/250 at f-5.6 with an Olympus 5060. I increased contrast and saturation in the Camera RAW converter. Frankly, I think it's quite lovely just as it is, but my job, for this book, is to add drama so that you can see how it was done.

I added two adjustment layers: Levels and Contrast. Levels uses a Lighten Blend mode. Color is neutralized with the Gray dropper in the Curves layer, which had the effect of resetting the overall color balance of the image. I thought the right side of the image was much too dark in comparison with the left side. As you will see as you read the rest of this chapter, having one side of the image darker or lighter seems to go with the territory when you use close cropping to isolate a part of the subject in order to abstract it from reality.

Next, I used another image to create a painting on the textures in the driveway. I took a photo of the reflection of several objects in a window, automatically corrected color, and then pasted that image into the Driveway image as a new layer. I then placed that layer in the Hue Blend mode and reduced Opacity to 50% so that I could see more of the pattern and texture of the original, and so that the colors become more subtle and "aged."

Finally, I added four lights in the Lighting effects filter to emphasize texture and color. That's easy enough to say, but it did take about half an hour of experimentation to get an effect that I felt worked. And when all was said and done, the difference was barely noticeable. Still, I feel it made this image "work."

Hedging Bets

Here's the original image after I made fairly typical Camera RAW adjustments that brought details back into highlights. In Photoshop proper, the Select Color command allowed me to quickly isolate the light patches of blue sky, then darken them with the Brightness/Contrast command in order to make them less distracting. I still feel the image is too dark, however.

I wanted more visible detail in the texture of the flowers and the vines. I could have used the Shadows/Highlights filter, but it is sometimes faster and easier to simply add a Levels or Curves layer and change the Blend mode to Screen. You can then control the effect by adjusting the opacity of that layer. After I did that, I pushed the wall itself into total shadow by painting it with the Burn tool set at 45% (an unusually high exposure).

Now I turned the whole thing into an abstract painting, with a lot of help from Xaos Tools' Paint Alchemy. Paint Alchemy hasn't changed much since it was developed, but it's still one of the most versatile and realistic means of more-or-less automatically making an image look as though it has been brush-stroked. There are virtually limitless brush-stroke looks and variations built into the program, but if they're not enough for you, you can create your own from scratch using the program's dialogs. (I say *program*, but this one works as a Photoshop plug-in.)

Bloomingdale

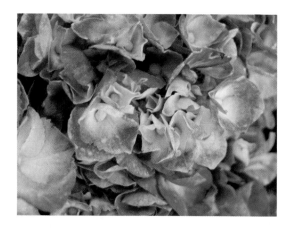

This photo of a bouquet was taken with the Oly C5060Z; 1/90 second at f-3.5, ISO 200. I had hoped to shoot a macro, but this was as close I could get without a close-up adapter. I should have zoomed in a bit more. I used the RAW converter to raise saturation and correct exposure. I then decided that I wanted to crop the image, but I didn't want to lose resolution.

Here's how I got around that problem: I cropped the original without resizing it. Then I used another photo as a background and pasted the original onto a layer above so that the background picture acts as a frame. In order to further distinguish the background image as a frame, I simply darkened it with the Brightness/Contrast adjustment. Next, I used Eye Candy 4000 Bevel Boss filter to make beveled edges for both layers, so that one image seemed to be sitting inside the other.

To make the background image look more like a frame than a part of the picture, I tried an art effect on the background layer—using Paint Alchemy. Then I put a canvas texture on the background layer using Texturizer.

Blackboard

This is a photograph of a café blackboard placed in a men's room so that patrons can leave erasable graffiti. Dim lighting made a truly sharp image nearly impossible. Exposure was about a half second, with the camera braced on a broomstick. A red line at the bottom was distracting, and so was cropped out. Then I performed extreme effects sharpening in Photo Wiz Focal Blade Pro to at least give the illusion of sharpness on a gritty blackboard.

In this case, I was looking for grittiness and drama, rather than accuracy. The image still wasn't as sharp or as textured as I wanted it to be, so I decided to experiment with the built-in Photoshop art filters. Thanks to the Filters palette, with which you can mix the effects of different filters, I had plenty of ammunition with which to experiment. I ended up layering Rough Pastels, Dry Brush, and Ink Outlines to get the impact I was really looking for. The best thing is that it still looked like blackboard graffiti.

I still wanted the image to look a bit more "painterly" or "artsy" (it's graffiti, after all), so I duplicated the layer and used Paint Alchemy to "paint" it with a sponge-paint effect. Then I took the Eraser tool and used a small brush to "scratch" away the effect strictly over the principal graffiti so that you can still see chalk strokes in the midst of the artwork. Someday, perhaps, this will hang in the Venice Beach MOMA—if there ever is such a museum. (There certainly should be.)

Tree Grate

Photographed with the Olympus C-5060 in RAW mode at ISO 200 at 1/60 second at f-4. The original RAW image wasn't nearly as dramatic, as the background leaves were much brighter and the grid much darker. After sending the adjusted image on to Photoshop, I used the Levels Curves to bring up the brightness of the highlights, and a Curves layer to emphasize the contrast between the various colors in the grid and to greatly darken the leaves and debris under the grid. Then I created a Hue/Saturation adjustment layer to emphasize the color within the textures on the grid.

Next, I just wanted to make the image prettier, so I made a layer mask with the Magnetic Lasso selection tool. Then I just opened the Swatches palette and used it to choose different colors as I painted the masked layer with a large, feathered brush that allowed the strokes to blend with one another as I selected different colors. Of course, I didn't really want an effect that's quite as obvious as that in the image at left. If you think I used a Blend mode next, it's because you've been reading this book.

As usual, I just experimented with the Layer Blend modes until I liked what I saw. The closest I could get to what I wanted was Color Burn, but it's a bit too garish. So I simply reduced the layer opacity to 70%, which makes the effect a great deal more subtle.

The finishing touch was making the leaves under the grate abstract, so that viewers can use their imaginations to determine what the grate is protecting or jailing. I simply recalled the layer mask for the grid, selected the Background layer, inverted the mask, and used the Eye Candy 4000 Swirl filter on the leaves. The result looked a bit like wigs trapped under the grid.

Sycamore Bark

Photographed with the Olympus C5060 1/20th second at F3.5. This is a close-up (but not so close as to qualify as a macro) of the bark of a sycamore tree. The sycamore has very flaky bark that sheds in layers; one could do a whole book (or at least an exhibit) consisting of nothing more than the abstract shapes found in sycamore bark. My first inspiration with this one was to make it look a bit like a topographical map. Fortunately, the circumference of this tree was big enough that there wasn't a great deal of depth-of-field falloff. The steadiness of the shot was simply due to my having taken about 10 nearly identical exposures and picking the one with the least camera movement.

I wanted to "improve" the composition a bit, as well as emphasize the roughness of the bark. First, I clone over the dark areas that border the right side of the frame. I then used the Adjustment and Curves layers, as well as a Hue/Saturation layer, to make the colors more vibrant. This did almost exactly what I wanted, except that it washed out some of the lightest parts of the image where the bark has peeled away. I used the History Brush to paint those areas back in from the original.

Next, I wanted to make this feel like a surface map. First, I flattened the entire image. Then I duplicated the Background Layer and over-sharpened it for even more drama in the texture. I duplicated the resulting image and changed the mode to Grayscale and used a Curves layer to make the black and white image even more "contrasty." I then flattened it to be used as a bump map. That's what you see at the left.

Next, I used the Texturize filter and used the Load Texture command to load the bump map as the texture for the image. The filter let me control the height and severity of the bump and the direction of the lighting. What you see here is the end result.

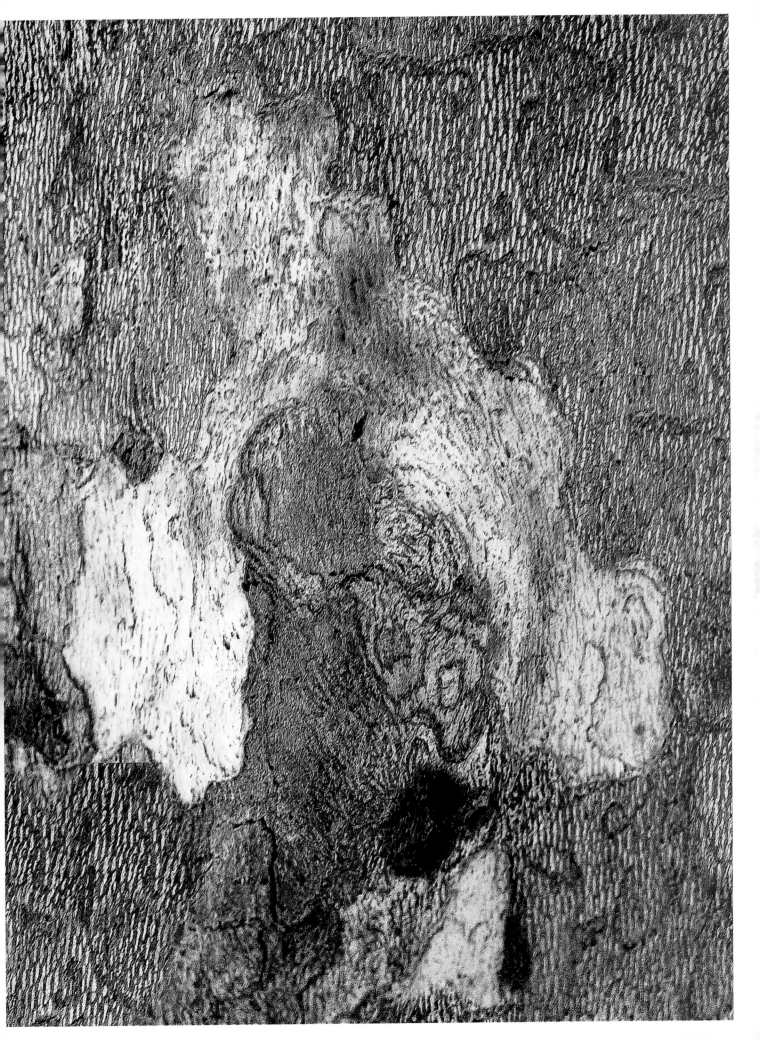

Autumn

This image was photographed with the amazing Casio EX-P600 6M camera; it looks like a professional rangefinder, with its shiny steel body. In fact, it is a very versatile "prosumer" camera. Like most of its competitors (such as the Olympus C-5060, which made quite a few of the images in this book), being a prosumer (high-end consumer verging on professional) camera gives it both advantages and disadvantages. When it comes to abstracts, the distinct advantage of the Casio EX-P600 6M is its relatively small image sensor, which dictates a short focal length. The advantage produced is extreme depth-of-field, especially at apertures wide enough to allow hand-held shooting. This image was shot with the lens at 7mm focal length (33mm equivalent on 35mm film). Everything is sharp as a tack, even at the relatively wide f-4 aperture used. Shutter speed was 1/400 second, which explains the sharpness of even the tiniest details.

Much as I liked the original composition, there were some improvements I wanted to make. I did a wee bit of cropping-to-size, and I cloned leaf textures over the asphalt background and lightened the bottom portion of the image to make it match the exposure of the top portion of the image. I then ran the Unsharp Mask routine to compensate for the transformation and applied the usual Levels and Curves adjustment layers.

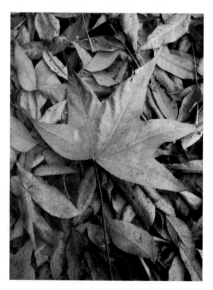

Finally, I selected the maple leaf, feathered it for a smooth blend of the upcoming effect, and then used a new Curves layer to increase just the contrast in the features of the leaf itself, and used a Hue/Saturation layer to boost the leaf's color. Then, to further boost the contrast between the maple leaf and the bed of leaves it had fallen on, I recalled the maple leaf selection, inverted it, and then desaturated the background leaves. Finally, I did a bit of burning around the edges of the image to force the viewer to focus on the maple leaf.

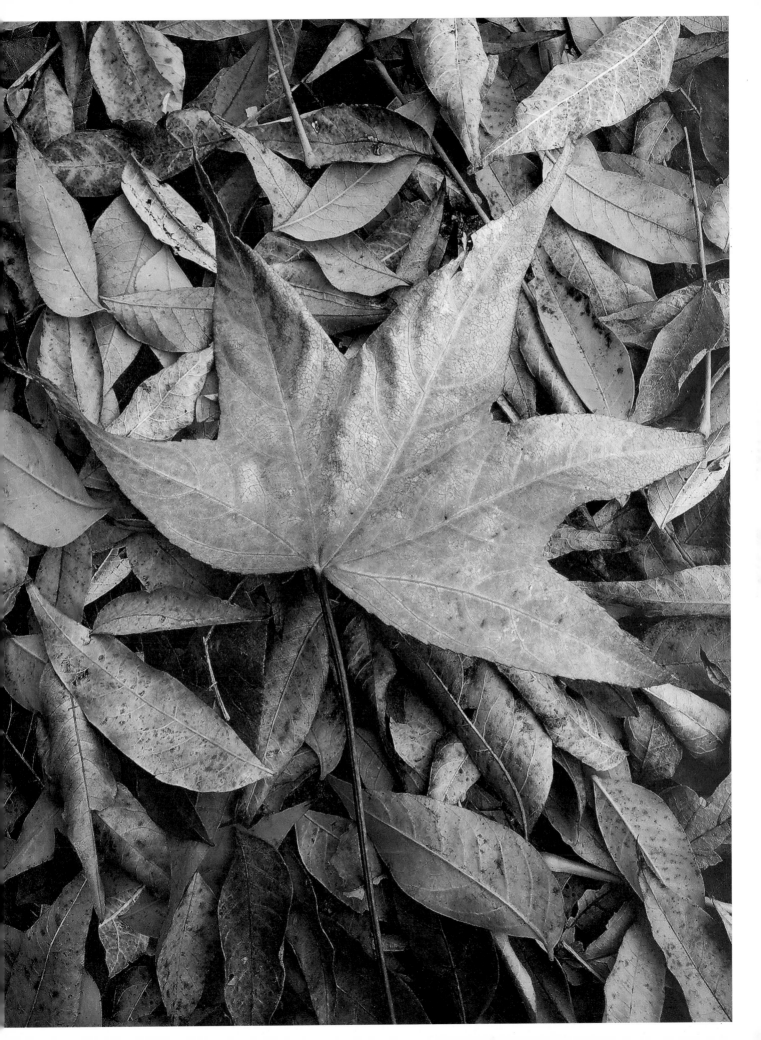

Lamp

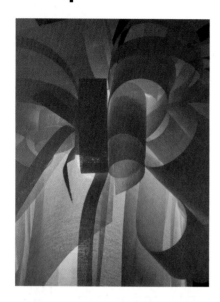

This image was "shot from the hip" with the Casio EX-P600 I simply "pointed and shot." I just couldn't resist the shading and curves in the lamp. Unfortunately, the resulting color balance was much too warm and the image was way too dark at the top.

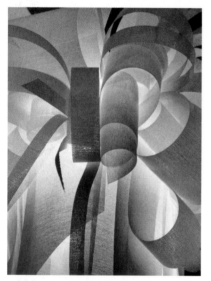

At left you see the first stage of basic corrections. I used three adjustment layers: Levels, Brightness/Contrast, and Curves. I did these operations as adjustment layers so that I could continue adjusting each of them until I was really satisfied with the range of tonalities in the overall image. First, I used the Levels mostly to eliminate underexposure and raise overall contrast. I then used the gray dropper to instantly correct the color balance. Next, I loosely Lasso-selected the darker portions of the image and feathered by about 180 pixels for a totally smooth blend before using the Brightness/Contrast layer to brighten the upper half of the image. Finally, I brought out all of the edges and textures with a Curves layer.

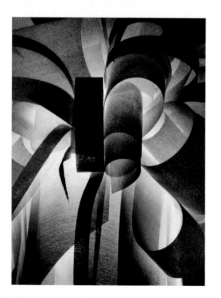

Now I really dramatized the image, using two simple procedures. First, I flattened the image. Then I used a Hue/Saturation at maximum setting to make small color differences in the grays appear to be slightly colored. Then, the strokes of genius: I added a blank, transparent layer to the top of the stack and changed its Blend mode to Soft Light. Then I just used a diffuse brush to blend colors into the image. It was a bit like hand-coloring a sepia-toned print with transparent oils. How did the image become so full of contrast? That was entirely the result of the Soft Light Blend mode.

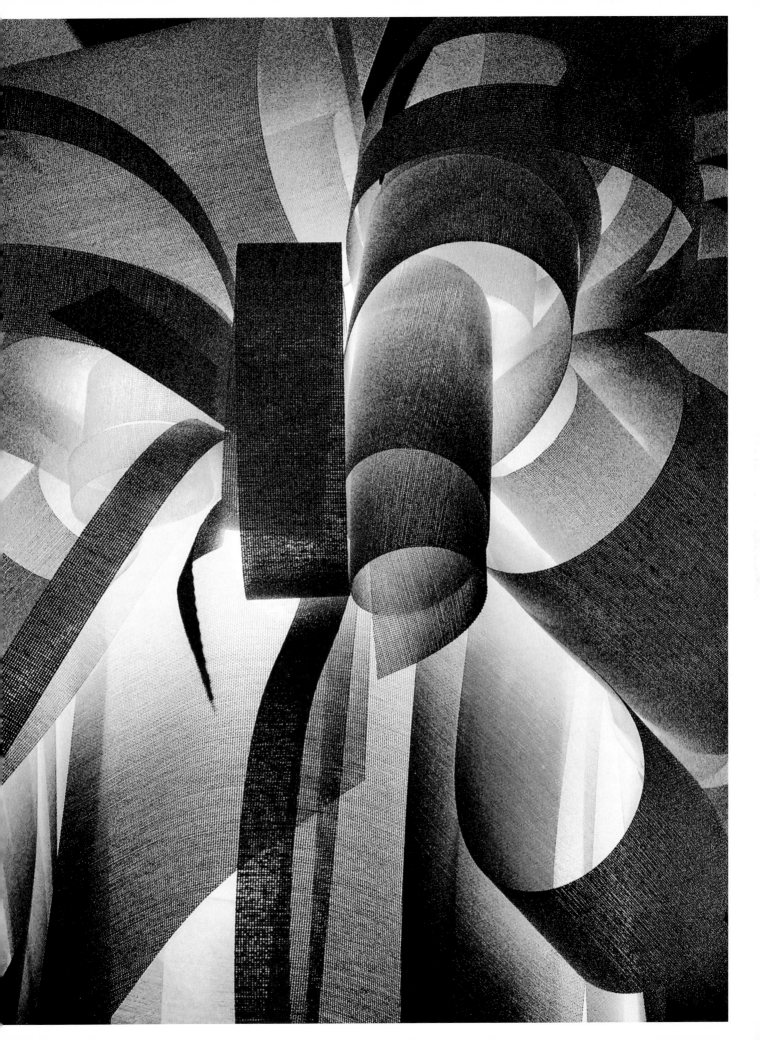

Bridge Trestle

Another image that would have been impossible without the Casio EX-P600. I cross the Richmond-San Rafael Bridge on my way between home and studio. It often occurred to me that a striking image could be made of the funky, elaborate overhead span structure. Unfortunately, I was always too busy driving to get the shot. Then, one day, I had to take the bus because my car was in the shop. I was lucky enough to get the front seat and fortunate enough to have a camera with a huge LCD viewfinder that I could push close to the windshield and still have a good idea of what was being framed. The bus was bouncing like mad, and I had to use a 1/1000 second shutter speed. Keeping the camera absolutely level was impossible.

I felt that the blue sky was a bit boring and undramatic, so I used the Select Color command and the Backspace key. Thanks to the contrast between the bridge and the sky, the sky was removed perfectly in mere seconds. Then I used a nik Color Efex Pro user-definable two-color gradation filter to fill a new layer so that the layer looks like a sunset. I then made a selection that hints at the silhouette of nearby Mount Tamalpais at the very bottom of the "sunset" layer, feathered it, and fill it with dark gray. Actually, the Mt. Tamalpais silhouette is hidden by the bridge, but the "feeling" is still there.

Once I put the sunset sky in, I zoomed in to 100% (part of my regular routine) and realized that, between having to use an ISO of 400 in order to get the high shutter speed and the curves layer to reveal detail in the dark structure of the bridge, I also really emphasized noise. I removed that with the Grain Surgery plug-in. Then I used Hue/Saturation directly on the bridge layer to warm the color balance, as would be the case if the image actually had been shot at sunset.

Sidewalk Art

This is the original Casio EX-P600 JPEG image, as shot. I just love the flow and motion of the grafitti against the natural pattern of stains in the sidewalk concrete. I actually like the subtlety of the image just the way it is, but couldn't resist the urge to dramatize it. First, however, I reduced noise and then did my standard initial Unsharp Mask routine. Whatever else you see that looks like grain is the actual texture of the sidewalk concrete and the spray paint.

I wanted to punch up the compositional elements in the image. Since that's largely a matter of contrast and brightness control, I used several sneaky and not-so-sneaky techniques. The routine part comes in first creating Levels and Curves adjustment layers that, should it be necessary later, can be re-adjusted at any time during the workflow. In the course of doing that, I realized that I needed to "even" the lighting of the sidewalk a bit. I used the Brightness/Contrast command directly on the Background layer in two different stages—first, inside a selection loosely Lassoed around the lower right quadrant, and second, inside a rectangular selection that covers the top half of the image. Both selections are feathered by 180 pixels before the Brightness/Contrast command is applied, so there is no apparent border where these adjustments were made.

I used this technique earlier in this chapter, but couldn't resist doing it again. I used a new transparent layer and painted on it in Soft Light mode. Soft Light works well as a starting place because the colors you paint are the ones you see. At the same time, the colors blend with the underlying textures and pattern. Color mode would produce a similar effect, as would a Color mode when you were using the brush. I just happen to prefer Soft Light. The difference here is that I then duplicated the paint layer and put the duplicated layer into Hard Light mode, then reduced the opacity of the layer to 40%.

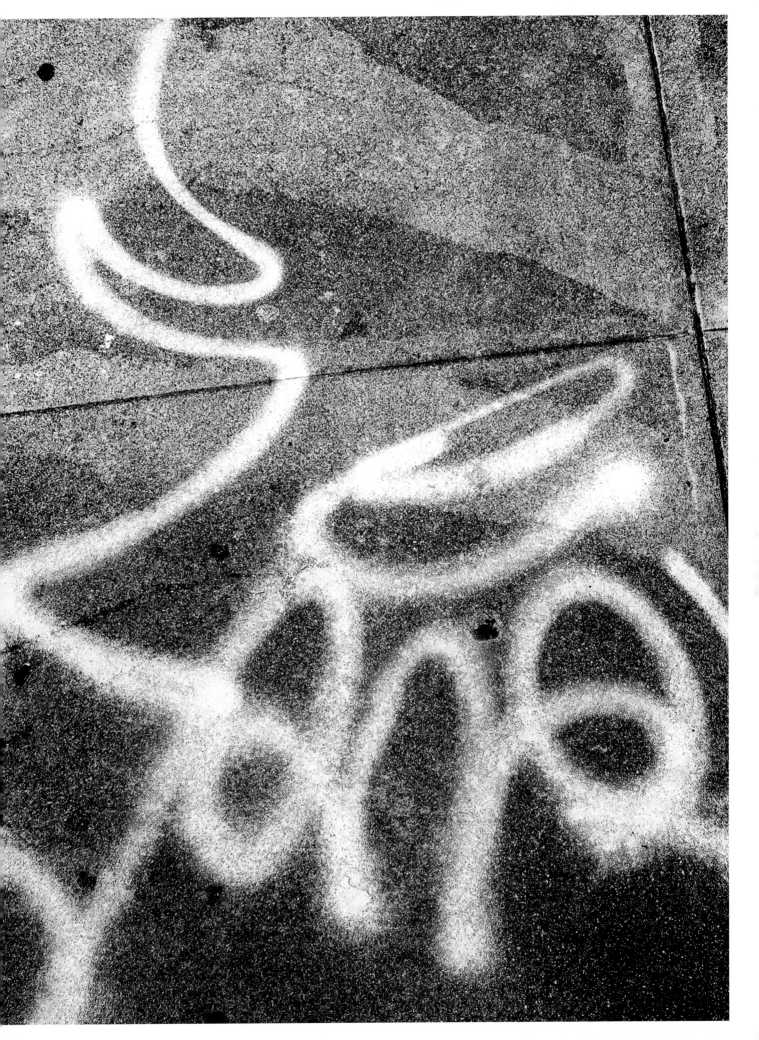

Layer Map

These are layers of paint, worn off after many years and applications. As I recall, this was a macro of a very small portion of a store wall. As far as I was concerned, the photo was all about texture and color. In this image, I've already done levels and curves. I also balanced exposure from left to right and did preliminary sharpening.

For some reason, I became fascinated with the depth of car grills when photographed from very close up. In this case, I used one of a section of a car grill as a bump map in the Texturizer filter. The highly texturized, raised parts are due to the "brushed chrome" texture of the grill. The smooth recessed parts look that way because that part of the image is totally black.

I really like the sculpture of the hubcaps that are so popular on today's sports cars and SUVs. Since it was another automotive texture, I decided to combine it with this image. I first converted it to grayscale. I used it both as a bump map and as a layer overlay. The layer overlay was left in Normal mode, with Opacity reduced to 38%. Finally, I used the Burn and Dodge tools to darken or lighten the low and high parts of the image to give it even more apparent depth.

Glossary

abstract. In this book, *abstract* is used to refer to digital photography that has been modified so that the end result conveys a message that otherwise might not have been seen in a more "representative" interpretation.

adjustment. A change in the image resulting from the use of any command on the Photoshop Image > Adjust menu.

adjustment layer. A special-purpose type of image layer with several useful characteristics: 1) All layers *below* the adjustment layer are uniformly adjusted. 2) Adjustment layers can be given a Blend mode. 3) You can re-adjust an adjustment layer as long as you don't flatten the image or merge the adjustment layer with any other layer.

available light. Whatever lighting existed at the time the picture was shot, not including any sort of light source (such as flood or flash) that was added by the photographer.

Auto Color command. Many image editors have automatic (often called *one-touch*) commands that adjust color balance. In Photoshop, the Auto Color command automatically adjusts the highlights and shadows, then sets the midtone at 50% gray.

background. Those portions of the scene behind the main subject.

background layer. The original layer in the original photo, before you have added layers of any kind. You can't change the stacking order, transparency, or Blend mode of a Background layer. If you wish to do any of those things, first double-click the Background Layer in the Layers palette. When the New Layer dialog appears, it will automatically rename the Background Layer to Layer 0—or you can type in any new name you like.

blend. When not referring to Blend modes, *blend* means there are no hard, defining edges to separate the edges of a selection or layer—for instance, the feathering of a selection is usually done in order to make the effect applied within that selection appear to blend smoothly with the parts of the image that are outside that selection.

Blend mode. Blend modes allow you to apply a variety of effects when image layers or brush colors are applied to underlying images. The best way to learn what Blend modes will do to specific images is to place the image of a color chart on the layer above a background image, select the color chart layer, then cycle through all the Blend modes by dragging the Layers palette away from the Palette Well, choosing the Move tool, and then pressing Shift and the + key until you've cycled through all modes. You will see the name of each mode appear as it becomes effective.

+ Normal: No effect.

+ Dissolve: Makes every other pixel in the top layer transparent so that every other pixel in the visible parts of underlying layers show through.

+ Behind (brush only): Paints only into transparent areas of underlying layers.

+ Clear (brush only): Turns the brush into an eraser as long as the underlying layer isn't a background layer and transparency isn't locked.

+ Darken: Colors that are darker than underlying colors in the blended layer remain, while all others are erased.

◆ Multiply: The color of the base layer is multiplied by the color of the blend layer or stroke so that all colors are somewhat darker. One way to darken a specific area of the image is to select that area, copy the selection to a new layer, and then choose the Multiply Blend mode for the new layer.

◆ Color Burn: Uses an increase in contrast to darken the underlying color by the amount of brightness in the overlaying color. The lighter the blended color, the less visible the change.

◆ Linear Burn: Uses a decrease in brightness to darken the underlying color by the amount of brightness in the overlaying color. The lighter the blended color, the less visible the change.

◆ Vivid Light: If the color in the blend layer (light source) is lighter than 50% gray, the image is lightened by decreasing the contrast. If the blend color is darker than 50% gray, the contrast is increased to darken the image.

◆ Lighten: The lightest color in the blend of the two images is the one that is kept. Colors that are the same brightness intensity in both layers remain unchanged.

◆ Screen: Multiplies the inverse of the blend and base colors, producing a high-contrast image that is lighter overall. This is an excellent way to create a high-key image from one that has been normally exposed.

◆ Color Dodge: Also creates a higher-key image, but with more contrast.

◆ Linear Dodge: Increases the brightness of the colors in the blend layer.

◆ Overlay: Lighter colors are multiplied and darker ones are screened.

◆ Soft Light: Light colors in the blend layer lighten the underlying layer, while dark colors in the blend layer darken the colors in the underlying layer.

◆ Hard Light: Highlights in the blend layer are lightened even more, while shadows (any color more than 50% gray) are darkened even more than in Soft Light mode.

◆ Vivid Light: Progressively more contrasty effect than Soft Light or Hard Light.

◆ Linear Light: Even more contrasty than Vivid Light.

◆ Pin Light: Flattens all tones in the image but the brightest highlights.

◆ Hard Mix: Posterizes the image and leaves few midtones.

◆ Difference: Subtracts the greater brightness value from either the blend or target image and leaves the difference. If the layer is duplicated, then the end result will be black. You can create some very striking abstracts by creating a transparent layer, assigning the Difference Blend mode, and then painting over the transparent layer while changing colors.

◆ Exclusion: Lower in contrast than the Difference mode. Brightness makes a great deal of difference in the final effect. The brighter the color, the more likely the underlying tones will be inverted or partially inverted. Darker tones have little effect and black has no effect.

◆ Hue: The hue of the blend color, mixed with the saturation and luminance of the base color.

◆ Saturation: The color in the base layer is preserved but is given the level of saturation in the blend layer.

- Color: Changes the color of the base layer to that of the blend layer, but the luminance of the base color is preserved.

- Luminosity: The inverse of the Color mode.

blur. In general, *blur* refers to any areas of the image in which the edges and details of the subject lack definition (even to the point where they become totally unrecognizable). You can also create blur "after the fact" by using an enormous variety of built-in and third-party filters. The major categories of blurring filters are as follows:

- Gaussian

- Motion

- Radial, Spin, Zoom

- Lens

Brightness/Contrast command. The name of a command that allows you to control the overall lightness and contrast of the currently chosen image, layer, or selection.

bump map. An image (usually grayscale) that is used to make an image look like a three-dimensional relief map or embossed image. Highlights in the bump-map image make corresponding portions of the target image look closer to the camera, while shadows in the bump map make corresponding portions of the target image look as though they are receding.

burn. In general, this term refers to any technique for darkening a specific portion of the image. Freehand darkening with a brush tool is accomplished with the Burn tool. The more the Burn tool is used on a specific area, the darker the area becomes. You can change the exposure of the Burn tool. The best blending is done with the exposure set to a low number (for example, 8%) while many passes of the brush are made over the same area.

Camera RAW. Can refer to either of the following:

- An image that contains all of the brightness and color information—without any adjustment or compression—that could be recorded by the camera's sensor at the time the picture was taken. Depending on the technical characteristics of the sensor, this image can contain a brightness range of five or more f-stops and can allow a full range of color-temperature adjustment. For those reasons, RAW files preserve the most data about the picture and give the artist the greatest amount of creative control

- The program now built-in to both Photoshop 7-CS2 and Photoshop Elements 3 that allows for adjustments of the camera RAW files created by virtually all varieties of camera RAW (for example, Nikon's RAF, Olympus' ORF, and Canon's CRW). Different versions of this plug-in have different mixtures of features, but all will allow you to set the highlight, midtone, and shadow points in much the same way you would set them when using a Levels command.

channels. Channels are grayscale images. Channels are divided into different categories that are used for different purposes. All of the brightness information for each of the color channels for

any type of image mode is contained in one of these grayscale images. In addition to the primary color channels, specific channels can be assigned to spot colors. Channels used for other purposes are called *alpha channels*. Alpha Channels can be applied as image masks, layer masks, or saved selections.

Channel Mixer. An adjustment command that allows you to indicate the mix of colors from all three channels that will be assigned to any one of the individual color channels or to a grayscale or toned image.

Chrome filter. Makes the image look as though it was embossed in shiny metal.

clone. In the broadest sense, this term says that a part of this or another image has been copied into a space in the image where it didn't exist before. The most commonly used tool for making a clone is a brush called the Clone tool (or, in some programs, the Stamp tool). To use such a tool, you press a modifier key (Option+Alt in Photoshop or Photoshop Elements) to designate the place from which you want to start copying the image. You then move the brush to the place where you want the image to appear and start painting. You can use all of the options (Size, Softness, Opacity, Blend Mode) available to any brush.

close-up filters. Though close-up filters are really lenses, they're usually called *filters* because they sit in the same screw-on or push-on adapters as filters. These single-element lenses are shaped to provide an increase in the main lens' close-focusing ability. This change is measured in diopters. You can "stack" these filters by screwing them atop one another. Once these lenses have been put in place, focusing is most reliable when you can preview the image before you shoot, either in the viewfinder of an SLR or on the ground-glass preview monitor of a point-and-shoot digicam.

collage. A collection of images that have been composed within the same image frame. Often used as a synonym for *montage*, but as used here, a collage is distinguished by showing a clear division between the different images in the collage. In other words, a collage does not try to imitate a scene that did not exist in "real life."

color. The term *color* is generally used in digital photography to mean any change in either color or brightness value that can be perceived by the human eye. So, for instance, there can be many colors of pink.

color balance. The overall color cast of the image. Different types of light sources produce a different color cast. For instance, tungsten light sources will make the overall tint of the image look quite yellow. Daylight is much cooler (more blue). In analog photography, color balance is controlled by changing the color temperature of the film or by placing a colored filter over the lens. Digital cameras let you simply choose settings for each type of light source. You can also change color balance during image processing by using the program's Color Balance command or by modifying color balance and tint in Camera RAW conversion dialog or program.

contrast. The difference in brightness between adjacent shapes within the image. For instance, raising contrast would cause the highlighted areas of skin tone in a portrait to be lighter and the shadow areas to be darker than before the adjustment was made.

control point. The anchor points along a vector path (usually designated by a dot or small hollow square if the path is active) that allow the user to edit the path by changing its shape, curvature, and direction of that path. It is also possible to change the type of the control point from curve to corner point. Curve points have "handle" extensions that allow the user to control the velocity and severity of the curve.

crop. To trim any or all of the edges, to any extent, from the original picture.

curves. *Curves* is shorthand for a brightness curves graph. You can change the brightness of specific ranges of brightness within the image by placing a point on the curve that represents a specific brightness tonality and then raising or lowering that point until you like the previewed effect. You can impose a Curve command either as a direct command from the program's main menu or as an adjustment layer.

Cut command. Copies a selected item to the Clipboard, simultaneously removing it from its original location. This will leave a transparent area in the layer from which the image was cut. You can subsequently paste the contents of the clipboard to a different location or image, provided you haven't made another cut.

depth of field. The distance between the closest and farthest objects in the image that are acceptably sharp to the naked eye.

Difference command. Subtracts the brightest color from the darkest color in either the blend or target (underlying) layers.

digital darkroom. A computer equipped with any sort of software that is capable of altering one or more aspects of the appearance of an image.

digital image processing. Anything you can do in the digital darkroom, especially using image-editing software, such as making adjustments, changes, and enhancements.

dissolve. Randomly elects to change the color of any pixel in the combined image by using any of the possible blend modes on each. The result looks quite pixilated (grainy).

dodge. Any technique used to lighten colors within specific portion(s) of the image. The term could also refer to using the Dodge tool, which is a brush tool whose effect is collective each time a stroke is made over the same area of the image.

download. To transfer digital information (including images) from one source (such as a camera, Internet site, computer, or data drive) to another.

drag. To move an item of any sort (for example, selection, control point, or selection border) from one place in the imaging workspace to another simply by placing the cursor atop it, then pressing and holding the left mouse button continuously while the movement is underway.

dynamic range. The number of visible steps between the lightest and darkest portions of the image. A sunny day image that showed detail in both the whitest clouds and in the shaded areas of the densest forest would have a high dynamic range.

edge. Any two pixel paths whose colors contrast enough so that the viewer sees an obvious difference between the two. There are always edges within edges in a photograph.

effect. Usually used as shorthand for *special effect*. For instance, Photoshop filters are best known for being able to automatically impose an "effect" or "look" on an image (or any selected portion thereof). A short list of examples includes a wide variety of brush and pen strokes, lens flare and lighting effects, and infrared and sepia-toned darkroom effects.

Equalize command. Changes the brightness range of individual pixels so that the entire range of brightness is represented within that picture. For example, a slightly over exposed cloudy sky would normally represent only a few percent of the overall brightness range. By applying the Equalize command, you would cause that same sky to represent all brightness tones from pitch black to stark white.

equalizer. The digital-imaging counterpart of a control panel used in audio studios to control the volume of sounds that fall within a specific pitch range. The digital-imaging counterpart controls the overall brightness and/or contrast for specific ranges of brightness. Differs from using the Curves command in that raising or lowering the brightness of the range of tones within one portion of the brightness spectrum has no effect on the tones that fall within any of the other ranges of brightness.

Eraser. A brush tool available in most all image-editing programs that reduces the opacity (increases the transparency) of the layer you are brushing over. Most programs will allow you to set the opacity of the Eraser brush to any level.

Exclusion. See *Blend mode*.

exposure. The combination of f-stop and shutter speed that was employed when the picture was taken.

feather. To soften the edges of a selection so that they graduate from 100% opacity at the inside edge of the selection to 100% transparency on the outside edge. The greater the number of pixels specified for feathering, the wider the distance between 0 and 100% opacity. To put it another way, the greater the number of pixels specified for feathering, the greater the degree of blending between the selected area and surrounding areas.

file format. The formula that specifies how the image will be interpreted by computer software.

- ✦ PNG (Portable Network Graphics): A format meant especially for compressing images for the Web. Supports bitmapped, grayscale, and 24-bit color images and allows for a single alpha channel mask dedicated to transparency. This allows irregularly shaped Web images because the areas outside the edges of the subject's shape can be transparent.

- ✦ PSD (Photoshop Data): The only format that will support all Photoshop features and any possible color mode, number of layers, and color bit-depth.

- ✦ RAW: The complete and unprocessed data from a digital camera. All professional digital cameras, but only a few "semi-pro" point and shoots, will allow their RAW data to be saved to your computer. RAW files insure the greatest range of brightness and color interpretation in an image. You can change the color temperature balance to anything you like and RAW files typically have a brightness range equivalent to about five f-stops. Your original data is always preserved because it is not possible to overwrite the original RAW data.

◆ TIFF (Tagged Image File Format): The most portable, cross-platform image file format. This format is non-proprietary and is supported by all popular operating systems. The newest version of the format will support layers, but only the most up-to-date programs can read these layered files. Features lossless compression that reduces file size by about half.

filter. Any type of operation that appears on the image editing software's Filter menu. This incorporates an ever-growing range of effects, as well as capabilities such as texturization, 3D surface mapping, and automated image extrusion and distortion.

Find Edges command. Locates adjacent groups of pixels that have a specified level of contrast relative to one another and then draws a line of pixels along that edge.

flatten. Collapsing all layers into one. Can also refer to reducing the overall contrast of an image.

flip. Allows you to reverse the image from left to right or from top to bottom.

focal length. The distance, usually in millimeters, between the nodal point of the lens and the surface of the film or image sensor (often called the *focal plane*). The focal length of digital camera lenses is often quoted as the focal length of the lens on a conventional 35mm that produces the same angle of view. However, the depth of field will not be equivalent unless the actual focal length of the lens is equivalent. This will only be the case if the size of the image sensor is the same size and proportion as a 35mm film image.

Glowing Edges. A Photoshop filter effect that finds the edges in the image, and then creates a transitional color spread (whose distance is specified by the user) between the current foreground and background colors.

Healing Brush. The Healing Brush is a retouching tool that was introduced in Photoshop 7. It operates by picking up the texture from a user-designated position in an image (it can be any currently open image or layer), and then transfers that texture to the area that is painted with the Healing Brush. At the same time the texture is transferred, the area that has just been painted takes on the color and brightness that is predominant in the target area of the image. The result looks amazingly natural.

High Pass. A Photoshop filter that is great for drawing edges and leaving the rest of the image white. The white can be blended or automatically selected and made transparent, so that an underlying image (perhaps the original) can be seen below it. It's a great tool for giving all manner of special effects to outlined edges.

highlight/midtones/shadow. These terms refer to regions of the image that fall within a given range of brightness. In a photo that contains a full range of brightness from absolute black to absolute white, the highlights would represent the lightest 33 percent of all tones, shadows the darkest 33 percent, and midtones everything in-between.

Hue/Saturation command. A command that allows you to use sliders to control the tint (hue), intensity of colors (saturation), and overall brightness (lightness) of the image.

ISO. International Standards Organization. In reference to digital photographs, it generally refers to the camera sensor's sensitivity to light. These ratings are meant to correspond to the sensitivity standards used for analog film.

Lasso. A freehand selection tool.

layer. The digital-imaging equivalent of layers of tracing paper stacked atop one another. Layers can consist of images (either the same or different from one another), adjustment commands, or special effects (such as edge bevels and drop shadows).

layer fill. The amount of the information in the original layer that will be used in calculating its effect on any underlying layers.

layer opacity/transparency. The degree to which you can see through the designated layer to the layers below. You could make several layers visible without changing their Blend modes by simply giving each layer a lower level of opacity; however, the total opacity of all layers must not exceed 100%.

Lens Blur filter. A Blur filter that was introduced in Photoshop CS that simulates depth of field by making the blurring more pronounced as the distance from the edges of the original subject becomes greater.

lens flare. Either a lighting phenomenon that occurs when the picture is taken or one that can be imposed on the image when using an image-processing program that has a special effect filter that performs a similar effect.

Levels command. A Photoshop command for controlling the brightness range of an image. A histogram shows the relative number of pixels in each range of brightness in the image. You can make the brightest and darkest portions of the image correspond to the pixels at the end of the histogram. You can then control midtone brightness by moving a center slider.

Lighting Effects filter. A filter that makes it look as though the 2D image was lit by any of several types of light sources: spotlight, flood (directional), or bare bulb (omni). You can use as many of these light sources as you want and can mix them in any combination.

Liquify. The name of a separate program within Photoshop that allows one to brush various types of distortion into the image. The area that is affected by these distortions depends on the current brush size.

locking layers. At the top of the Layers palette are four icons that let you lock the transparency, image pixels, position, or all three. Locking one of these characteristics means that those characteristics cannot be changed on the chosen layer until you re-click the icon to turn the lock off.

long lens. Any lens that has an equivalent focal length of more than about 75mm.

luminance. The overall brightness of the image.

luminosity. A synonym for *brightness*.

macro. The strict definition is any photograph that records the image at a magnification of the subject that is greater than 1.1 on the original film or sensor. The term is often used, however, to describe virtually any shot that is an extreme close-up. That is the definition I use when referring to macros in this book.

Magic Wand. A selection tool that automatically selects all tones within a given brightness range. You can choose whether you want all those tones to be continuous (connected) or not.

Mode command. Dictates the bit-depth that is assigned to an image. You can use the Mode command to decrease the bit depth. If you convert the image to a higher bit depth, you can then add information that could otherwise not have been contained in an image of lower bit depth. So, for instance, you could convert an image from RGB to grayscale, then convert it back to RGB mode to add color to what had become a monochrome image.

montage. Several images combined into one, usually with no identifiable borders between the images. See *collage*.

natural media. In the context of this book, the term *natural media* refers to digital effects and brush styles that imitate the visual effect of using traditional artists materials (for example, watercolors, oils, pastels), brush styles (for example, mixed colors, brushes, palette knives), and artistic styles (for example, Rembrandt, Van Gogh). Such effects can be created with brush styling, filters, plug-ins, and paint programs that are dedicated to creating artistic effects. Corel Painter is the most well known of these.

noise. The digital equivalent of film grain, but on close examination can consist of a wider variety of pattern types due to a variety of factors, such as color cross talk between the sensors in the image. Deep shadows and long exposures tend to create the most noise.

opacity. The degree to which you can see through one image or brush stroke to the image below. The term is synonymous with *transparency* in that when you specify how opaque the layer or brush will be, you are specifying the degree to which the stroke or layer image/effect will influence the underlying image(s).

out of gamut. Colors within an RGB photograph that are beyond the printable range of the CMYK colors used by all printing devices.

perspective. Our visual perception of the size, relationship, and point of view of objects that are within the boundaries of the photograph. For instance, if two objects are the same size, more distant objects will appear to be smaller. If one is viewing an object or scene from an angle, parallel lines will appear to converge as they move farther away.

pixel. Short for *picture element*. The smallest unit in a digital image. A pixel can contain only one color or shade of color.

plug-in. A program that works within the context and workspace of another program. Some plug-ins come installed with the program, but you can also install plug-ins at any time. Plug-ins can come from a variety of software publishers.

render. To process the image according to the adjustments you've made using a command or palette.

Replace Color command. A command that lets you choose any color from the image and then choose any other color as a substitute for that color.

rotate. This term refers to a kind of transformation that allows you to turn the image by dragging it. Most programs also have a direct command that allows you to rotate the image in 90-degree increments, either clockwise or counter-clockwise.

saturate. To intensify the color values in a photograph.

Select Color Range command. A Photoshop command that allows you to select (place a marquee around) all objects within the photograph that are within the range of color and brightness that you specify. The command also allows you to automatically select any given primary color (regardless of brightness), highlights, shadows, midtones, and any colors that are out of gamut.

selection. A closed, dashed line (also called a *marching ants marquee*) that indicates a part of the image that will be isolated from the rest of the image during the performance of most subsequent image-editing commands.

- Lasso: Lets you draw the outline of the selection freehand.

- Magnetic Lasso: Automatically adheres the selection marquee along any edges that have a user-specified range of contrast.

- Polygonal Lasso: Draws the selection in straight lines between any two sequential mouse clicks (main or right button only).

- Rectangular selection: Automatically draws a dashed box around the subject. By default, proportions of the box will be according to the diagonal between the starting corner point and the finishing corner point. However, you can also specify specific proportions or a given size.

- Elliptical selection: Makes elliptical or circular selections using the same options as for rectangular selections.

- Magic Wand: Automatically makes a selection when the mouse is clicked while the cursor is over a specific spot. All colors within the user-specified range are then selected.

Select Color Range command. A Photoshop command that allows you to select (place a marquee around) all objects within the photograph that are within the range of color and brightness that you specify. The command also allows you to automatically select any given primary color (regardless of brightness), highlights, shadows, midtones and any colors that are out of gamut.

sharpen. To post-process the digital image so that it creates the impression of a sharper image than was originally photographed.

- Initial: Ironically, because most digital images are created by blending and transferring pixels across several colors or by physically changing the shape and position of the original pixels, virtually all digital images need some sharpening just to make the image look as sharp as the camera's optics would have made it look had it been shot on film.

- Effect: There will be times when, in addition to initial sharpening, you will want to create more definition between edges—especially if those edges are already very low in contrast or if the shapes you want to show the viewer are all nearly the same color.

✦ Output: This is sharpening that is done to match the image's edges to the resolution and positioning of dots inherent in the printer or other output device that will ultimately be used. Always do output sharpening on a copy of the image just before printing. Otherwise, you will be unable to do effective output sharpening if you want to print at another size or on another device.

shutter lag. The time differential between the instant when the shutter is fully depressed and the instant at which the picture is actually recorded. Generally speaking, the lower the cost of the camera, the more likely you are to experience objectionable shutter lag.

Softened. Term for adjusting the feathering or the shape of a brush so that the effect of the brush becomes gradually less intense (fades) on either side of the edge of the brush. At maximum softness, the fading starts at the center of the brush and reaches 50% opacity at the edge of the brush and then continues fading to 0.

sliders. Controls in a command's dialog or in a palette that allow you to control the intensity of some aspect of that command, such as the overall intensity of that effect or the amount of a specific color.

spin. A variation on a motion blur effect that creates a radial blur. The amount of blurring becomes more severe as it moves toward the outside of the designated blur area.

stroboscopic motion. A blur filter variation (so far, available only in third-party filters) that leaves a fading trail of copies of the portion of the image that was selected for blurring. Think of the high-speed motion effect you often see used by comic book artists.

swatches. Squares of pre-set, predetermined color that you can choose without having to mix them in the program's Color Picker dialog.

texturize. To make the image look as though it were printed on a textured surface, such as watercolor paper, canvas, or burlap.

Threshold. An adjustment that turns the image into black and white, but lets you choose the level of brightness that divides the two.

tonal range. The range of brightness tonalities in the original scene when compared to the tonal range visible in the digital image.

toned. Changing the basic colors in a monochrome (or near-monochrome) image. The Duotone command in Photoshop allows one to pick how many and which colors will make up the toned look.

transform. Any operation that allows you to change the size, rotation, shrink, or stretch the image from side to side, or distort the image by stretching or shrinking one corner of the image at a time. You may transform either layers or the contents of a selection.

USM. Unsharp masking.

unsharp masking. A term often used in digital-image processing that refers to an analog photography darkroom process in which the edges in a photo are masked and the edges in that mask softened or thrown out of focus so that increasing the contrast within the unmasked portion of the

image will blend smoothly with the masked portions of the photo, where there has been no increase in image contrast.

workspace. The area within an application's interface within which you can actually see and make changes in the image.

zoom. A term used to describe both the ability to change lens focal lengths without physically changing fixed focal length lenses and the process of doing the same. It provides a method for changing the cropping and depth-of-field in an image without having to physically move closer to or further away from the subject.

Index